Bernard Denvir
is the author of a four-volume documentary history
of taste in art, architecture and design in Britain, as well as of
books on Chardin, Impressionism, Post-Impressionism and
Fauvism. A contributor to many journals and magazines, he
was head of the Department of Art History at Ravensbourne
College of Art and Design, a member of the Council for
National Academic Awards, and for several years President
of the British section of the International Association of Art
Critics. His other books include *The Impressionists at First
Hand* (1987) and *The Encyclopaedia of Impressionism*
(1989), also in the World of Art series.

D0187410

WORLD OF ART

This famous series
provides the widest available
range of illustrated books on art in all its aspects.
If you would like to receive a complete list
of titles in print please write to:
THAMES AND HUDSON
30 Bloomsbury Street, London WC1B 3QP
In the United States please write to:
THAMES AND HUDSON INC.
500 Fifth Avenue, New York, New York 10110

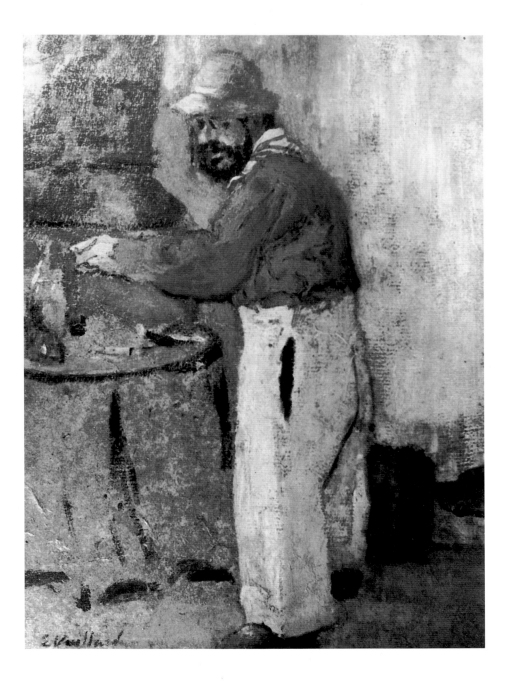

TOULOUSE-LAUTREC

BERNARD DENVIR

170 illustrations, 31 in color

THAMES AND HUDSON

For Joan

FRONTISPIECE Edouard Vuillard, *Portrait de Toulouse-Lautrec*, 1898

© 1991 Thames and Hudson Ltd, London

First published in the United States in 1991 by Thames and Hudson Inc., 500 Fifth Avenue, New York, New York 10110

Library of Congress Catalog Card Number 90-71451

Printed and bound in Singapore by C.S. Graphics

Contents

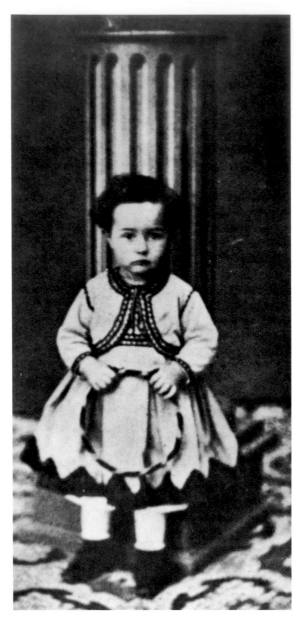

1 The child Henri at three years old

Devoid of elegance

In his uncompleted, fragmentary foray into the principles of criticism, *Contre Sainte-Beuve*, Proust examined the relationship between an artist's life and his work, concluding that the one was almost completely irrelevant to the other. This profoundly anti-romantic concept ran contrary to prevailing informed and popular belief, for since the latter part of the eighteenth century there had been an ever-growing critical emphasis on private sensibility and personal expression, freed from the constrictions of stylistic dogma and accepted precedents. Inevitably this gave an artist scope to conduct his life in a fashion complementary, even supplementary, to his art. Baudelaire, in his promotion of the idea of the 'dandy', had provided an ideological basis for a close relationship between creativity and what sociologists would term 'the presentation of the self in everyday life'. He postulated an image of the artist as a person detached from the mundane things of life, contemptuous of the accepted conventions of bourgeois behaviour, impeccable if unconventional in dress, observing others with a sense of ironic objectivity and always assured of the validity of his own genius. For the next hundred years or more a whole tradition was cultivated amongst some writers and artists in which eccentricities or flamboyance of behaviour became almost as integral to their creativity as what they actually produced. Swinburne, Courbet, Whistler, Oscar Wilde, Gauguin, Rodin and Augustus John are the best-known earlier examples of the artist as the creator inseparable from his creation, which has survived into our own time in the 'created' personae of artists such as Joseph Beuys, Andy Warhol and Gilbert and George.

Of course, public image is not always deliberately developed by artists themselves. Some – Van Gogh is an outstanding example – have been seized on by the hagiographers of a secular civilization as suitable candidates for cultural canonization, a process exaggerated by the rapid growth in communication techniques – colour reproductions, film, radio, television – which took place in the twentieth century. This is most true in the case of Henri de Toulouse-Lautrec,

who has inadvertently become part of the mythology of our own time. His life has been 'immortalized' on film, his works are omnipresent in private and public places, his style is imitated by illustrators and advertising artists with such prolific abandon that it has become, in all its varying distortions, one of the visual clichés of the twentieth century. Such mythicization clouds any attempt to assess with any degree of objectivity the separate, respective values to be attributed to the inner and outer life of the artist.

There are various inescapable facts. Even in the most basic terms his achievement, whatever its motivation, was remarkable. When he died in 1901 at the age of thirty-six he left behind him some 737 oil paintings, 275 watercolours, 368 prints and posters, 5,084 drawings, pieces of sculpture, ceramics and a stained-glass window, and this in addition to countless other works lost or destroyed. Nor was his, in all its aspects, a spontaneous, instinctively expressed art. To the execution, printing and publishing of his graphic work he brought the most meticulous skills, supervising them through every stage, highly cognizant of the nature of paper, inks and other technological minutiae of the craft, in constant contact with the technicians who produced them. In no category of his work did he rely on any innate facility, and the mere volume of his drawings that have survived testifies to the constant observation, analysis and exercise of those basic skills which underlay all his work. What makes this output all the more remarkable, achieved as it was in less than fifteen years (a hundred or so of his drawings and a score of paintings being produced in childhood and early adolescence), is that it was created during periods when the artist was experiencing all the physical and mental problems produced by alcoholism. In August of 1901, for instance, little more than a month before his death, suffering from the effects of alcholic poisoning, his mind blurred, all power gone from his legs as the result of a stroke, he produced one of his most remarkable paintings, *Un Examen à la Faculté de Médecine de Paris*, showing his cousin Gabriel Tapié de Céleyran being examined for his thesis by two professors of the faculty, Würtz on the right and Fournier on the left. (It is, concludes the catalogue of the Musée Toulouse-Lautrec, Albi, where the painting is now housed, a reconstruction. Céleyran was in fact examined two years earlier.) The colours are sombre, black and green predominating, the main areas of brightness coming from the window, the light from which is reflected on the heads of the two professors, the red on the academic gown, and the whiteness of the writing paper. The brushwork is confident, the draughtsmanship

firm and accurate, and the shadow of Honoré Daumier which hangs over the work inescapable.

Other artists, of course, had alcoholic problems, Rembrandt and Van Gogh being the most obvious examples, but this fact alone does not unduly, if at all, incline one to emphasize their behavioural and social rather than their creative personalities. With Lautrec, however, it is different. Alcoholism was almost the most trivial of his problems. He was born of a family that, like many others of aristocratic lineage, was almost dynastically devoted to intermarriage. His grandmothers were sisters, his parents first cousins; his father's sister married his mother's brother and they produced fourteen children, three of whom suffered birth defects, and at least one of whom was a dwarf. There can be little doubt that Lautrec inherited a rare disease, *pyknodysostosis*, which leads to dwarfism and in which twenty per cent of cases are found in people whose parents come from the same family. The two accidents that happened to him when he was in his early teens had little or nothing to do with his basic deformity, although they were seized on as a socially acceptable explanation of his condition by his parents, anxious to deny any hint of congenital disease in a family of such genealogical distinction, and all the more vehemently, no doubt, because of deeper, less conscious feelings of guilt. *Pyknodysostosis* usually becomes apparent at adolescence and leads to a cessation of growth in the 'long' limbs – arms and legs. During his adult life he was a little under five feet high, with a normal-sized head and torso but short legs, with knock-knees, short, thick arms (he was an excellent swimmer) and hands which seemed even larger than they actually were, with club-like fingers. He was marked by other symptoms of the disease: large nostrils, a receding chin, thick, protuberant and unusually red lips, an enlarged tongue which made him lisp and salivate excessively, accompanied by a persistent sniffle. Short-sighted, he wore pince-nez and, possibly because one of the symptoms of *pyknodysostosis* is that the fontanelles – the soft membranous gaps between the bones of the front part of the skull – do not knit together after birth, thus leaving a sensitive area above the forehead, he nearly always wore a hat, even indoors.

Lautrec was not the only artist who had suffered from such handicaps. Cézanne painted a famous portrait (1868–70) of his friend Achille Emperaire showing a dwarf perched on a chair, with a large musketeer-like head and thin, spindly, bare legs. Emperaire was a remarkable draughtsman, whose drawings are comparable to those of Odilon Redon, yet who, spending most of his life in Aix-en-

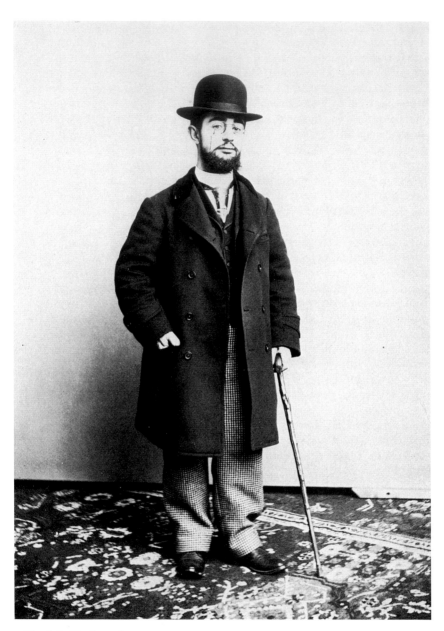

2 Henri de Toulouse-Lautrec, 1892

Provence, ended up selling pornographic pictures to the students at the university there. But by the very nature of his life and its context – the art world of *fin-de-siècle* Paris – Lautrec was especially exposed to all the handicaps and the indignities that his condition imposed on him. Walking itself was not all that easy; he needed the support of a stick (significantly he possessed one, now in the Musée Toulouse-Lautrec, which had been hollowed out to accommodate a glass container replenished every day with brandy or absinthe) and the polished floors of art galleries and museums offered a special hazard, compelling him to hold on to the arms of his companion or any accessible support. Even seating himself in a chair could present problems. But the real perils were less avoidable – the mirth, scorn or ridicule of others, for though many were kind, some were not; this was especially the case in those places of entertainment which he so assiduously frequented, where the uninhibiting effects of alcohol diminished charity, blunted tolerance and promoted derision.

His reaction to these problems was not an unusual one. It has frequently been observed that those who suffer from an obvious disability are often more concerned with putting those around them at their ease than with any implied requests for pity and understanding; and everyone who came into contact with Lautrec agreed on the extent to which his humour, his wit and his absolute refusal in any way to curry sympathy reached remarkable lengths. Time and time again people referred to his charm. François Gauzi (1861–1933), his intimate friend and fellow student at Cormon's studio, was to write, nearly half a century later: 'Lautrec had the gift of endearing people to him, all his friends were absolutely devoted to him, he never addressed a provocative word to anyone and never sought to exercise his wit at the expense of others.' Thadée Natanson, a friend of long-standing, put it more succinctly: 'It required enormous effort to see him as he appeared to the rest of the world.' Frequently, too, his friends remarked upon his eyes. When Yvette Guilbert, the music-hall singer, first met him she was struck by 'the huge, dark head, the red face and black beard, the greasy, oily skin, the nose broad enough for two faces, and a mouth that gashed the face from cheek to cheek, with huge violet-rose lips that were at once flat and flaccid'; but then she goes on: 'At last I looked Lautrec straight in the eyes. Oh, how fine, large, richly warm and astonishingly bright they were! I kept on gazing into them, and suddenly Lautrec became aware of it and took his spectacles off. He knew his one magnificent feature, and he offered it to me with all his generosity.'

Conscious charm was one of the weapons with which Lautrec redressed his all-too-apparent physical vulnerability. Underlying this was an extraordinary quality that was at the centre of his being. Stoicism, courage, conceit, even a disregard for the judgment of others, are all elements that play a part in its makeup, even though they do not completely define it. When in 1878 he broke his thigh and had to endure not only a series of painful operations but also, over the next two or three years, even more complicated medical devices such as 'electric brushes' (whatever they were), in a letter to his grandmother of 1 March he could write about them with a humour and equanimity remarkable for a boy of his age: 'On Monday the surgical crime was committed, and the fracture, so interesting from the surgical point of view (but not, needless to say, from mine) was revealed. The doctor was delighted, and left me in peace until this morning. But then, under the shallow pretext of making me stand up, he let my leg bend at right angles, and made me suffer agonies.' Significantly, he had already found in art the basic consolation that was to sustain him throughout the next twenty-two years, and that he was to pursue with such dedicated vehemence. A short time after the last letter, he wrote to one of his cousins, 'I am indeed alone all day long. I read a little, but end up sooner or later getting a headache. I draw and paint for as long as I can, until my hand becomes weary.'

The moral courage that sustained him was reinforced by its physical counterpart: despite his infirmities – or perhaps because of them – he was pertinacious in his pursuit of the activities expected of him: he had been riding since the age of four; he swam extensively and vigorously (there are numerous photographs of him disporting himself like a dolphin off the coasts of Normandy and the Côte d'Azur); he was an active crew member in his friends' sailing ships; he cycled, he shot, he danced, and showed in his social life a vivacity which kept him at parties and dances until well after dawn.

It would be wrong to infer, however, that so dogged a resolution to surmount his disabilities resulted from the facile evasions of self-deception. A glimmer of self-loathing repeatedly escapes from the insouciant prose of his ever-amusing letters. The above example, to his cousin, is signed 'Monsieur Cloche-Pied'; and in others he describes himself ironically as 'the darling of the Graces', and comments that his figure 'is devoid of elegance', that he has 'a strident and ugly voice', 'a bearded face which looks like that of a water-seller' (an obvious reference to Velázquez' *The Water-seller* in Apsley House), and 'a chin like an old shoe brush'. He was conscious of not

being able to keep up with others, and praised the kindness of his friend and fellow artist Louis Anquetin (1861–1932) 'whom I cramp with my slow, small person by keeping him from walking at his own pace, but pretends that it doesn't bother him'. Once he told Gustave Coquiot, the critic and friend of Huysmans, that 'he would like to find a woman who had an uglier lover than himself', though he did, somewhat typically for one so afflicted, claim sexual endowments of a high order; he was likened to a coffee-pot with a large spout, and he saw in the sturdy growth of his beard a symptom of his virility.

There was sometimes, perhaps understandably, an edge to some of his responses. Gauzi relates that 'In Montmartre Lautrec had become acquainted with M. de la Fontenelle, a young man much smaller than himself. Whenever he met Fontenelle he would stop to have a few words. These must indeed have been the only occasions when he was able to look down upon the person whom he was addressing. He drew from this a certain kind of empty pride, and once said to me, "I am small, but not a dwarf. Fontenelle really is a dwarf. Urchins often run after him in the street . . . no urchins have ever bothered me."' This last statement may have been true, though he did in fact have one traumatic experience with a group of spastic children on an outing who, meeting him in a park, thought him to be one of themselves and swarmed over him with such vigour that he had to be rescued by a friend.

If his reactions to his disabilities fuelled in him a source of energy which found an outlet in his art, there was yet another aspect of his personal life which had considerable bearing on his creative output. It is almost impossible to find a book devoted to Toulouse-Lautrec that does not feature a lengthy and exhaustive family tree, tracing his ancestry back to the counts of Toulouse who, enmeshed in the wild savagery of the Crusades, fought with ferocious courage for the maintenance of the true faith against the insidious heresies of the Albigensians. He himself was descended from a cadet branch of the family which had been established in the eleventh century by Baudoin, the younger brother of Comte Raymond vi (who eventually hanged Baudoin for siding with Simon de Montfort) through his marriage with Vicomtesse Alix de Lautrec, heiress to the lordships of Monfa – the full family name was Toulouse-Lautrec-Monfa.

In comparison with this historic background, that of his mother, Adèle-Zoë Tapié de Céleyran (1841–1930), was comparatively *arriviste*. A family of magistrates, treasury officials and upper-ranking

clergy originating from the village of Azille-en-Minervois near Carcassonne, they joined the aristocracy in 1798 when the amply forenamed Esprit-Jean-Jacques-Toussaint Tapié was adopted by his cousin Jacques Mengau, second Seigneur de Céleyran and Councillor of the Sovereign Court of Accounts of Montpellier. In this way they inherited, in addition to the considerable wealth which they had already acquired, a title, a castle and some three thousand acres of prime vineyards. The year was not an auspicious one to become an aristocrat, but the Tapié-Céleyrans emerged unscathed and it was a happy day when their wealth and that of the Toulouse-Lautrec-Monfas united in the marriage of Esprit-Jean-Jacques-Toussaint's great-grand-daughter to the Comte Alphonse-Charles.

There is often an implication – even a belief – that this lineage conferred on Lautrec a kind of inherited distinction that had something to do with his achievements. It did not, but what it did do was to provide him with a very special kind of social and cultural environment which influenced his reactions and behaviour, moulded his sensibilities and was at least partly responsible for determining his attitudes towards life and towards his art. The position of the aristocracy in nineteenth-century France was a peculiar one. Although it still had considerable power in the army, and some of its members had successfully entered business and industry, there had been a general and steady decline in its influence which had been initiated by Louis XIV and was continued by subsequent political and economic changes as France moved towards democracy and industrialization. Increasingly its aristocratic families came to live in a world of their own in which the sensibilities of status were heightened by the successive dilutions effected by the 'inferior' nobilities created to prop up the First and Second Empires. Devoted to the church (the Toulouse-Lautrecs, for instance, not only had a private church and a chaplain but could also call on bishops to officiate at family ceremonies and summon an archbishop to lunch to admonish their son on the error of his ways), they utterly rejected Republicanism: they believed that Henri, Comte de Chabord, or Henri v as they called him (Lautrec was named after him), the last descendant of Louis XIV, was the true king of France, and even that he would eventually ascend the throne. Faced with the egalitarian and homogenous nature of the Third Republic, they took refuge in a kind of dream-world of exaggerated individualism, cultivating personal eccentricities as a counterblast to conformity and using their wealth to build citadels of aggressive sensibility. Something of their attitude is reflected in the characters in *A la recherche du temps*

14

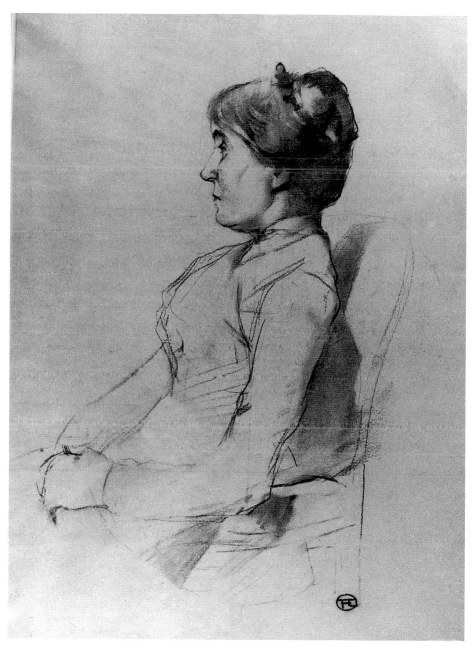

3 *La Comtesse Adèle de Toulouse-Lautrec*, 1892

4 Château du Bosc

perdu and the people on whom Proust based them: Comte Robert de Montesquiou, the Prince de Polignac, Henri, Comte de Rochefort (whose autobiography ran into five volumes), Comte Boni de Castellane, whose marble palace was one of the sights of Europe, and Baron Fernand de Christiani, who attacked President Loubet with his walking stick at Auteuil over the Dreyfus affair. Self-confident, arrogant to the point of megalomania, they were intent on affirming their contempt for those bourgeois virtues and canons of behaviour which they saw as an affront to French culture, a denial of traditional values, and a symbol of their own real impotence.

There could have been few figures more typical of this genre than Lautrec's father, the Comte Alphonse (1838–1913). He was, in the first place, consumed with a passion for hunting. His letters to his young wife shortly after their marriage consisted of as many as six pages giving details about his horses, his dogs and the game he had massacred: 'Odon is keeping ten hounds to be used for roe deer, and is handing over fifteen to me to use for wildboar. I have had to look for a new horse and have found a little mare which goes perfectly in harness. I was able to take the hounds out yesterday. I laid the hounds on at once, and in two hours they had brought on and killed a boar which gave us a very good hunt. The next day my horse was hurt in

16

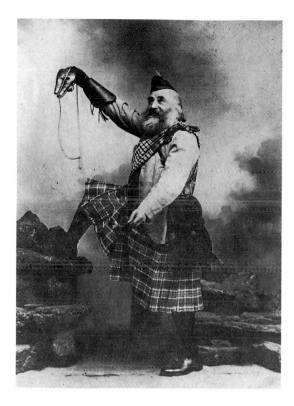

5 Comte Alphonse de Toulouse-
Lautrec dressed as a Highlander

the foreleg and he'll need ten days' rest. Odon also had a fall with
Paroli, who is also lame. A few days later we drew a blank. I attacked a
two-year-old boar, which was brought to bay after an hour's run.
The hounds were unhurt; only Lucifer and Blucher were slightly
scratched.' The other pastime he ardently pursued was dressing up.
He had a complete wardrobe of costumes in which he had himself
photographed: as a Highlander, a Turk, a Caucasian, a Crusader. 5
When he went riding in the Bois de Boulogne he often wore a strange
semi-Asiatic helmet with a crest of red cloth, and once came down to
luncheon at the family Château du Bosc in a plaid and a ballet-
dancer's tutu. He was not only devoted to kite-flying, he was also an
ardent falconer, and in summer would walk through the streets of
Albi with his shirt hanging out and a hawk on his wrist, which he
would feed with chunks of raw meat carried in a paper bag, and he
claimed that he only gave it holy water to drink. On 1 January 1876 he
gave the eleven-year-old Henri a book on falconry published in 1862,
inscribing it with the following, basically melancholic message: 'This

little book on falconry will teach you to appreciate the life of the open spaces; and should you one day encounter the bitterness of life, first the horse, then the hound and the hawk will be precious companions and help you to forget things a little.' Once he lived for some weeks in a tent pitched under the stairway to the cathedral at Albi, and at one time made an unsuccessful attempt to persuade his farmworkers to use wooden spades because iron was an 'ignoble' metal and poisoned the earth. Passionately involved in the night-life of Paris when he was resident in one or other of the different apartments he rented, he was a devotee of vaudeville shows, *cafés-chantants* and brothels. His sexual appetite was voracious, which partly accounts for the fact that from 1868 he and his wife led separate lives.

Physically a short man, Alphonse Toulouse-Lautrec created for himself an image much larger than life, compensating for the disparity between the splendours of the family history and its present political impotence with a calculated scorn of convention which bordered on the hysterical, but which made his son once observe, 'Wherever Papa is, you no longer stand a chance of being the most remarkable person present.' Significantly, it was his father who insisted on driving the hearse at his son's funeral, a symbol perhaps of the relationship which had always existed between them. Lautrec – almost in spite of himself – clearly admired his father enormously, though it was an admiration tinged both with envy and with a perceptible sorrow that he fell so far short of what the Count would have liked his son to be. He absorbed from him a disdain for the conventional which, in view of his physical appearance, did not have to find expression in extravagances of behaviour. It manifested itself, rather, in a certain kind of insulation from the opinions of others, a clinically detached observation of people, and a contempt for the bourgeoisie which brought him close not only to the working classes and 'the lower orders', but also to the outburst of Anarchism that so forcibly expressed in late nineteenth-century Europe the sense of frustration, bitterness and anger created by an industrialized, exacting and ostentatious society.

An anecdote recounted by Leon Daudet, though it may be mythical, admirably illustrates the attitudes of both father and son. One evening at a party at Webers, at which both Lautrec and Proust were present, someone told a story about Comte Alphonse. It related an episode in which the Count, walking one day along the boulevards with the Comte d'Avaray, saw a young working-class woman staring enviously at a ring in a shop window. Taking her by the arm he led

her into the shop and bought her the ring for 5,000 francs. 'But, Monsieur,' said the bewildered girl, 'I don't know you.' 'Nor I you,' replied the Count, 'but never shall it be said that a pretty woman desired a jewel in vain', and with that he raised his hat and walked off. 'What a marvellous gesture,' Proust had remarked at the end of the tale, 'a real sign of an aristocrat.' To which Lautrec had rejoindered: 'What a typical middle-class thing to say.' In fact he himself, especially towards the end of his life, was apt at times to impose his background on others, describing himself to bewildered vintners and sceptical prostitutes, quite erroneously of course, as the 'Comte de Toulouse'. On one occasion, when asked about his family by Milan, the ex-king of Serbia, he replied: 'Oh, we took Jerusalem in 1100, as well as Constantinople. You of course are only an Obrenovitch.' Awareness of his family background also had its influence on collectors and critics, adding greatly to the publicity which his works attracted. This could be of a negative kind, however, for there were those who saw in the 'baseness' of his works an affront to the honour of one of France's greatest families.

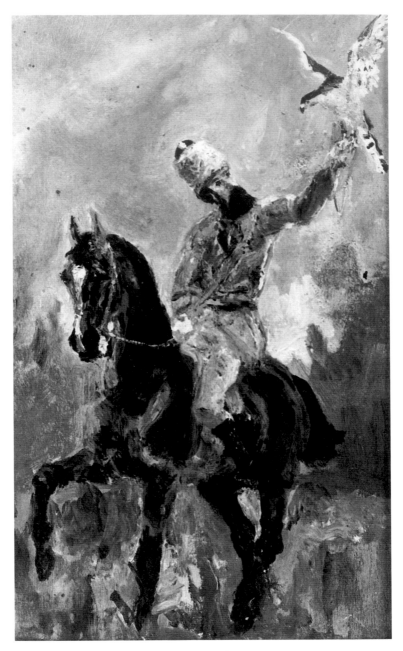

6 *Le Comte Alphonse de Toulouse-Lautrec en fauconnier,* 1879–81

From Provence to Paris

His earliest years had been happy enough, divided between the tall town house in Albi at the base of the hill, with the city walls running through its gardens and dominated by the massive castle like cathedral – its dark shuttered rooms and the highly polished floors creating such hazards for him –, the two family châteaux, at Le Bosc near Carmeaux, where he went on falconing trips with his father, and at Monfa, and his mother's ancestral home at Céleyran near Narbonne. Whether or not he was conscious of the tensions between his parents at this time, or whether indeed he was used by them as a ploy in their guerilla warfare with each other it is hard to say. At any rate, the characteristic humour, linked with a kind of precocious self-deprecating irony which was always to remain one of his main defenses, became apparent at a very early stage. When he was eight he moved to Paris with his mother so that he could attend school at the prestigious Lycée Fontanes, later known as the Lycée Condorcet. They lived in the Hôtel Pérey in the Cité du Retiro near the Faubourg Saint-Honoré where the family kept a more or less permanent suite of apartments, and where mother and son were frequently visited by the Count, who slept in a small studio in the basement.

From Paris he wrote frequently to his paternal grandmother at Le Bosc. One of these letters, dated 30 December 1872, is typical:

My dear Grandmother, I am awfully glad to be sending you this letter, for it is to wish you a happy and prosperous New Year. I am anxious to be back at Bosc for my holiday, although I don't mind it here in Paris. We are on holiday now, and I am trying to have as much fun out of it as I can. Too bad that I have pimples, which causes me to lose a lot of time scratching. Please tell Aunt Emilie that my little canary Lolo sings very well, he is awfully nice. I have bought him a pretty cage with my New Year's present. [In a footnote he adds:] Please be kind enough to wish Urbain [one of the grooms at Bosc] and the other servants a happy New Year from me.

The eight-year-old Henri was indeed, pimples apart, having a good time. At school he made a life-long friend in Maurice Joyant (1864–

7 Comte Raymond de Toulouse-Lautrec, *Cheval arrêté vers la droite*, 1838

8 Comte Alphonse de Toulouse-Lautrec, *Deux Chevaux se suivants*

9 Henri, drawn by Comte
Charles de Toulouse-Lautrec,
c. 1878

1930) whom Lautrec chose as his executor and who, after his death,
became an impassioned propagandist of Lautrec's works. He was also
sampling the pleasures of Parisian life, thanks to his father who was
currently manifesting an amiable interest in his son-and-heir. There
were visits to the zoo, to riding schools, to race courses and to the Bois
de Boulogne.

Even more remarkably, however, it was the Count who first
introduced him to a world that was to influence the whole of his life.
The Toulouse-Lautrec family was unexpectedly artistic. Comte
Raymond (1812–71), Henri's grandfather, was an accomplished
draughtsman (as drawing no. 1.8 in the Albi Museum testifies);
and Charles, his uncle, who drew a convincing portrait (c. 1878) of his
adoring nephew, was a dedicated amateur artist. It was Charles who
first encouraged Henri to draw, even when he was still quite a young
child, and during much of his life Henri kept his uncle informed of his

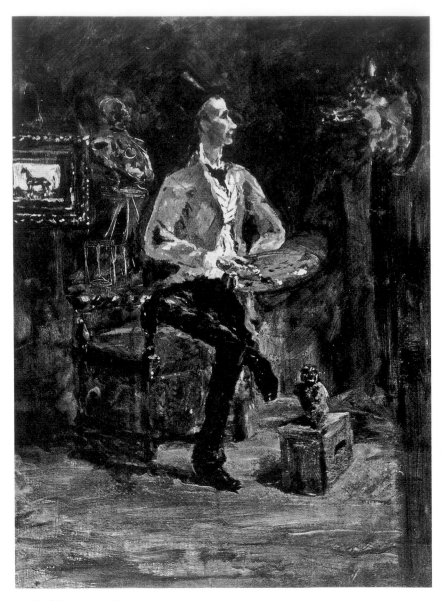

10 *René Princeteau*, 1882

11 René Princeteau, *Le Comte Alphonse et son fils Henri de Toulouse-Lautrec à cheval, c.* 1874

artistic activities. But most important of all, Comte Alphonse himself was deeply interested in art; he drew, painted, and even dabbled in sculpture. He had a wide range of artist friends and, somewhat surprisingly, took his small son to meet them. These acquaintances were to have an important influence on the boy, not only by exposing him to the delights of *la vie de bohème* but also in more specific ways. His father's favourite painter was René Princeteau (1839–1914), a deaf mute who was famous for his paintings of horses and his expert knowledge of the species. Princeteau was to take a direct interest in 'le petit' and was to continue giving him instruction for the next five or six years. It seemed indeed as though their respective disabilities linked them together in a way of which neither was consciously aware. By the time Lautrec had entered his teens, Princeteau was introducing him to the allure of vaudeville, and to the pleasures of the Cirque Fernando, which had been founded in 1874 and renamed the Cirque Médrano in 1898, at 63 Boulevard de Rochechouart, a venue very popular with Degas and Seurat.

There were others, too, somewhat similar to Princeteau, with whom the young Lautrec came into contact through his father,

10,11

including John Lewis Brown (1829–1890), whose skills as a horse portraitist had won him the particular praise of Napoleon III and made him the rival of Jean-Louis-Ernest Meissonier, and Charles Busson, the marine painter. But the member of his father's circle who made the greatest impact on him was Jean-Louis Forain (1852–1931) whose sarcastic tongue was matched by an ironic graphic wit, and by an unblinking acuity of observation which was all the more attractive in that it was directed at contemporary life. In some ways, Forain combined certain qualities of Daumier with those of Constantin Guys (cf. p. 59), and the Count had a particular affection for the artist in whose work he no doubt saw something of that disdain for bourgeois society which he cultivated himself. The Count frequently helped him financially, as indeed Henri was to later, once remarking towards the troubled end of his life: 'I'd like Forain to be hard up so that I could send him some money, but he would not have to know about it, or he'd tell me to go to hell.' Forain's influence on Lautrec was at its strongest between 1887 and 1889, but throughout his life he kept a portrait of his father by Forain which, according to Maurice Joyant, was 'the object of an admiration that the years could not diminish. Lautrec always had this portrait before his eyes, and held it to be an example of what a good drawing should be.'

Another aspect of his early upbringing which was to prove influential in his later career was his strong childhood affiliation with England. His father had an English groom with whom he had contact and his mother often spoke to him in English at mealtimes. He had an Irish governess, a Miss Braine, with whom he kept in touch for a considerable time. He came to speak English well and was able to lard his French conversation with English words and phrases, such as 'fuss' and 'that is the question'. He often ended his letters 'Yours' or, to his mother, 'Your boy'. In later life, he was to encounter English artists such as Conder, Hartrick and Rothenstein, who were living in Paris; and above all else, like many Frenchmen of his age and social background, he was a fervent Anglophile, frequenting places such as the Irish and American Bar in the Rue Royale, haunted by British jockeys and sportsmen. He drew and painted characters such as an 161 English soldier smoking his pipe (1898) and Dolly, the barmaid-singer 162,164 at the English sailors' pub the Star in Le Havre (1899). Then there was 152 Oscar Wilde who, in addition to several portraits, also appears as a 56 spectator in one of the panels Lautrec painted for La Goulue's booth (cf. p. 79). Lautrec had been in England in 1895 at the time of Wilde's trial. Conder had taken him to see the writer, who, understandably

12 Page from one of Lautrec's early sketchbooks, *c.* 1873

enough in view of his current situation, refused to sit for a portrait, but Lautrec attended the trial and did several remorseless sketches, one of which was published in *La Revue Blanche* on 15 May.

Lautrec's juvenilia were extensive, consisting mostly of small sketchbooks dating back to 1873, and containing drawings in varying media – pencil, sanguine, watercolour, ink and crayon – as well as school exercise books from between 1875 and 1878, in which French and Latin texts and exercises are interspersed with ornamental letters, drawings of herons, falcons, horses and monkeys. His desire to draw seems to have been almost compulsive, and he was prepared to tackle subjects that, for a child, were of considerable complexity, such as an officer standing with an air of *braggadocio*, his legs apart (one of a whole series of drawings he produced in 1880 when military exercises were taking place in Carmeaux near the Château du Bosc). Helped by his uncle Charles, his visual vocabulary became more complex, his subjects more demanding, especially after the accidents to his leg had imposed on him lengthy periods of boring solitude for which art was a comforting antidote. Writing an account of his accident in a letter to his friend Charles Castelbon, in June 1878, he concluded, 'I am sending you the first watercolour I have done since my recovery. It's not very good, but I hope that you will think of it only as a memento from me.' In fact it is very good; a picture of a brake driven by his

12

13

14

father, with a groom seated behind; vivacious, sparkling in colour, accurate in observation.

The kind of artistic education he received from his uncle must have been basic, that from Princeteau more sophisticated but perhaps a little meretricious and limited in subject-matter mainly to horses – though marked by that lightness of palette which the example of Impressionism was starting to spread through the main body of traditional French painting. A survey of the individual sketches and drawings that he produced between the ages of nine and sixteen makes immediately apparent the fact that he had already evolved some of the basic elements that were to characterize his work throughout the rest of his life. At a very early point there appears a special kind of profile – aquiline, domineering, rather sardonic, usually surmounted by a top hat – which was to recur time and time again; in the portrait of Gauzi with his family, usually called *Un Jour de*
61 *première communion* (1888); in the various representations of

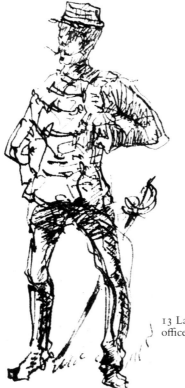

13 Lautrec's childhood drawing of an officer, 1880

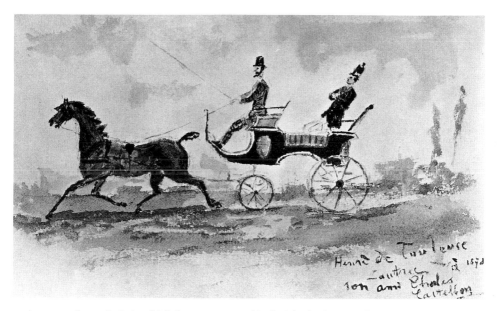

14 A watercolour of 1878, which Lautrec sent to his friend Charles Castelbon

Valentin le Désossé (cf. p. 75); and which first found expression in his drawings and watercolours of the 1880s. Another stylistic mannerism was his use of very revealing stances, created by a slightly exaggerated posing of the legs in a manner customary amongst jockeys and other horse-riders. It first made its appearance in his drawings of soldiers in the middle 1870s, and most strikingly in *Le Souvenir d'Auteuil* (1881), where it appeared not only in the figure of the groom but also, in an equally well-defined way, in the stance of his white-hatted father. In the work of an artist who was to become so absorbed by dancing in all its social forms a concern with legs was inescapable, but Lautrec often gives them a central prominence; as, for instance, in the dance of le Désossé and his partner (1890); in the akimbo stance of Gabrielle in *Au Moulin Rouge: La Clownesse*; of Aristide Bruant in the Mirliton poster of 1893; and of the black clown Chocolat dancing in the Irish and American Bar to the unlikely accompaniment of a lyre (1896). It is possible that this attention to the legs was a reaction to his own deformity, a notion also supported by his tendency to over-elongate male figures in his works.

Lautrec left the Lycée Fontanes in 1875 and for the next six years his

18

81
153

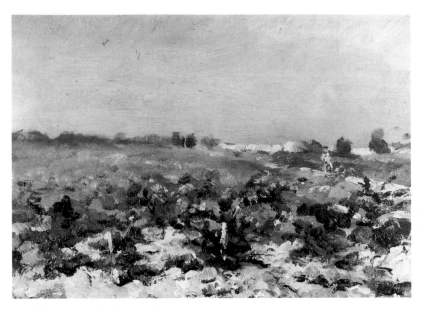

15 *Céleyran, vue des vignes*, 1880

education continued, not very successfully, at home. These were probably the happiest of his life. His time was divided between the house at Albi, the country estates at Céleyran and occasional visits to Nice and Paris. He found himself mainly in a rural environment and, for the only time in his life, he painted landscapes. Most of these, carefully preserved by his mother, are now in the Museum at Albi. Fresh, light and lively, usually small in scale, some of them suggest the early works of Sisley, or even Pissarro, and all are concerned with the play of light and shade, all vibrate with vivacious colour.

15,16,17

The last of these were painted in 1881, after which he was never to return to landscape as such, except as a studio exercise for his teacher Cormon. This was very unusual, especially in France at that time; and his aversion to landscape was neither accidental nor the result of some limitation imposed by the inaccessibility of subject-matter. Initially he truly felt that he was incompetent when painting nature, but by 1896 he had succeeded in converting what he saw as an incapacity into an ideology, stating to a group of friends: 'Only the figure exists; landscape is nothing more, and should be nothing more than an extra; the painter who paints purely landscape is a villain. Landscape should

30

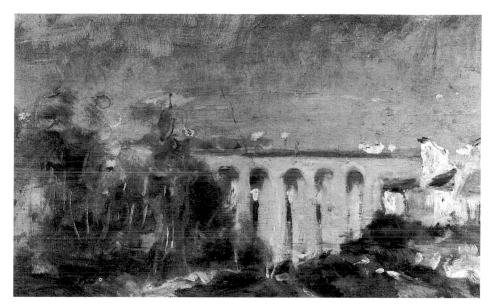

16 *Le Viaduc du Castelvieil à Albi*, 1880

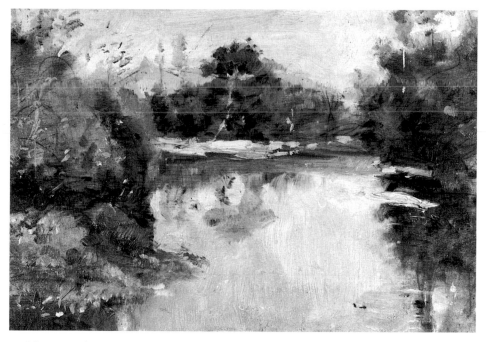

17 *Céleyran, au bord de la rivière*, 1880

only be used to make the nature of a figure understandable. Corot is only great in his figures; the same goes for Millet, Renoir, Manet, Whistler; as soon as figure painters paint landscapes they treat it like a face; Degas' landscapes are extraordinary because they are dream landscapes; Carrière's are like human masks. If he had not neglected the figure so much, Monet would be even greater.' Perhaps this peculiar creed was stimulated by his tendency towards *épatant* hyperbole often induced by alcohol; alternatively, the whole passage could well have been largely created by Joyant on the basis of a stray remark made by Lautrec a quarter of a century before he wrote it down; whatever its origin, however, Lautrec's apparent vehement antipathy to landscape was to prove more than fortuitous.

The corresponding part of his prejudice was most certainly Lautrec's genuine feeling, for he was, right from the start, enamoured of portraiture; he was passionately interested in the physical appearance of people, in the characteristic aspects of their faces, in the stances of their figures, in all the outward signs of inner personality. He himself was the object of his own early interest, and in the Albi Museum there

22 are five drawings leading up to the *Portrait de Lautrec devant une glace* (*c.* 1880–83). Painted in oil on cardboard, the picture is predominantly in the same silvery-grey that Corot or Whistler might have used, and the different objects on the shelf which supports the mirror echo this tonality, the only strident note being the redness of the fleshy lips – that is the only emphatic personal touch. The mere fact that the mirror intervenes between the artist and the spectator creates a barrier, and there is something at once quizzical and evasive in the expression of the sixteen-year-old as he peers out at us.

There was no suggestion of this in the other portraits he was painting, for which he found no shortage of models. The picture of his father on horseback with a falcon perched on his wrist, and arrayed as some kind of Middle-Eastern notable is ambitious rather than successful, more attention being paid to the horse than the rider. So too with a curious portrait of Princeteau, in which the element of caricature and exaggeration presage much of his future artistic development. But when concerned with the straightforward record-ing of his family and friends, Lautrec's intent was more simple, his approach less compositionally ambitious, his brushwork more meticulous. His mother, now in her early forties, was naturally a frequent sitter, and a comparison of Lautrec's renderings of her face in various portraits reveals different and even conflicting interpretations.

21 An oil painting of 1882 shows something still of that almost rustic

18 *Le Souvenir d'Auteuil*, 1881

19 *Vieille Femme assise sur un banc à Céleyran, 1882*

20 *Vendanges à Malromé, retour au chai,* 1880–83

vitality which is apparent in photographs of her taken at about the
time of her marriage, though this is accentuated by the quick,
pochade-like nature of the work. A charcoal sketch of about the same
period, however, suggests an air of what might be seen as melancholic
meditation, whilst the more famous portrait of 1883 painted in her
recently purchased château of Malromé near Bordeaux – to remain
one of Lautrec's favourite retreats – exudes a sense of dejection, of a
more deliberate resignation. Evident here, too, is Lautrec's awareness
of Impressionism, to be seen especially in the fragmented brushstrokes
of the background and in the lightness of the palette. There are strong
analogies with the portraits Manet had been painting in the late 1870s

24

21 *La Comtesse Adèle de Toulouse-Lautrec*, 1882

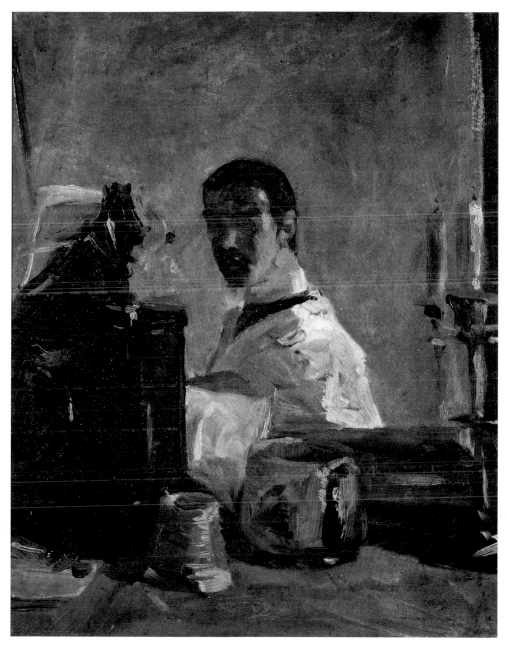

22 *Portrait de Lautrec devant une glace, c.* 1880–83

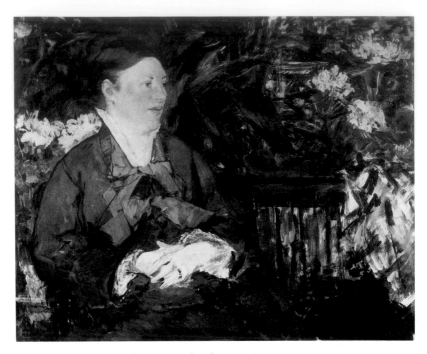

23 Edouard Manet, *Madame Manet dans la serre*, 1879

62 – with *Le Prune* (*c.* 1877), for instance, or *Madame Manet dans la*
23 *serre*, of 1879.

The influence of Manet's paintings is apparent too in several of the many portraits he did (three paintings, seven large-scale portrait
25 drawings and one tracing have survived) of young Routy, son of one of the estate workers at Céleyran, who was about the same age as himself. The version in oil, of Routy's head and chest, was painted in 1882, the year in which Manet exhibited the *Bar aux Folies Bergère*, (which Lautrec must have seen, as in April of that year he had enrolled as a student at Bonnat's studio on the advice of Princeteau, who felt that he had nothing further to teach him). In his commentary on this portrait, Adriani points out: 'It was the characteristics of Manet's later paintings that now gained the upper hand over the rather pastose, blotchy and contrasty [sic] application of paint derived from Princeteau. Not only the light, sketchy brushwork in which finely rubbed passages complement long strokes of paint – this is

24 *La Comtesse Adèle de Toulouse-Lautrec*, 1883

25 *Le Jeune Routy à Céleyran*, 1882

incidentally very similar in form to the contemporary charcoal drawings [for example, that of his aunt, Emilie, which is also in Munich] – but also the hardness, indeed the abruptness, with which Lautrec juxtaposes the light colour modulations with dark grey or almost black, are reminiscent of Manet, whose ability to handle black had only been equalled by Velázquez and Goya.'

Princeteau's advice, to attend the studio of a professional painter such as Bonnat, had been precipitated by the fact that by the end of 1881, despite vigorous and eventually successful attempts to pass the *baccalauréat* at Toulouse, it had become apparent that Lautrec was never going to surmount the hurdles of the French academic system and that, whilst the Count, once he had discovered that his son was not likely to be a sportsman, put up no violent objections to his obvious desire to become a painter, his artistic uncle Charles was positively enthusiastic about the idea and his mother was complaisant; after all, one of the most famous French sculptors of the time was a Viscount – the infelicitously named Vicomte du Passage. His choice of teacher was first suggested by a new friend whom he had met in Toulouse, Henri Rachou (1855–1944), and was warmly applauded by Princeteau.

On 17 April Lautrec wrote to his father describing his 'initiation' by his fellow students (usually, as any reader of Du Maurier's *Trilby* will know, a rowdy and often a frightening experience): 'Thanks to the good offices of Rachou I had a good reception. By chance a young American from the hotel went in with me. They had us talk and pay for a toddy. That's all there was to it. Not so terrible. They made enough racket, but there wasn't too much actual fighting. There are a lot of English and Americans. So here I am; one of the boys. Draw, draw all the time; that's the boring bit. Mr Moore, the American deaf-mute painter has brought a lot of splendid Japanese bibelots. Yesterday I met Du Passage, who asked after you. Yesterday he drew for *La Vie Moderne* the different ways a horse jumps . . . Goodbye, dear Papa. Be so kind as to remember me to everyone.'

Léon Bonnat (1833–1922), a Basque by birth, was not so much a famous painter as a national institution. His academic realism, flavoured with the influence of Caravaggio and Ribera, was an ideal medium for the production of portraits that were both flattering and aesthetically convincing. Nor were his talents confined to the depiction of the great and the good. His mural skills were equally popular, and his frescos adorned the Panthéon (where his *Martyre de Saint-Denis*, of 1885, can be found, held by some to be the greatest

painting of nineteenth-century France), the Palais de Justice and many churches. Every important distinction in the French art world was lavished on him – a member of the Institut, first a professor at the Ecole des Beaux-Arts he rose to become its director in 1905. And yet he was a far more complex figure than his career would seem to suggest. He was a life-long friend of Degas; he counted amongst his pupils artists as disparate as Dufy and Friesz on the one hand, Jean Béraud and Alfred Roll on the other; he was a discriminating, even an inspired, connoisseur and his collection, which he bequeathed to the museum of his native city of Bayonne, is the institution's main treasure.

Seeing himself as the heir of Ingres, Bonnat laid great stress on drawing and most of Lautrec's time in his studio was spent in front of plaster casts of Hellenistic bric-à-brac. Bonnat was not encouraging. 'You may be wondering', Lautrec wrote to his uncle Charles on 7 May, 'what kind of encouragement I am getting from Bonnat. He tells me "Your painting isn't bad, it's rather stylish, and really quite good, but your drawing is frankly atrocious." So I must pluck up courage and start again, when I've rubbed out all my drawings with bread crumbs.' Bonnat seems to have been less than favourably inclined towards Lautrec, though this may have been occasioned rather by the subsequent development of his career than by any innate prejudice. As late as 1904, when Lautrec's status was generally accepted in the art world, a group of his admirers proposed offering his portrait of Léon Delaporte (1893) to the Luxembourg Museum.

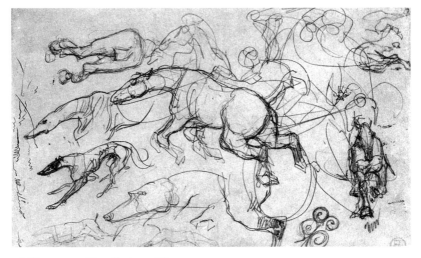

26 *Chevaux et chiens lévriers*, 1881

27 *Le Comte Charles de Toulouse-Lautrec*, 1882 28 *La Comtesse Emilie de Toulouse-Lautrec*, 1882

Bonnat, who had become president of the Commission des Musées, refused to accept it. 'He seemed beside himself. No argument could influence him. In fact he seemed beset by a kind of religious frenzy about the whole affair', commented Joyant at the time.

Whatever the relationship between pupil and master, it was not destined to persist in that form for long. Bonnat had been appointed to a job at the Ecole des Beaux Arts and decided to give up private teaching in the summer of 1882. He had imposed on Lautrec a sense of artistic discipline, self-criticism, and a vastly improved painterly technique, even though this had involved a temporary darkening of his palette. On holiday in Albi, he wrote to his father in Paris early in September, 'Bonnat has let all his pupils go. Before making up my mind I wanted to have the consensus of my friends, and by unanimous agreement I have just accepted an easel in the studio of Cormon, a young and celebrated painter, the one who did the famous *La Fuite de Caïn* in the Luxembourg. A powerful, austere and original talent. Rachou sent a telegram to ask if I would agree to study there with some of my friends, and I have accepted. Princeteau praised my choice.'

31

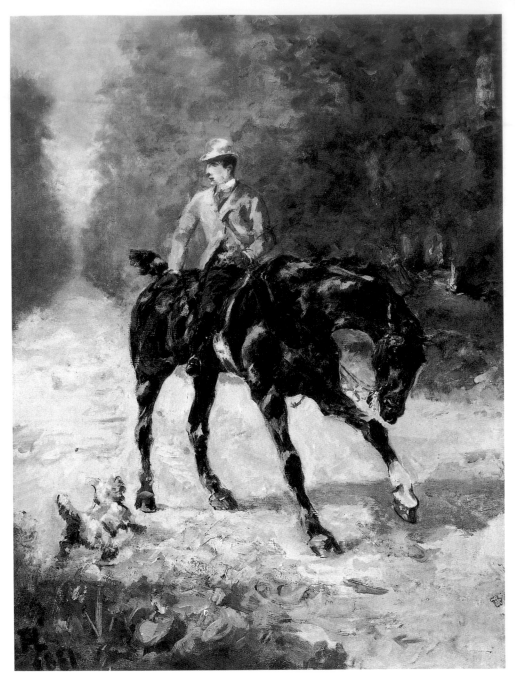

29 *Cavalier, Monsieur du Passage*, 1881

Apprenticeship

'A powerful, austere and original talent' is how Lautrec, but not perhaps how everybody, described Fernand Cormon (1845–1924). Born Fernand Piestre, lean and morose in appearance, he was intriguingly, in view of Lautrec's later interests – the son of a well-known vaudeville writer, and almost as famous for the variety and vigour of his sexual life as for his paintings. His early works had been devoted to Eastern scenes (one of his teachers had been the well-known Orientalist Eugène Fromentin) but his decision to explore the iconographical potential of the earlier reaches of the Old Testament brought him fame and recognition on a wide scale when his *La Fuite de Caïn* of 1880, a dramatic painting of a stone-age family trying to escape from the consequences of the actions of their fratricidal father, was the success of the Salon. Cormon was – somewhat to Lautrec's disappointment – a tolerant and undemanding teacher. He visited his thirty or so students twice a week, at the first studio in the Rue Constance, half-way up the Butte Montmartre, and then after 1883 in the Boulevard de Clichy. The main thrust of his teaching was towards the importance of what a later generation would call 'plastic values', placing heavy emphasis on formal structure; yet the imaginative verve of his own paintings must have infused his opinions and advice with a more stimulating quality than the dry probity of Bonnat's aesthetic pedantry.

31

30

Cormon's reactions to his new pupil were chronicled with touching regularity by Lautrec in his letters to his family, especially those to his mother, in a tone which combined a certain amount of emphasis on how hard he was working and how reasonably successful he was being, with an undercurrent of self-deprecation. 'My life is dull. I drudge along sadly and haven't talked to Cormon yet', he wrote in November 1882; but a month later: 'Things are jogging along pretty well with me. Cormon gave me a warm welcome; he likes my drawing.' Then in 1884, 'I saw Cormon this morning. He rather congratulated me, at the same time making me conscious of my ignorance'; and a few days later: 'I thought I'd spoken about my poor

daubs at Cormon's in my last two letters. He thought my cattle was bad, the little Laffittes pretty good, and the landscape really good. In sum, it's all very feeble stuff compared with the landscapes Anquetin produced. Everyone is amazed. They're in an Impressionist style that does him proud. One feels like a little boy indeed beside workers of this calibre.'

Lautrec's relations with his parents at this time were not all that easy. Clearly he was dependent on them not only for the necessities of life, but also for those self-indulgences he craved, including the goodies sent up from Le Bosc; crates of wine, tins of goose liver, and money enough to entertain both himself and his friends with some lavishness. His mother was reconciled to him taking up a career as an artist, but was highly sensitive to the moral dangers involved, being herself a woman of daunting piety. It was no doubt on her instigation that, when in 1883 Monseigneur Bourret, the bishop of Rodez, came to consecrate the new chapel in the Château du Bosc, he addressed the family heir from the altar with the words, 'My dear son, you have chosen the finest of professions, but also the most dangerous.' Comte Alphonse saw nothing dangerous in what his son was doing; indeed he probably wished it contained some greater element of hazard.

30 Cormon's studio. Cormon is seated at the easel, Lautrec on the left in the foreground.

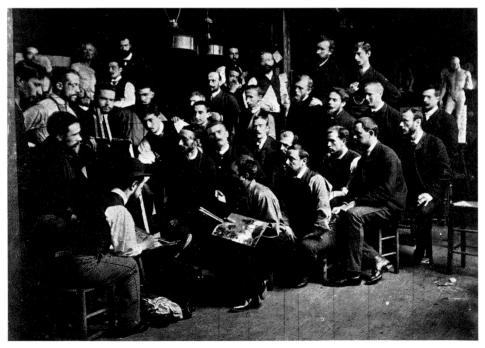

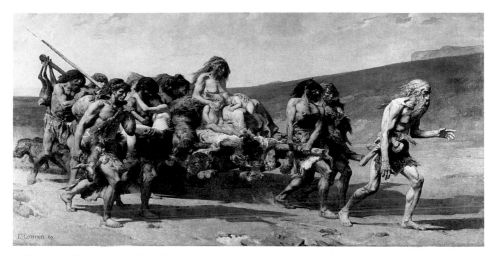

31 Fernand Cormon, *La Fuite de Caïn*, 1880

However, although he had resigned himself to the fact that Henri was never going to be the son he would have liked to have had, he was still deeply concerned that the family honour should not be besmirched by being connected with the kind of artist he suspected Henri might become. His feelings were not unique. On several occasions, especially during the next decade, several hostile critics, such as Edmond le Pelletier (in the *Echo de Paris*, 28 March 1899), made a point of emphasizing the extent to which Lautrec was bringing the reputation of a great French family into disrepute by painting dancers and prostitutes. The Count insisted that he should sign any works that appeared in public with a pseudonym. In fact Henri was still signing the name 'Tréclau', an anagram of Lautrec, as late as 1887, on the cover drawing for the August issue of *Le Mirliton*; on other occasions he often used the less familiar final name of the family, Monfa.

A significant step towards family recognition of his professional standing, however, was reached in June 1884, when Cormon asked him to collaborate with him in the production of a series of illustrations for a projected edition of the complete works of Victor Hugo, the first volume of which was to be *La Légende des siècles*. The kind of reactions this provoked in Albi are suggested by the letter the Countess wrote to her own mother on the fourteenth of the month:

I am writing as promised to let you know that Henri has definitely been chosen from amongst all the students of the atelier to collaborate with the

best and most famous artists on the first edition of the works of Victor Hugo. All arrangements have been made with the publisher, and it is to be hoped his painstaking work will be approved by Cormon and the contract not broken. The first 500 francs (!!!) earned by your grandson are supremely significant to me since they prove he was not the smallest member of the atelier in every respect . . . They are now predicting for Henri a future of great fame, which seems unbelievable.

The sentiments expressed by his mother reveal in fact the complexities of her reactions to her son; surprised pride that he had achieved anything; acute awareness of his physical deformity; defensive affection; and a concern about his financial situation based less on domestic avarice than on a desire to provide tangible proof that she was right in supporting his desire to become an artist. (In the event, however, the project fell through and the work was never published, but the offer had been a significant achievement for Lautrec.)

During the first eighteen months at Cormon's he lived with his mother in the Cité du Retiro, turning up at the studio regularly at 9.30 in the mornings, and returning home at increasingly later times in the evenings. Even during this period under the maternal wing it had become apparent that Cormon's studio, with which he was to maintain contact in varying degrees of intimacy for some five years, provided him not only with an artistic base, but also with a new home, a new family. The friends he made there he was to keep for the rest of his life, and they were to provide him with the kind of support and security that, despite his apparent insouciance, he so desperately needed. He clearly laid himself out to be likeable. Rachou, the most tutelary of his friends, recorded his own impressions of him at this time: 'His most striking characteristics, it seemed to me, were his outstanding intelligence and constant alertness, his abundant good will towards his devoted friends, and his profound understanding of his fellow men. I never knew him to be mistaken in his appraisal of any of our friends. He had remarkable psychological insight, put his trust only in those who had been tested, and only occasionally addressed himself to outsiders with a brusqueness bordering on asperity. Impeccable as was his usual code of behaviour, he was nevertheless able to adapt himself. I never found him either overconfident or ambitious. He was above all an artist, and although he courted praise, he did not over-estimate its value. To his intimate friends he gave little indication of satisfaction with his own work.'

Cormon had attracted some remarkable students to his classes,

32 *Etude de nu, femme assise sur un divan*, 1882

amongst them Emile Bernard (1868–1941), the provocative, self- 33
styled 'father of Symbolism', already affected by that pietism which
was eventually to dominate his life and work, François Gauzi,
Adolphe Albert (1865–1928), the engraver who was to be of great
help to Lautrec, whom he was to sponsor at the Salon des
Indépendants, René Grenier (1861–1917), a rich dilettante from
Toulouse, to whose house Lautrec was to move in 1884, and most
formidable of all, Louis Anquetin and Vincent van Gogh 34
(1853–90).

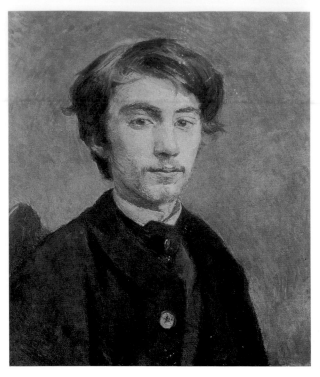

33 *Emile Bernard*, 1885

Anquetin was a dominant personality in Lautrec's early days, and one whose name recurs frequently in his correspondence. He was tall, swaggering, self-confident; but it was only in later life that he seemed to achieve his ambition of becoming, stylistically, the Rubens of the twentieth century. At the time Lautrec knew him he was far from being the painter of the flamboyant rococo murals that marked the apogee of his fame. At Cormon's he was devoured by a passion for innovation and experiment. He, more than anyone else, provided the channel through which Lautrec and his contemporaries established contact with the activities of the artistic innovators of his time. His role as catalyst was assured by his extraordinary intellectual energy; and, as Signac noted, 'One tenth part of the talent which Anquetin shows would, in the hands of an artist with real creative powers, produce miracles.' The first influences on his work had been Michelangelo and Delacroix, the latter leading to an interest in Impressionism, stimulated no doubt by the successive exhibitions which he saw from the first in 1874 to the last in 1886, and by the fact that his red-headed mistress not only admired the Impressionists but

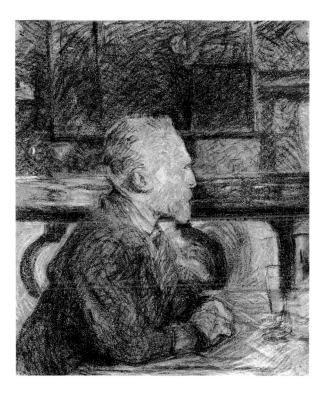

34 *Vincent van Gogh*, 1887

even possessed a painting by Caillebotte. At one point he went so far as to stay for some time at Vétheuil, so that he could sit at the feet of Monet. But Anquetin was in this area labouring under an illusion. He subsequently discovered that his true primary concern was with colour, not with light, and he was to receive more guidance from Japanese prints than from the work of either Degas (in whose subject-matter – racecourses, dancers, fashionable women – he found themes that were to preoccupy him, and whose use of pastel he was to imitate) or Monet (whose approach to art was in any case largely pragmatic). He developed a penchant for large, flat areas of colour, which greatly impressed Van Gogh, who especially admired a landscape entitled *Le Faucheur à midi*, painted in 1887 almost exclusively in various tones of yellow. The next great influence on Anquetin was the work and theories of Seurat, and in 1887, in association with Bernard, he evolved a style known as *Cloisonnisme*, which merged into the self-descriptive Pictorial Symbolism. This was his final innovative excursion. By the next decade he was safely ensconced in the academic muralism that was to dominate the rest of his career.

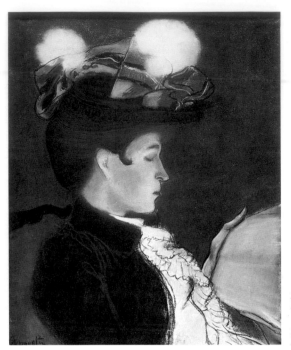

35 Louis Anquetin, *Jeune Femme lisant un journal*, 1890

36 Cover for *L'Estampe Originale*, March 1893

Lautrec, who is reputed to have said that Anquetin was the greatest painter since Manet, was obviously influenced by him, but it is not all that easy to define this influence in purely stylistic terms. Anquetin was largely responsible for introducing Lautrec into the circle of Aristide Bruant and *Le Mirliton* (cf. p. 98) and so confirming in him an already established interest in the world of cabarets, vaudevilles and in Montmartre generally, but there can also be little doubt that his *Jeune Femme lisant un journal* (1890) caught Lautrec's imagination and influenced much of his imagery, including especially the cover for *L'Estampe Originale*, published in 1893. Both of the paintings which Van Gogh admired, the aforementioned *Le Faucheur à midi* and the *Avenue de Clichy à cinq heures de l'après-midi* show Anquetin displaying a skill in the presentation of large planes of colour, which Lautrec was to make a distinctive aspect of his own style. The two artists also shared certain themes, including La Goulue (cf. p. 75), and in 1893 Anquetin produced a large painting, *La Salle de danse au Moulin Rouge*, which was virtually a pastiche of Lautrec's style, and featured

35

36

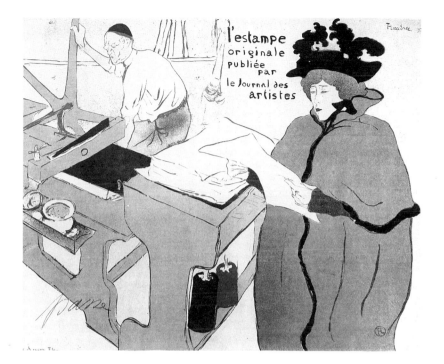

in it the Jane Avril poster as well as the painting *Le Bal au Moulin Rouge*.

With Emile Bernard (who entered Cormon's atelier at the age of sixteen but who was expelled for 'rebelliousness' two years later), Lautrec also had close personal and stylistic connections. The latter are suggested by two caricatures of Bernard's, one showing Lautrec at an easel, the other with him sitting painting a picture, and also by a painting of Bernard by Lautrec, executed in the winter of 1885, about which the sitter was to write later: 'He spent twenty sittings without succeeding in bringing the background into harmony with the face.' Bernard was interested in brothel scenes as early as 1884 when he produced a large pastel drawing, *L'Heure de la chair*, showing couples embracing in a suitably shaded room, and four years later he brought out an album of a dozen watercolours which he entitled *Au Bordel*, which inspired Van Gogh to undertake two paintings with a similar theme. Although Bernard and Lautrec owed a common debt to Degas in this area, Bernard's approach in these

33

115,116

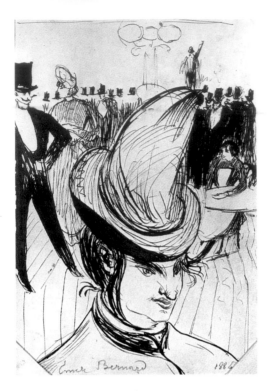

37 Emile Bernard,
La Goulue, c. 1886–89

38 Honoré Daumier, *La
Muse de la brasserie*, 1864

works clearly influenced Lautrec, even though he himself would not take up this kind of subject until the 1890s. There are definite analogies between Bernard's *La Femme au salon* from this album and Lautrec's *Au Salon de la rue des Moulins*, and also similar echoes of Lautrec's Moulin Rouge poster of 1891 can be found in Bernard's drawing *La Goulue* done some time before 1889, especially in the emphatic pose of le Désossé, the silhouetted audience, the row of nimbus-like lights and the daring spatial dispositions.

120

37

In describing Lautrec's student days, Rachou wrote, 'With me he studied diligently in the mornings at the Atelier Cormon, and spent the afternoons painting our regular models . . . I don't believe I had the slightest influence over him. He often accompanied me to the Louvre, Notre-Dame, Saint-Séverin, but much as he continued to admire Gothic art, he had already begun to show a marked preference for that of Degas, Monet and the Impressionists in general, so that even while he was working at the Atelier, his horizon was not bounded by it.' Although it seems a little naive to site Lautrec's artistic interests between the extremes of Gothic art and Impressionism, the impact of

the latter must have been considerable for any young painter of the period, and will be discussed in depth in chapter seven. But as Lautrec's style and creative personality evolved during his time at Cormon's, it became apparent that there were still other influences at work. The growth of an illustrated press, the proliferation of satirical magazines and the polemical vigour created by the tumultuous history of French politics in the first half of the nineteenth century had stimulated the resurgence of political caricature. At the same time the rapid changes that were taking place in French society as a result of the effects of industrialization bred hatreds, insecurities and sensitivities about status which spawned a plethora of social satire on an unprecedented scale. Lautrec was seen by both Cormon and his fellow students as being almost from the start a caricaturist – as in one who deals with *la caricature des moeurs* – and he consciously took advantage of the achievements of his predecessors in the medium. For him, the most significant of these was Honoré Daumier (1808–79), who had produced some four thousand lithographs for a variety of papers and periodicals. Both he and Lautrec were captivated by contemporary life which they observed in slightly different ways, Daumier with a suspicion of evangelistic venom, Lautrec with a sense of ironic detachment. Each worked for a different kind of outlet: Daumier

drew for a mass market, which demanded an anecdotal element, or a joke, reinforced by a caption; whilst Lautrec, who in effect produced very few caricatures as such, introduced into all of his work elements of exaggeration which were intended – either maliciously or fondly – to bring out personality, to stress the nature of a situation, or to fulfil some purely aesthetic function. Both observed episodes of action snatched from the flow of events to encapsulate in visual terms moments of significance; both eschewed the pretty and the beautiful, emphasizing with something that approached enthusiasm both the ugly and the vulnerable. It was Daumier who in his *La Muse de la brasserie* of 1864 first gave memorable expression to a theme that was later to attract Manet, in his *Bar aux Folies Bergère*, and in different permutations to run consistently through the work of Lautrec, especially in *Le Gin Cocktail* which appeared in *Le Courrier Français* in July 1886.

38

60

Daumier in fact was one of many who opened up to art the life of the streets, and especially of the women of the streets, and not merely for voyeuristic reasons (as did the purveyors of the saucy engravings, who used squally days as a pretext for revealing dainty legs or bending waitresses as displayers of comely bosoms). Some of Daumier's most powerful images, such as that of the washerwoman, seen hoisting a load of wet clothes on her back, or perhaps just trudging along the

39 Honoré Daumier,
La Blanchisseuse, 1852

40 *La Blanchisseuse*, 1888

41 *Yvette Guilbert*
saluant le public, 1894

street dragging her child with her, were taken up by Lautrec – 39
especially in the illustrations he did for those magazines which first
saw his published work in the late 1880s: *La Blanchisseuse* appeared in 40
Paris Illustré, 'Le Petit Trottin' in *Le Mirliton*, and *Boulevard Extérieur* in 141,66
Le Courrier Français. Daumier too had been one of the first to exploit
that theme of the popular entertainer, which had been deployed by
Watteau more than a century before; and in their images of the theatre
both Daumier and Lautrec displayed an interest in the audience and
the reaction of the spectators which reinforced the notion of the artist
as *flâneur* formulated by Baudelaire in his essay *Le Peintre de la vie
moderne*, and which Daumier, Manet, Degas and Lautrec were so
forcibly to illustrate: 'The crowd is his domain, as the air is that of the
bird, and water that of the fish. His passion and his vocation are to
become part of the crowd. It is an immense pleasure for the perfect
flâneur, the passionate observer, to take up his abode in the heart of the
multitude, in the undulating and moving, in the fugitive and the
infinite.' The specific focus of Baudelaire's description was Constan-
tin Guys (1802–92), whose spirited drawings of *le monde* and *le demi-
monde* anticipated many of Lautrec's favourite themes and his spirit of
ironic detachment. Guys, like Daumier, realized that this kind of
approach inevitably demanded the cutting edge of caricature, of
exaggeration, of observation that hovered between the sadistic and
the sympathetic, and their explorations of this ambiguous approach
were exploited by Lautrec in all his most powerful images.

His caricature, ranging in intensity from the savage images of
himself which appeared in his sketchbooks and on his letters, through
the vindictive pictures of bloated lechers and hard-faced prostitutes
(typified by the poster for the novel *Reine de Joie*), to the half-
mocking, half-affectionate distortions which characterize, for
instance, the pose of Jane Avril in the poster he did of her in 1899, or 155
the images of Yvette Guilbert with her hag-like face (in the album of
lithographs accompanied by Gustave Geffroy's text and published in
1894), played a central role in all his graphic works, though hardly at
all in his paintings. Distortion and exaggeration in public art forms are
a more effective way of attracting attention than straightforward
visual descriptions, and Lautrec exploited this fact to an extent which
none of his predecessors – Chéret, for instance – had dared to.

In part this vehemence may have been motivated by his own
ugliness, and Freudian commentators on the arts have emphasized the
degree of sadism which tends to underlie the impulse to caricature;
but a more important impulse was the significant role which

caricature had come to play in nineteenth-century France. In part this had been due to technical innovations. The invention of lithography which so greatly increased the potential for reproducing complex images in newspapers and magazines, the application of steam power to the printing press, which made production so much cheaper, and the better methods of communication and transport afforded by railways, all conspired to make printed material of all kinds more accessible to a public whose literacy was increasing steadily as the century progressed. Images were essential to break the monotony of endless columns of unadorned print, and until the invention of the half-tone plate towards the end of the century news pictures which had to be engraved by hand were laborious to produce and visually unconvincing. There was indeed a vast hunger for caricatures – Monet as a young man in Le Havre had made a satisfactory income producing caricature portraits of local notabilities in the 1860s – and this was due to a variety of reasons.

The scientific preoccupations of the century engendered a passion for categorization – of plants, animals, rocks, and especially of human beings. Ever since the publication in 1801 of a French translation of the four-volume work by the Swiss physiognomer Johann Caspar Lavater (1741–1801), appropriately titled *Essai sur la physiognomie destiné à faire connaître l'homme et à le faire aimer*, there had been an interest in the human face and head as clues to character, and this led inexorably – as indeed the illustrations to Lavater's book themselves suggest – to a need to exaggerate salient features. By this means visual clues to character had become available to the artist, and made more powerful by the instantaneity of their impact. This was especially so in the case of political caricature, which was given an added impetus by the violence and vituperation which characterized so much French history in the nineteenth century.

There were underlying factors too. Never before in history had so many people been brought into such close contact with each other as they were in the massive urbanization brought about by the Industrial Revolution, and the title of Lavater's book suggests the social and indeed the emotional dimensions involved in the need so to categorize people. The German sociologist Georg Simmel wrote in 1958: 'Interpersonal relationships in big cities are distinguished by a marked preponderance of the activity of the eye over the ear', and when these relationships were often dependent on status the art of caricature became a powerful weapon of aggression in social warfare. In so doing, however, it had opened up to the artist a new dimension of

realism. The 'types' who throng Lautrec's graphic works – barmaids, jockeys, waiters, sailors, English dandies, washerwomen, shopgirls, singers – had all been converted originally into material for the artist through the work of caricaturists during the previous half century.

In a sense Daumier, Guys and, of course, Lautrec's near contemporary, Jean-Louis Forain were reacting to that concern with modern life, depicted in a non-heroic manner (which was sweeping literature as well as art, finding expression in the writings of the Goncourts, Zola and others) in the paintings of Courbet, and in much of the philosophy of the Impressionists. Likewise, Lautrec was at this time displaying an approach (especially in public and commercial work such as his posters) more anodyne than that which he exploited in his personal and immediate observations of the life around him. It was at Cormon's and in his early days in Paris that he acquired that interest in Japanese prints, and indeed in all things Japanese, which was to be persistent throughout his life. He appears in photographs of fancy-dress student parties attired as a samurai, in one of them holding a Japanese doll. In 1886 he discussed with Van Gogh the notion of making a journey to Japan and ten years later, in one of his periods of abstinence and convalescence at Tassaut on the Basin d'Arcachon, he returned again to the idea. Near Cormon's studio at 51 Rue Lepic there was a retired builder from Louveciennes named Portier, who sold works not only by Daumier, Corot and Cézanne, but prints by Hokusai, Utamaro and Haru-Nobu as well, several of which Lautrec bought. The vogue was no new thing. Monet had been buying Japanese prints at Le Havre some thirty years earlier from the crews of merchant ships; La Porte Chinoise in the Rue de Rivoli had been the haunt of artists such as Henri Fantin-Latour (1836–1904) and James Abbott McNeill Whistler (1834–1903), and by the 1880s Bing's gallery, which sold nothing but Oriental art, was a source of inspiration to Van Gogh, Anquetin and Bernard, as well as Lautrec himself, whose interest extended to the actual materials – paper, brushes and paints – that were used in Japan. It was especially in the area of graphic art, which Lautrec was to make so specifically his own and which at this time was expanding into chromatic forms of technical virtuosity, that the example of the Japanese was so fruitful. He acquired from them the ability not only to organize space in such a dramatic and convincing way, but also to manipulate contour lines, echoing forms, flat areas of pure colour and to devise the overall arrangement of decorative patterns which coincide with, but are not limited to, pictorial elements in a composition.

42

42 Lautrec in Japanese samurai costume, *c.* 1892

The discovery of Montmartre

In the summer of 1884, the year in which he celebrated his twentieth birthday, Lautrec took two significant steps: he grew a beard, and he left the family abode in the Cité du Retiro to take up lodgings with his friend René Grenier and his wife Lily in their comfortable apartments on the second floor of 19 bis Rue Fontaine, described by Degas (who, from 1879 to 1886, lived in part of the same house), as 'the most beautiful rooms in the whole quarter'. The Countess was not very keen on the idea, being understandably apprehensive that her son, free from maternal restraints, would be getting into bad ways, and his letters to her are full of (probably fictitious) reassurances: 'I'm back in the old routine that will last till spring. Too exhausted even to think of going out. It's so nice in the evenings at Grenier's in the warm studio. A good thing if you were to knit me a stocking cap and slippers. The café bores me, going downstairs is a nuisance; painting and sleeping; that's all there is.'

In terms of social standing and respectability, the Greniers were impeccable. René, who had been in the cavalry and was a few years older than Lautrec, belonged to a landed family from Toulouse and had a personal income of 12,000 gold francs. He was an amiable extrovert with a horde of friends, but very few creative gifts. His wife, Lily, a country girl from Brie-Comte-Robert who had modelled for Degas, entranced everyone with her frankness, innocence and vitality. To Lautrec she was warm, protective and flirtatious enough to nurture his tiny flame of self-esteem. The relationship between them is suggested by a note he sent her round about this time:

Duchess, I want to remind you that tomorrow we are eating together. The waiters at the Ermitage told me that the other day you were there waiting for us with an old man. Kindly forget him in some cupboard.

I kiss your little hands,
H.T.L.

The most memorable portrait Lautrec painted of her, in 1888, gives some indication of why he called her 'Duchess'. Seated in a chair, 44

43 Lily Grenier, wearing the kimono given to her by the artist Albert de Belleroche

43 dressed in a kimono which had been given to her by Albert de Belleroche (1864–1944), who was currently a student of Duran's, she stares down with an air which is at once imperious and whimsical, as she toys with a ribbon. The clearly defined face surmounted by loosely swept hair, part of which falls over her left eye, contrasts with the almost ecstatic brushwork of the kimono and the roughly painted dark green background. The resemblance is perfect, as can be seen from a whole series of photographs of the period, in which Lily appears – in most of them wearing fancy dress: with René, and
45 Lautrec dressed as an altarboy; with René and Lautrec both dressed as women; playing with a guitar; with Lautrec in the clothes of a female Spanish dancer; and with a group of Cormon's students, Lautrec sitting beside her, his elbow propped reflectively on her chair.

This passion for dressing up – widespread in the Greniers' circle – can bear many interpretations, though few of them are particularly enlightening. On Lautrec's part it may well have been in imitation of his father's predilections, or it could be seen as an escape into fantasy

44 *Lily Grenier*, 1888

from a harsher reality. In any case, the phenomenon has been a recurrent element in human social behaviour throughout history, institutionalized at carnivals, and at religious and secular ceremonies. It is common in young adulthood, for reasons which have never been adequately explained, and was especially rampant in Europe in the period roughly between 1850 and 1930.

Curiously enough, there was a strong resemblance between Lily and two other women who posed for him at about the same time. One was Carmen Gaudin, whom he met in the street one day (shortly after he had left the Greniers in 1885 to live at Rachou's flat at 22 Rue Ganneron, just behind the cemetery of Montmartre). She was a working-class girl, meek in spirit but a marvellous model, who later appeared as a stone-age woman in one of Cormon's works and as Carmen in a painting by the Belgian artist Alfred Stevens (1823–1906). Lautrec did many drawings of her, mostly to be later incorporated into two illustrations, *La Blanchisseuse* which appeared in *Paris Illustré* on 7 July 1888, and *Boulevard Extérieur*, a straightforward portrait, posed against a window, which appeared in *Le Courrier Français* in 1889. This last work was used to illustrate one of Bruant's songs – like many other artists Lautrec exploited a good creative idea to its ultimate capacity. There is also a painting in oil on canvas, as well as several drawings that served as preparation studies, which showed Carmen looking out of the same window and gripping the end of an ironing board, on which lies a crumpled shirt.

The theme of the working-class girl was popular in French art in the latter half of the nineteenth century and, though Lautrec did not exploit it as assiduously as Degas did, it clearly attracted him, especially in the period before he began to devote his attention to workers of a less reputable kind. In part this was due to the demography of Montmartre which was largely populated by small tradesfolk and those who supplied the service industries and the well-to-do households in central Paris. Laundries were especially common and the girls who worked in them were to be seen everywhere carrying their baskets of freshly ironed clothes, exuding a fragrance of cleanliness and sensuality. Many of them did indeed drift in and out of prostitution, though to use that word would indicate a degree of professionalism which most of them did not possess. An analysis of female occupations and their degree of involvement in clandestine prostitution, conducted by a Dr O. Commenge in 1887, attributed the highest number, 1,326 (the accuracy of the figures is endearing if not convincing), to girls who worked in milliners' shops and such

45 The 1889 fancy-dress ball of *Le Courrier Français*. Lautrec is dressed as an altarboy, René and Lily Grenier are seated in the background. The photograph is by François Gauzi.

like, the second highest, 614, to laundry women (who actually delivered the laundry to the clients themselves – a practice which, as Degas discovered, was productive of new models as well as other amenities). Language teachers could only rustle up one. But there was a larger dimension. Shop girls and laundry women had assumed the role played in eighteenth-century art and literature by peasant girls. They are dominant figures in novels by Zola, the Goncourts and other Realists; they figure prominently in the paintings of Tissot, Renoir, Augustus Egg and Degas. With those who used to be called their 'unfortunate sisters', they competed for the role of the heroine of modern life.

The other sitter in whom Lautrec was deeply interested was the strong-faced Hélène Vary, who had worked as a model at Cormon's studio when still a child, and was seventeen when she posed for Lautrec at one of the various studios he rented at 21 Rue Caulaincourt. It is this studio that figures prominently in the three of

67

46 *Hélène Vary*, 1888

47 *La Blanchisseuse*, 1888

48 Hélène Vary,
photographed by François
Gauzi in 1888

four portraits he did of her, a choice of background that was clearly
intended to isolate her from any surroundings that might detract from
the stark simplicity of his presentation. The effect suggests something
46 of the quality of a Renaissance portrait, with the stretchers of the
canvases stacked against the wall deployed to add an element of
compositional complexity. It is clear that he depended heavily on a
48 photograph taken by François Gauzi, although in the painting her
pose is more upright, the chair and the canvases more clearly defined
and an engaging lock of hair over her ear tidied into place. Signed
with his own name, it was shown at an exhibition of the Cercle
Artistique et Littéraire in the Rue Volney in 1890.

Life at the Greniers' was pleasant enough with its parties, its
dressing up, and its excursions to Seine-side resorts such as Argenteuil
and Villiers-sur-Morin. Lautrec painted four murals there, in the inn
of Père Ancelin, where he and Anquetin usually stayed. These

displayed scenes from the life of the theatre, rather in the style of Degas, showing a call-boy summoning the cast on stage, a ballet, a dancer in her dressing room, and a view of the audience, including the artist himself dressed as an apache (one of his favourite guises), with a peaked cap and the obligatory red scarf. The choice of subject and the dress he painted himself in were indicative not of the fact that he had discovered a new world — he had been conscious of it since his childhood excursions round Paris with his father — but that he had now started to make it his own. In France generally there had always been a tradition of popular entertainment in working-class districts, and in Paris during the nineteenth century this had been greatly stimulated by the rebuilding of parts of the city with wide boulevards and pavements ample enough to contain the overflow from cafés (by 1900 there were some twenty-seven thousand of them in the capital and its environs) and encourage the growth of the one hundred and fifty or so *cafés-concerts*, with their bright lights, their posters and their flamboyant façades. There had been a deliberate attempt on the part of government to make Paris into the capital of pleasure for the whole of the western world, and its attractions had been emphasized and enhanced by the series of international exhibitions that continued from the time of the Second Empire till the beginning of the twentieth century. This promoted a great increase in the city's population, most of it due to immigration from the provinces. Those who came from the south, from the Auvergne, from Normandy, or from other regions, tended to live in proximity to each other, creating communities that preserved old local traditions, songs and forms of entertainment.

The popular culture of working-class society and working-class entertainment in Paris entered a golden age which was terminated only by the arrival of the cinema. In the period between 1893 and 1913 the gross amount spent on entertainment rose from 32,599,084 francs to 68,452,394 francs, and the population of Paris grew by thirty-two per cent. Both money and leisure were in more abundant supply than ever they had been before, and a sign of the changing spirit of the times was the publication of a tract by a Marxist revolutionary, Paul Lafargue (who was married to one of Marx's daughters), entitled *Le Droit à la paresse* (*The Right to be Idle*) which strenuously advocated the right, indeed the duty, of the proletariat to enjoy itself, suggesting that the working day should be limited to three hours, after which 'everyone should be able to loaf and carouse away the rest of the day and night'.

Most of the crowds who thronged the diverse places of entertainment provided in the less affluent quarters of Paris had no knowledge of, nor need for, the apologias of Dr Lafargue, especially not in Montmartre, which held a unique position in the world of self-indulgence. Achieving national, indeed international, fame during the Commune for its sturdy and bloody opposition to government forces, it had only recently emerged from the status of a debased village, undermined with quarries, scattered with a number of mills which took advantage of its lofty position to grind not only flour but roots for cosmetics as well. The closing of the quarries encouraged building there, and by the 1880s, now encircled by the great boulevards at its foot, it was still distinct, and consciously so, from Paris itself. It was inhabited largely by small-scale craftsmen, entertainers, petty criminals, prostitutes, artists and a conglomeration of people who, by choice of principle or force of circumstance, were more inclined to rebel against the establishment than to support it; Montmartre had thus acquired something of the quality of a refuge from the pressures of industrial society, a bastion against the forces of conformity. When, in Zola's *L'Assommoir* (1877), Gervaise and Goujet walk up there, they are deeply moved by the echoes of a still perceptible rural past, the very epitome of the *banlieue*: 'There

49 Vincent van Gogh,
Le Moulin de la Galette, 1886

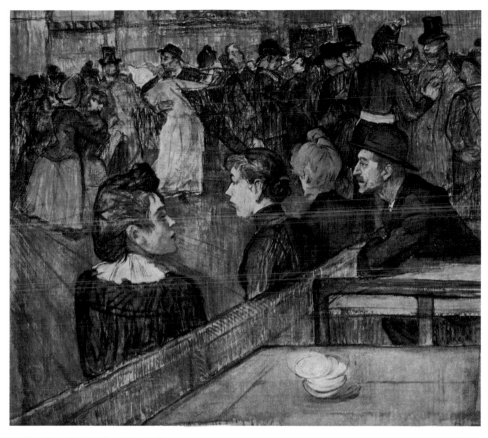

50 *Un Coin du Moulin de la Galette*, 1889

between a mechanical sawmill and a button works, a strip of meadow had survived with patches of scorched yellow grass; a goat tied to a post walked around in circles, bleating; further on a dead tree crumbled in the hot sun . . . The two of them said nothing. In the sky a flock of white clouds swam past as slowly as a swan. They looked into the distance, lost in thought on the pallid slopes of Montmartre, surrounded by the great forest of factory chimneys blocking out the horizon, in that chalky and desolate *banlieue* where the green trees shading the cheap taverns moved them to the verge of tears.'

At Cormon's, Lautrec had made an early acquaintance with the simple *cabarets*, places originally intended for drinking as well as for the lighter varieties of refreshment. But what a later generation would

call 'the entertainment industry' had been developing more elaborate and diverse forms by the time his acquaintance with the area had started to become more intimate. The earliest institutions devoted to communal pleasure were based on the tradition of spontaneous public dances, which in the 1870s were taken over by entrepreneurs who provided fixed sites with rudimentary accommodation and re-freshments.

49,51 The first of these to achieve fame was the Moulin de la Galette, so memorably painted by Renoir in 1876, deriving its name from the small cakes – *galettes* – that were its speciality. Still occasionally grinding iris roots for a Parisian perfumier, the mill itself was used as a place from which to survey Paris for ten centimes a visit; but in addition to this attraction, the Debray family who owned and so successfully exploited it had built a café-restaurant in the grounds and devoted the intervening space to a dance area, brilliantly lit in the evenings by the gas lamps that form such a prominent element in Renoir's painting. There was an orchestra of ten players and the atmosphere was still redolent of the old street dances. The clientèle varied a good deal; on Sundays, when it was open from three o'clock in the afternoon till midnight and after, the atmosphere was 'respectable', very much as Renoir saw it – the charge was two sous for waltzes, four for quadrilles – but Mondays had been taken over by the less reputable elements of local society, and was notorious for its fights and incidents. Lautrec was not a frequent visitor, no doubt the additional climb involved did not appeal to him, though he was apparently partial to the wine mulled with cinnamon and cloves that was a speciality of the place. In a rare flash of social intolerance he once remarked on a visit there, 'For God's sake let's get out of here. All this self-indulgence of the poor is even worse than their misery.' It was, however, the subject of several works of his, the most important being his first large-scale dance scene (measuring 35 by 39 inches, in oil on canvas), *Un Coin du Moulin de la Galette*, showing a row of girls of the approximately respectable type seated against a bar or counter, the major part of the composition being occupied with people dancing and a group of top-hatted men speaking to a Zouave officer. Although primarily a dancing hall, the Moulin de la Galette, in response to the changing demands of the time, also presented in the café-restaurant a limited amount of entertainment, offered on an almost spontaneous basis by professional singers and dancers.

50

Two of these first made their appearance in Lautrec's work in the middle of the 1880s, in an oil sketch which is virtually a *grisaille* in

52

74

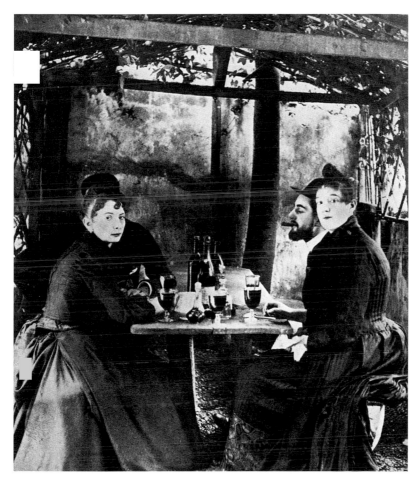

51 Lautrec with friends in the garden of the Moulin de la Galette

black and white with a few shades of grey on ochre-coloured
cardboard, catching perfectly the atmosphere of theatricality which is
the essence of the scene. They were Louise Weber, known
professionally as 'La Goulue' ('The Glutton'), who was as famous for
the grace of her dancing as for her voracious appetite and the
uninhibited vigour of her language, and her partner Etienne
Renaudin (1843–1907), who was called, because of his remarkable
double-jointed versatility, 'Valentin le Désossé' ('Valentine the

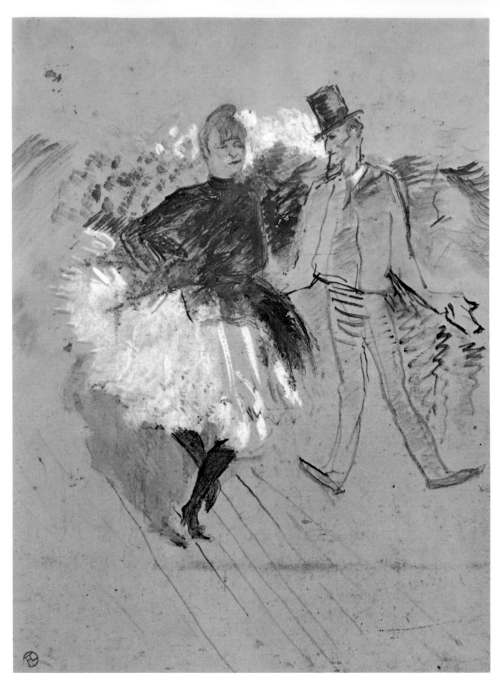

52 *Au Moulin de la Galette, La Goulue et Valentin le Désossé,* 1887

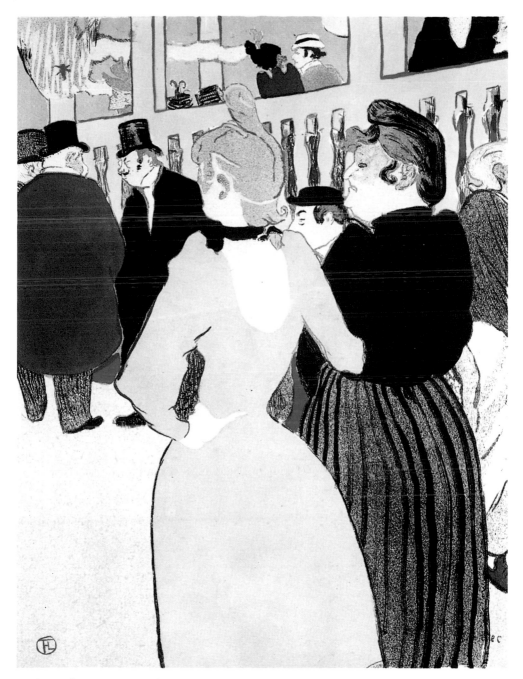

53 *Au Moulin Rouge, La Goulue et sa soeur*, 1892

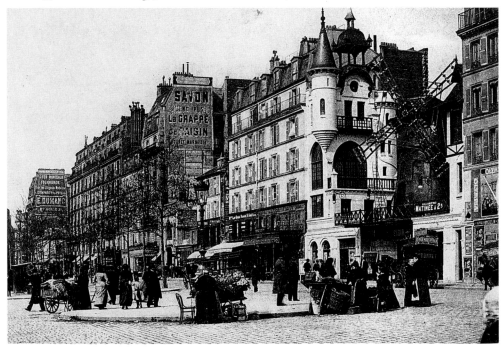

54 *La Baraque de La Goulue*, 1895

55 The Moulin Rouge, in the Boulevard de Clichy

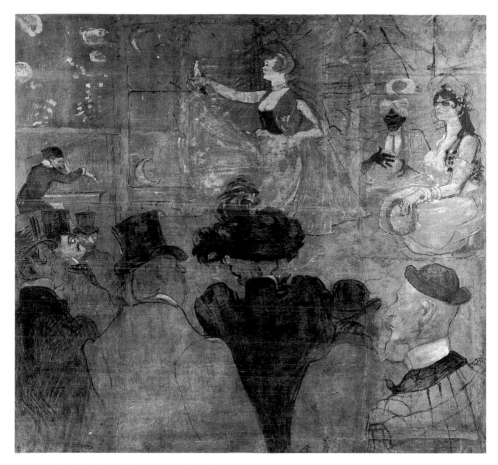

56 *Foire du Trône* (panel for La Goulue's booth), 1895

Boneless') and who had himself discovered Weber. By day he was a respectable wine merchant in the Rue Coquillière, by night his cadaverous countenance, his sure-footed agility and his battered top hat which never fell off, no matter how complex his gyrations, were an essential part of the Montmartre scene.

La Goulue's career was meteoric. From the Moulin de la Galette she migrated to the Moulin Rouge, where she was paid 3,750 francs a week (over £1,000 in late twentieth-century money), and later featured in a fairground booth of her own at Neuilly, which was decorated with two panels by Lautrec, one showing her dancing with Valentin, the other on the stage in front of an audience; here, she

53,55

54
56

79

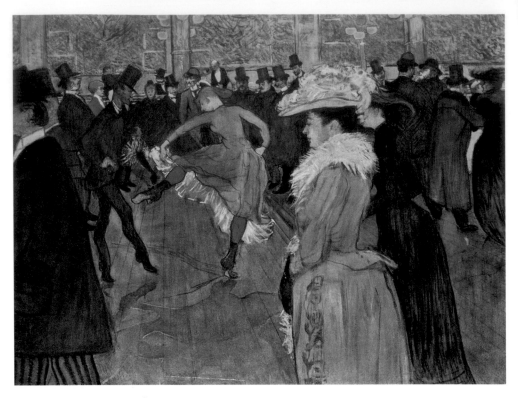

57 *Au Moulin Rouge*, 1890

specialized in 'Oriental' dances of a dubious nature. (Now in the Musée d'Orsay, the panels present life-size images of La Goulue herself, Jane Avril and Valentin le Désossé; and, amongst others, Oscar Wilde and Felix Fénéon are in the audience). She then became a wrestler, especially skilful in splitting her tights and, when her girth prevented even that activity, she bought some lions with which she appeared on stage, but when one of them tore off a child's arm in a fair at Rouen this too had to be abandoned, and she became a servant in a brothel. Eventually she ended up as a rag-picker, living in a caravan at Saint-Ouen with a dog which she called Rigolo. She died in January 1929, the year in which the panels Lautrec had painted for her booth were hung in the Luxembourg.

Analogous to the Moulin de la Galette, but tending to attract a more sophisticated clientèle, was the Elysée-Montmartre in the Boulevard Rochechouart. It was the scenario for several of Lautrec's

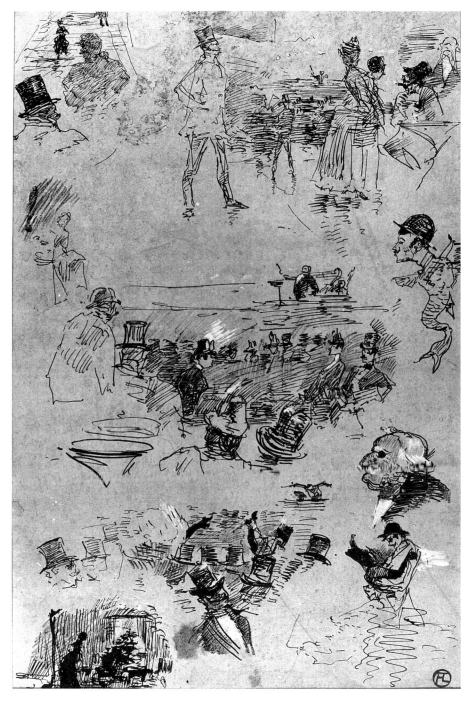

58 *Le Quadrille de la chaise Louis-XIII*, 1886

58 paintings and drawings, a group of which refers to an episode that took place in 1885 connected with a dispute about the possession of a Louis-XIII chair between Aristide Bruant and ex-art student and founder of the Chat Noir, Rodolphe Salis. Salis wrote a song on the subject with the following chorus:

> Ah, Mesdames qu'on est à l'aise
> Quand on est assise sur la chaise Louis-Treize.

The Elysée-Montmartre closed in 1889, a symptom of the change which was occurring in the *quartier*, for the space it had occupied was taken over by a *café-concert*, the Trianon. Participation had given way to spectacle. A new social phenomenon, the *cabaret-artistique*, had appeared, which was to help mould the careers of Lautrec as well as other artists and writers by creating an environment that stimulated political scepticism and creative adventurousness at the same time that it broke down social barriers. Descended ultimately from the café, which had for long been the salon of painters and writers, stretching in an unbroken line from the Guerbois, the Nouvelle-Athènes and the Voltaire to the Coupole and the Deux-Magots, it had a more direct prototype in the *cafés-concerts* which had appealed so deeply to Manet and Degas. The most famous of these, such as the Ambassadeurs and the El Dorado, attracted audiences not only from all over Paris but also from all over the world; yet even they, at least until the end of the century when they massively increased their entrance fees, attracted a socially mixed audience. The material that was presented in them was almost invariably of a coarse, even obscene, nature and they became embodiments of, or escape valves for, all kinds of vaguely revolutionary, anti-establishment sentiments, so much so that at times of political crisis they were often closed, and until the twentieth century they were haunted by police spies and closely watched by the Ministry of the Interior. In the 1870s Jules Simon, the Minister of Education, described *cafés-concerts* as 'distributing and selling poison amongst us'.

The *cabaret-artistique*, however, was a more personal, more intimate and, in many ways, more outrageously anti-conformist version of the *café-concert*, and was particularly characteristic of Montmartre, with its mix of intransigent proletarians and artists whose failure to accommodate themselves to the rules of official art tended to brand them, sometimes despite themselves, as Anarchists and Communists (in the public eye the words were interchangeable). The first and for long the most important of these *cabarets-artistiques* was the Chat

59 The Chat Noir,
at 84 Boulevard
Rochechouart

Noir, which Rodolphe Salis founded in 1882. Salis, who was in his
thirtieth year, had in his search for a suitable profession previously
been a caricaturist, a medal-engraver, archaeologist and painter of
murals (he had decorated a building in Calcutta). Then he hit on the
brilliant idea of the Chat Noir, which he opened in a disused post 59
office at 84 Boulevard Rochechouart, though the venture was so
successful that three years later he moved to more commodious
premises in the Rue Laval, the third floor of which was capable of
holding more than a hundred people. The decorative style was
extraordinary, half museum, half theatre-set, composed of medieval
and Renaissance bric-à-brac, church pews, pewter and copper pots,
coats of arms, tapestries, paintings and murals. The waiters were
dressed in the uniforms of members of the Académie Française, and
Salis himself usually appeared attired as a *préfet*, addressing his clientèle

in such terms of archaic dignity as 'Monseigneur' or 'Your Exalted Highness'. So famous did the Chat Noir become that such honorifics might not always have been misplaced; amongst the visitors there during the first ten years of its existence were the kings of Greece and Serbia, the Prince of Wales, Renan, Pasteur and General Boulanger.

But the attraction the place held for *le gratin* was indeed its least beguiling aspect. Its success and its fascination for Lautrec and many others sprang from a number of causes. Salis was a brilliant showman and publicist; the programmes were remarkable, the lyrics and poetry bawdy, ironical, sentimental and cynical, reflecting contempt for accepted values, the performers superb of their kind. Aristide Bruant sang of the underworld, its miseries and pleasures, and poured scorn on the bourgeoisie; Charles de Sivry the pianist attracted his own huge following, and sometimes the singing was led by Debussy; the painter Henri Rivière, who had done most of the murals and Caran d'Ache, the highly successful caricaturist and illustrator, operated a *théâtre chinois*. This entailed manipulating cut-out silhouettes of zinc in front of a light to project images on a screen, and such fantasies as Albert Robida's version of a future aerial battle over Paris were performed. Salis encouraged writers and artists such as Théophile-Alexandre Steinlen (1859–1923), whose mordant drawings and prints carried a social message more incisive than those of Lautrec, but with which they had analogies, and Léon-Adolphe Willette (1857–1926), whose enormous picture *Parce Domine* covered a wall of the Chat Noir, and the influence of whose style was to be seen in two of Lautrec's later works, the poster *La Vache Enragée* of 1896 (which advertised a journal of that name edited by Willette) and the lithograph *Picnique* of 1898.

At the very beginning Salis had invited a group of writers and artists founded in 1878 and calling themselves 'Les Hydropathes' to make the Chat Noir their headquarters. Although much of the motivation of the group was social, it did have strong underlying concerns with other matters of a wider nature, which found expression in a magazine (originally called *L'Hydropathe*, but which changed its name to *Le Chat Noir* to satisfy Salis' publicity hunger). Satirical, iconoclastic, cynical, idealistic, the magazine used artists such as Steinlen, Caran d'Ache and Willette, and during the fifteen years of its existence represented a state of mind (which had much to do with Lautrec's art, his interest in cabarets and dance halls, in brothels and prostitutes) in an attitude that could alternatively be described as a desire to *épater le bourgeois* or, more pretentiously, as a

kind of anarchistic urge to protest against the all-too-apparent squalor, poverty and injustice created by a rapidly expanding industrial society, and the complicated structure of morality and social standards which underpinned it.

In the latter half of the nineteenth century Anarchism, in a bewildering variety of forms, was a significant element in French life. It had always attracted certain artists. In 1889 Pissarro joined the Club de l'art social (whose aim was to establish contact between artists, Anarchists and Socialists) and, though that only survived for a year, he continued to support Anarchism enthusiastically, contributing illustrations to two of the movement's papers and producing in 1890 an unpublished album of twenty-eight propaganda drawings entitled *Turpitudes Sociales*. Lautrec was no political activist, but in his attitudes he was close to Degas, an aristocratic, cynical reactionary about whom, however, Pissarro said, quite rightly, 'Such an anarchist! In art, of course, and without realising it!' Lautrec's political scepticism was realized, however, especially by the critic Félix Fénéon (1861–1944), himself an Anarchist and probably responsible for the bomb thrown into the luxurious Hôtel Foyot. He had been the first to notice Lautrec's work when it was exhibited at the Salon des Indépendants in 1889 and in the penultimate number of the Anarchist magazine *L'Endehors* he published an extensive review of an exhibition which Lautrec was holding at the Galerie Boussod Valadon et Cie early in 1893, and which he had asked the engraver Charles Maurin (himself an Anarchist, who had introduced him to the technique of dry-point etching) to share with him. In the course of the article, Fénéon emphasized Lautrec's 'ferocious boldness' and noted how he 'transforms his favourite subjects. He loves them, studies them insatiably. The male spectators, morose and empty creatures inclined to senility, become laughable, whilst the young lady dancers are sepulchrally malevolent.' Amongst other points, he asserted: 'His colour is not at all "pretty". By drawing not a traced copy of reality, but a set of signs suggesting it, he immobilises life in unexpected images. Technique, colour and drawing conspire, in works that have authentic originality, and a stealthy, almost hostile, but indubitable beauty.'

Fénéon returned again a few weeks later to the kind of 'hostile' anarchistic element he saw in Lautrec's work in an article for *Le Père Pinard*, an Anarchist weekly, illustrated by Pissarro, Willette, Steinlen, Félix Valloton and Maximilien Luce, and written in rather self-conscious *argot*. Reviewing the Indépendants exhibition, he

commented: 'One who has a hell of a lot of guts and nerve is Lautrec. There's nothing highfaluting either in his colour or his drawing. There some white, some red, all in big splashes with very simple forms; that's his way of doing things. He has no rival in painting pictures of rich old buggers getting sloshed with tarts who slobber kisses all over them to get their money.'

Another aspect of Lautrec's empathy with Anarchism, especially at this period of his life, was his links with Les Incohérents. Founded in 1882 by Jules Lévy, it was a group of writers and artists which can be seen as a forerunner of the Dadaists and the Surrealists, with Anarchism supplying the ideology later to be supplanted by Communism. It commenced its activities with a series of exhibitions; the first, held at Lévy's own apartment, included amongst other artefacts a sheet of hardboard painted white by Alphonse Allais, one of the pillars of the Chat Noir, entitled *Première Communion de jeunes filles anémiques dans la neige*; most of the other works were by people who had literally never learnt to draw. In the following year there was a much larger exhibition, now entitled L'Exposition des Arts Incohérents, which attracted some two thousand visitors, and established these exhibitions as an annual event which received a great deal of publicity, so that the word 'Incohérent' became a symbol of cultural revolt. Exhibits included a large number of satirically grotesque images of politicians and soldiers; an armless and bearded *Monsieur Venus de Milo* figured amongst various parodies of famous works of art; alongside *jeux d'ésprit* such as a cardboard sun rising out of a bidet, and the image of 'a bewildered child, not knowing which breast to suckle'. Exhibitors used pseudonyms, and when Lautrec exhibited there in 1886 and again in 1889, he signed his works 'Tolav-Segroeg, Hungarian from Montmartre'. His entries included sculpture made out of bread, and an oil painting on emery paper entitled *Les Batignolles cinq ans avant Jésus-Christ*. (The Batignolles was an area between Montmartre and Saint-Lazare, and had been the original breeding ground, as it were, of the Impressionists, most of whom had lived there at one time. In using emery paper, Lautrec might have been making a sly reference to the 'rough' texture of their works.) Lautrec was also a frequenter of the Incohérent balls which became a regular part of the Parisian calendar. Noted for the bizarre nature of the costumes worn, they were taken over in 1888 by the satirical magazine *Le Courrier Français*.

The art gallery of the streets

Despite popular myths to the contrary, it is rare to find artists, including those of distinction, who are backward in promoting their careers, diffident about publicity, slow to take advantage of contacts, and unconcerned with the financial rewards their work may bring them. Lautrec was no exception; despite the junketings of Montmartre, the nights spent at parties and his ever-growing fondness for alcohol, he showed from his earliest student days a spirit of enterprise, a dedication to making his name, a skill in utilizing his contacts to their best advantage, and even a concern with the money he made – a tangible proof of his acceptance – which he was to maintain till virtually the end of his career. He very soon appreciated the outlet afforded to him by the many magazines and journals that flourished at this time – some 1,343 in Paris alone. Those spawned in and around Montmartre were especially accessible, and with their general artistic background had already established a tradition of pictorial excellence. Although Lautrec was deeply concerned with painting as such, he was also very aware of the difficulties of breaking into the art-dealing circuit, and for some considerable time was diffident of submitting his works to the various exhibiting bodies that offered the most commonly approachable market-place for unknown artists; to have his work reproduced in magazines, however, was to get his name known and his creative personality displayed.

His first incursion into this field appeared in the pages of *Le Courrier Français* on 6 September 1886. Despite its ambitious name, this was in effect a local paper, subtitled *Chronique de la Vie Montmartroise*. It had been founded two years earlier by Jules Roques, who was also publicity agent for a brand of throat pastilles manufactured by the firm of Géraudel, whose products figured prominently in its pages. The first issue had contained on the cover a full-frontal nude, a feature which no doubt contributed to the fact that within a few years it was available in 997 Paris cafés. Numerous editions were seized by the police as being offensive to public morals, subsequent to which it was vociferous in its defence of freedom in art as well as in the press.

60 *Le Gin Cocktail*, 1886

Lautrec probably met Roques through the Greniers, and Roques commissioned a drawing from him; the result, *Le Gin Cocktail* (rather slack in its draughtsmanship), falls far short in its reproduction of the
60 very vital, on-the-spot charcoal and white chalk sketch of the same year, on which it is based, now in the Museum at Albi.

During the next three years Lautrec had some fifteen illustrations in other magazines, including *Paris Illustré*, edited by Maurice Joyant, his friend from schooldays. For this he produced a series on the life of the city (nearly all based on black-and-white versions of more complex works), which were used to illustrate a series of articles by Emile
61 Michelet entitled 'L'Eté à Paris'. *Un Jour de première communion*, for instance, which appeared on 7 July 1888, was originally drawn in charcoal and oil on cardboard, the colour of which is used for the buildings in the background, whilst all the rest is in black and white. The approach to a subject usually smothered in pious sentimentality is

61 *Un Jour de première communion*, 1888

62 Edouard Manet, *Le Prune*, c. 1877

63 *La Gueule de bois*, 1889

dramatically prosaic and deflating, the actual treatment uneven. The father pushing the pram is a sketch of Gauzi, of whom he had done several drawings and a portrait, and who had posed for this (holding the back of a chair) in Lautrec's studio. In Gauzi's own words:

His composition required five persons, and he only had one model, but he easily dispensed with the missing four by drawing them from memory. He added a cab down the street and some starched shirts in a shop window. Transformed into a working man, my greatcoat became an overcoat, my trousers were shortened, and my feet increased in size. A baby waved its arms in the pram. The little communicant, all white beneath her veils, went in front of her mother, who was dressed in black, and wore a bird's nest bonnet, and who held her child's hand, a grotesque, thin-legged child with white stockings and black boots with high uppers.

The fact that Lautrec had no models for four of the figures is obvious enough; the faces are perfunctory, white spheres, with black dots for

90

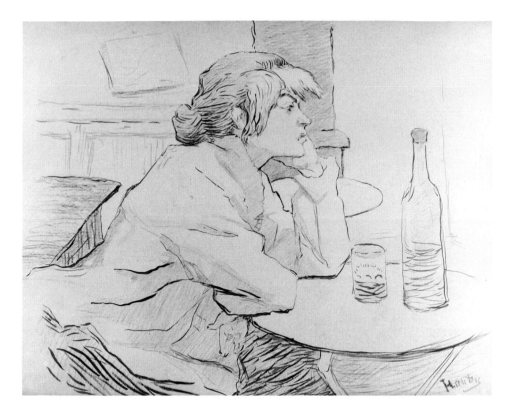

eyes, and even in the figure of Gauzi the right foot and leg are drawn in such a way that he seems to be walking with his legs crossed. It is in the concept of the composition and the brisk handling of the chalk and charcoal that Lautrec's particular gifts are revealed.

In 1889 Roques came back to him with a commission to prepare for reproduction in the pages of *Le Courrier Français* drawings from four of his paintings. The first of these, *La Guele de bois*, appeared on 21 April. It was a portrait of a young girl sitting somewhat (but not very) dispirited at a table in a bar; the antecedents of the work both in concept and in composition are obvious in Degas' *L'Absinthe* of 1876, exhibited at the second Impressionist Exhibition (though by the time Lautrec produced his work it was in Captain Hill's collection in Brighton) and Manet's *Le Prune*, which Lautrec could have seen either in the exhibition at La Vie Moderne gallery in 1880, or more likely at the Manet retrospective in the Ecole des Beaux-Arts in 1884. The model had a special interest for Lautrec, who in 1887 had rented a studio in the Rue Caulaincourt, where she was living.

63

62

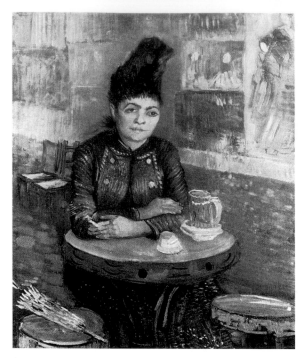

64 Vincent van Gogh,
Au Tambourin, 1887

She was Marie-Clémentine Valade (1867–1938), known as Maria,
who had been born in Bessines-sur-Garetempe in the Limousin, and
brought to Paris by her mother who was a laundress. First of all she
became an equestrienne and trapeze artist at the Cirque Molier in the
Rue Benouville (famous for the performance of amateurs such as the
Comte de Sainte-Aldegonde, a versatile clown when away from the
salons of the Faubourg Saint-Honoré, and the Comte Hubert de la
Rochefoucauld, whose prowess on the trapeze was legendary).
Having been injured in an accident, Marie-Clémentine became a full-
time artist's model, posing for Renoir in *La Danse à la ville* (1883), and
for Pierre Puvis de Chavannes (1824–98) as the Muse in the *Bois Sacré*
(1884), parodied by Lautrec in a sketch of 1884. She also posed for
Federigo Zandomeneghi (1841–1917), who lived in the same house.
At the end of 1883 she had given birth to a son, Maurice (surnamed
Utrillo after his putative father Miguel Utrillo y Molins, a denizen of
the Moulin de la Galette), and taken up art herself with the active and
kindly encouragement of Degas, who had one of her drawings
hanging in his dining room. At about this time she changed her name
to Suzanne Valadon. Her romantic life was active and amongst her

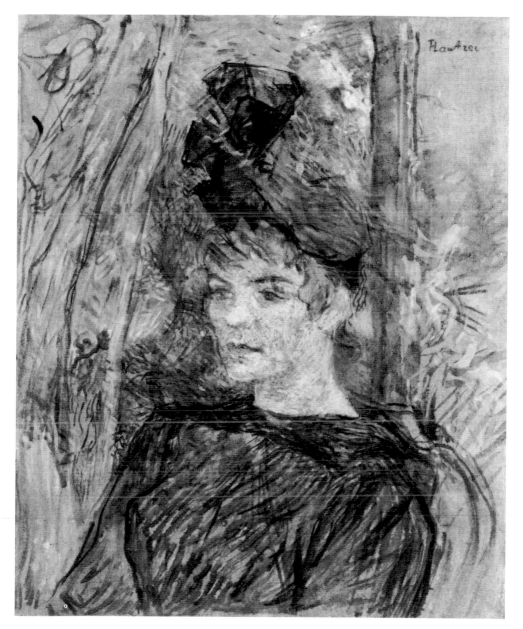

65 Suzanne Valadon, 1886

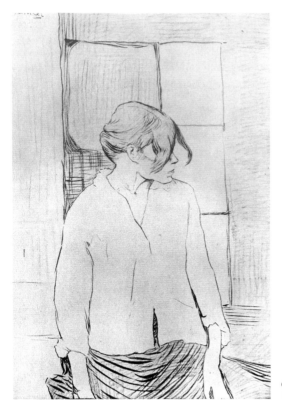

66 Study for *Boulevard Extérieur*, 1889

many lovers were Lautrec, Zandomeneghi, Erik Satie and probably Anquetin. Lautrec painted and drew her, usually in profile. The
65 exception is an oil painting now in the Ny Carlsberg Glyptotek, Copenhagen, dating from 1886, which shows her in a three-quarter profile with her hair done up in a kind of turban, suggestive of Van
64 Gogh's *Au Tambourin* painted in 1887.

The Dutchman had kept very much in contact with his fellow students from Cormon's, and in the April of 1888 had written to his brother Théo: 'Has Lautrec finished his picture, the one of the woman
68 with her arms propped on the little café table?' This refers to *Poudre de riz*, a painting in oil on cardboard, which is almost certainly a portrait of Suzanne seen from the front. The stylistic contrast between Lautrec's two portraits shows something of the conflicting influences which he was experiencing. The earlier one is painted in a very loose, almost Expressionistic style, not dissimilar from that employed
50 in the *Un Coin du Moulin de la Galette* (a reproduction of which

94

67 Jeanne Wenz, 1886

appeared in the *Courrier* on 19 April 1889). *Poudre de riz*, however, so-called because of a tin of the cosmetic powder on the table in front of her, is in some ways more traditionalist, looking towards Pissarro perhaps more than to any other contemporary artist, though there is perceptible in it definite indications of an interest in Divisionism as it was being advocated by Signac (in his book *De Delacroix au Néo-Impressionisme*) and Seurat, with the active assistance of Emile Bernard. It was one of the eleven paintings that he sent to Brussels for his first participation in a public exhibition, that of the avant-garde group known as 'Les XX' ('Les Vingt') which had been founded in 1883 and held the first of its annual exhibitions in the following year, continuing until 1893 when it was reformed under the guidance of the critic Octave Maus into a new body, 'La Libre Esthétique', which not only involved design but also other arts such as music and literature.

The next painting to be reproduced in the *Courrier* was a portrait of
67 Jeanne Wenz, the sister of a fellow student, Frédéric, whose father had been the first to buy a painting by Lautrec, from an exhibition of L'Union Artistique of Rheims, where the family lived. Its title, *La Bastille*, was derived from a song popularized by Aristide Bruant. *Boulevard Extérieur* finally appeared on 2 June, again connected with a song by Bruant, though when Lautrec drew this study (which featured Carmen Gaudin, the red-headed laundress of whom he had
47 made four portraits), he almost certainly had no such idea in mind.

These reproductions of his actual paintings in a journal with so wide a circulation clearly provided welcome publicity of a kind to which he was demonstrably not averse. Publicity was all he did get. Roques not only failed to pay him but also endeavoured to sell the drawings at the Hôtel Drouot. Lautrec had to take legal action to get them back, an action which incurred the undying enmity of the journalist, whose revenge was to take the form of an obituary published on 15 September 1901 in which he described Lautrec as

a sort of Quasimodo, whom nobody could look at without laughing . . . who did all he could to make the girls of Montmartre look ridiculous, base, slovenly or trivially obscene. In his business methods he was like an accountant and bailiff all rolled into one; he knew very well how to set the whole machinery of the law into motion and unleash a whole stream of officially stamped papers, as soon as he thought that his interests were at stake, even though the sum of money involved might have been quite a small one . . . Just as there are enthusiastic admirers of bullfights, executions and other harrowing spectacles, so there are admirers of Lautrec.

96

68 *Poudre de riz*, 1887–88

69 Théophile-Alexandre Steinlen, cover for *Le Mirliton*, 15 January 1886

70 *Le Dernier Salut*, cover for *Le Mirliton*, March 1887

71 Cover for *Le Mirliton*, August 1887

But Roques was not the only one to publish a journal, nor was Salis the only one to run a *cabaret-artistique*. Partly through Salis, who employed him originally in the Chat Noir, partly through Anquetin, whose work he admired, Lautrec came into contact – and a very fruitful contact it turned out to be – with Aristide Bruant, at this time in his mid-thirties. Born in the Gâtinais, brought up by a drunken father and a resentful mother, he worked first in a lawyer's office, then in a jeweler's, before becoming a clerk in the Chemins de Fer du Nord at the Gare Saint-Lazare. There he was attracted to nearby Montparnasse, and soon started writing and singing his own songs. Originally repelled by the dialect and attitudes of the working classes, he very soon started to savour the cynicism, the vitality, the wit and the underlying bitterness that informed their language and their approach to life. He made himself the poet of the down-and-out, the scourge of the self-indulgent complacency of the bourgeoisie – and both factions adored it. It was this success that soon prompted him to start his own *cabaret-artistique*, the Mirliton (the word means, literally,

Le dernier saint, par Tréclau.

Dessin de Tréclau.

'reed pipe', but by extension any kind of street or popular music),
which he advertised as 'The place to visit if you want to be insulted.'
Its popularity did indeed stem from his realization that clients of places
of entertainment can derive a greater pleasure from being openly
abused than from being fawned upon, and adore being called *mon
cochon* (swine) or referred to collectively as *un tas de salauds* (a bunch of
bastards) – though he himself gained a more personal satisfaction. 'I
get my revenge by treating the well-to-do like this', he once said.

Lautrec and Bruant had a natural affinity for each other; Lautrec's
paintings were on view in the Mirliton, along with those of Anquetin,
Steinlen and others, and the pages of *Le Mirliton*, the journal which
Bruant edited in opposition to *Le Chat Noir*, offered him opportuni-
ties of a more constructive kind than Salis afforded. On 29 December
1885 it featured a double-page spread in photorelief printing of the
painting *Le Quadrille de la chaise Louis-XIII* (commemorating the 58
aforementioned incident with Salis that Bruant had made into a
song), which hung on the walls of the Mirliton, a fact emphasized in

99

the caption. Lautrec produced four cover illustrations for the magazine, three of them coloured in stencil from separate relief plates, for which the artist had to give specific instructions. This technique was cheaper than colour printing as such and whereas other artists, Steinlen for example, used it for local descriptive purposes, Lautrec used colours – ranging from one to four – almost entirely for dramatic and compositional reasons, sometimes isolating it towards the front of the centre of the image, and always exploiting to the full the white of the paper and the blackness of the line of the basic drawing. Working for these *Mirliton* covers during the years 1886–87 provided Lautrec with an incentive to explore and expand the potential implicit in an apparently rigid technical framework. The necessity of using flat colours, themselves restricted within a narrow range, promoted in his art those tendencies towards adventurous and startling compositional devices which were to become so characteristic of his work as a whole.

Typical of this approach is the cover of *Le Mirliton* for March 1887, entitled *Le Dernier Salut*, startling in its admixture of simplicity and sophistication, Realism and Mannerism. More than half the picture surface is untouched. The composition is dominated by the figure of a working man, awkwardly holding his cap in his hands, and is executed in purple, yellow and blue. At the top of the picture, tilted upwards, is the pure black profile of a hearse, driver and four hired mourners, very clearly influenced by the figures that Lautrec had seen in the *théâtre chinois* of the Chat Noir; the funeral cortège is following a road that curves abruptly off the picture space around a street lamp. It is a work of intense poignancy and remarkable technical sophistication.

The actual process by which coloured illustrations of this kind were made was complicated. In his *Les Arts et les industries du papier en France* (1894), Maurias Vachon described it thus:

The basic drawing of the composition is traced on paper or canvas in concise lines, in outline or else in bold, deliberate strokes, intended to form the partitioning and the bed of colours. Photography reduces the drawing in order to give it more sharpness, and fixes it on the metal plate. From this plate a proof is pulled, which the artist works into colour, following the number of tints that have been decided on; or sometimes he may abandon himself to his unfettered inspiration and paint the drawing without reference to the colour printing. In the first instance the printer's colour specialist simply has to transfer to each plate the corresponding colour; in the second he may proceed to an interpretation, made relatively easy by a predetermined use of colours,

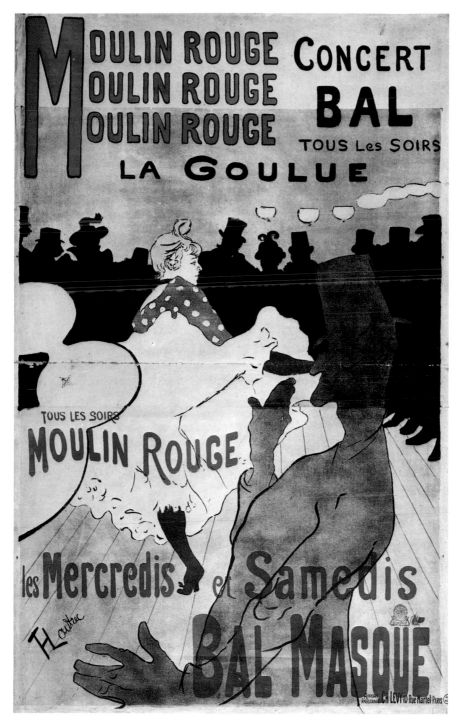

72 *La Goulue*, poster for the Moulin Rouge, 1891

and he will succeed in rendering, with the almost absolute exactitude of a perfect imitation – by fine stippling, by ingenious superimpositions, and by special tricks of the trade – all the subtle nuances and colour harmonies of the original work.

Lautrec was to continue intermittently with this process throughout the next decade, using it with consummate effect, and with all the chromatic freedom he was in the meantime achieving in his illustrations for *Le Rire* and *Paris Illustré*. The printseller Edouard Kleinmann of the Rue Saint-Victoire, one of his most enthusiastic supporters, sold signed and numbered proofs of these illustrations, a significant indication of the new prestige that was accruing to cheap graphic art forms.

Through Bruant, however, Lautrec was to explore other reproductive processes in which he was to find more spectacular fulfilment, greater renown. The poster had played a significant part in the appearance of Paris since the end of the eighteenth century, but its role and nature were changed in the second half of the nineteenth by the combination of a particular artist and the improvement of a process. Jules Chéret (1836–1932) first attracted attention at the age of twenty-two, with a three-colour lithographic poster for what was possibly the most successful musical work produced in nineteenth-century France, Offenbach's *Orpheus in the Underworld*. The poster made a sensational impact, but Chéret did not follow it up immediately because he spent the years between 1859 and 1866 in London working for the publisher Cramer, mainly designing posters. There he became acquainted with English innovations in lithographic techniques, and when he returned to Paris he opened his own press and started producing posters that transformed its streets, already suitably prepared for such displays by the appearance, in addition to the traditional hoardings, of those green metal display columns known as 'Colonnes Morriss', after the Englishman who introduced them.

The impact of these posters and its implications were fully realized by writers such as the Goncourts and Huysmans. The politically perceptive Fénénon was not the only one to suggest their democratic dimension: 'Look at the art of the streets. There instead of pictures in dirty gold frames you will find real-life art, coloured posters. It's an outdoor exhibition all the year round, wherever you go. They don't pretend to be valuable stuff at all, even if made by a great artist. They'll be torn down in a short time, others will be put up, and so the process will go on; the artist doesn't care. That's just how it should be;

73 Pierre Bonnard's poster *France-Champagne*, 1889

74 Jules Chéret's poster *Bal au Moulin Rouge*, 1889

that's art by God, and the best kind too, mixed up with life, art without any pretence, without bluffing or boasting, and within reach of ordinary people.' Persuasive though Fénénon's argument was, it erred in one respect. The commercial value of posters – especially by Chéret, Steinlen, Félicien Rops, Forain and Lautrec – was very quickly realized by certain dealers. Edouard Kleinmann had already been selling Lautrec's *Mirliton* illustrations before he added posters to his stock, and Edmond Sagot, who had a shop in the Rue Guénégaud on the Left Bank, had become the recognized dealer in posters and the like by 1886.

The revolution that Chéret had initiated with spectacular mixtures of typography and images, such as the *Valentino: Grand Bal de Nuit* of 1869, was basically stylistic, assisted though it was by technical refinements. He himself said that for him posters were not a good form of advertising, but that they made excellent murals. Avoiding

emphatic shading, using large areas of colour that were flat and transparent, and adopting imagery that was derived partly from Japanese prints, partly from the popular advertising used for public entertainments such as circuses, he worked directly on the lithographic stone, the lettering being added afterwards.

In 1893 Edouard Duchâtel published *Traité de lithographie artistique*, which described for the first time the potential combinations open to artists using the medium. According to this, four stones had to be employed for the yellow, red, blue and black elements. When, in the summer of 1891, Lautrec was commissioned to produce a poster for the hugely successful music hall, the Moulin Rouge, by its manager Charles Zidler, this (with some elaborations) was the technique that he used. The Moulin Rouge had been opened in 1889 by the Spanish businessman and impressario Joseph Oller, who had bought Lautrec's *Au Cirque Fernando: L'Equestrienne* and hung it in the hall. Zidler was responsible for both the dancers and the publicity, and there is a photograph of him at this time pointing out to an attentive Lautrec the beauties of an earlier Moulin Rouge poster by Chéret mounted on an easel, presumably indicating that this was the kind of thing he wanted. Lautrec needed no prompting. He had always been an admirer of the older artist (an admiration that was warmly reciprocated by Chéret) and he clearly saw the commission as a challenge. Both technically and compositionally he had to break new ground. He achieved the latter by combining various media: brushwork and chalk, and above all by using a scattering technique which involved spraying paint from a heavily charged brush through a sieve, thus allowing rich mixtures of colour. The foreground figure of le Désossé, for instance, which together with that of La Goulue dancing in the background, forms the main element in the composition, is achieved with black, red and blue sprayed over each other to produce a dark violet. Originally he had used a larger combination, but the printer had simplified these.

The whole work was quite different from Chéret's, or indeed from anything that had appeared before; there is a detectible Japanese influence at work, and some clear connection with Bonnard's poster *France-Champagne*, published in the same year and produced by the same printer, Edward Ancourt et Cie. (Lautrec admired Bonnard's work, came to meet him and formed a friendship which continued throughout his life, with both artists frequently participating in the same exhibitions.) In comparison with Chéret's poster, Lautrec's is a model of simplicity. Whereas, for instance, the former gives the

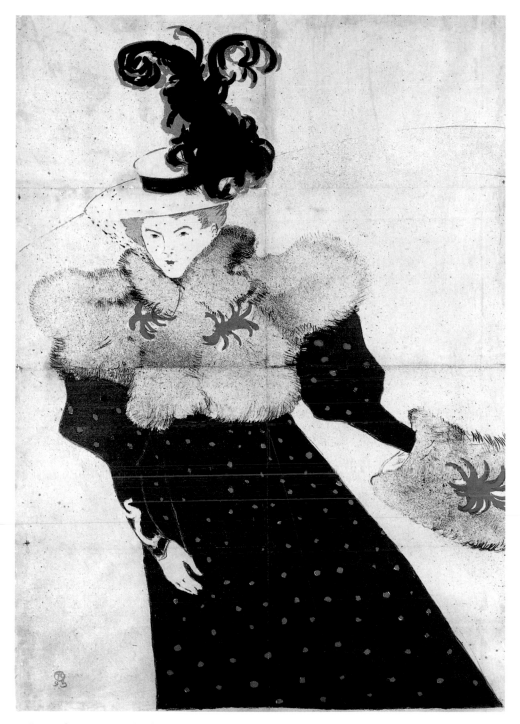

75 Poster for *La Revue Blanche*, 1895

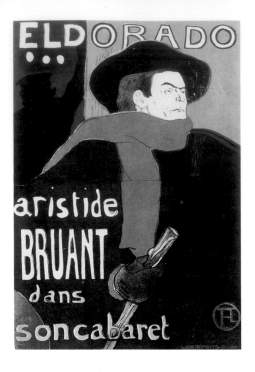

impression of being overcrowded, with the attendant spectators and
revellers individually depicted in a swirl of figures, Lautrec confines
his to a large continuous black mass broken by silhouettes of top hats
and women's finery, with the emphasis concentrated on La Goulue,
all gold, white and pink, a combination emphasized by the slightly
sinister, caricature-like image of le Désossé. Whereas Chéret had
depicted anonymous people, Lautrec personalized them to the point
of caricature.

The appearance of the poster – in an edition of about three
thousand – was the most important event so far in Lautrec's career as
an artist. It confirmed him in the choice of a medium that he was to
make especially his own; it brought him at first notoriety, and very
soon fame. He had been vaguely conscious of this right from the start.
In June he had written to his mother: 'I am still waiting for my poster
to come out – there is some delay in the printing. But it has been fun to
do. I had a feeling of authority over the whole studio, a new feeling
for me.' Then, on 26 December, the same year, 'The newspapers have
been very kind to your offspring. I'm sending you a clipping written
in honey, ground in incense. My poster has been a success on the walls,

76, 77 *Aristide Bruant dans son cabaret*, posters for his appearances at the Eldorado and the Ambassadeurs, 1892

78 *Bruant à bicyclette*, 1892

despite some mistakes by the printer, which spoiled my production a little.' An article that especially pleased him was two columns of praise by Arsène Alexandre, one of the first to defend the Impressionists, which appeared in *Le Paris* ('a very Republican paper. Don't tell the family', he wrote to his mother). To underline his pride in the work, he exhibited it at the eighth Salon des Indépendants and at the annual exhibition of Les XX in Brussels.

In the meantime, Bruant was spreading his wings and had been engaged to appear at the Ambassadeurs, a *café-concert* in the Rue Gabriel, and at the Eldorado in the Boulevard de Strasbourg. For both of these he commissioned posters from Lautrec – two more were to follow later and these were to make Bruant probably the most recognizable entertainer in the history of art – with the possible exception of Watteau's *Gilles*. Pierre Ducarre, the manager of the Ambassadeurs, by all accounts a small, old, penny-pinching conformist, who thought the poster to be 'a revolting mess', refused to accept it, and commissioned the more conventional artist Georges Lévy to produce another. Bruant, with that idealistic flamboyance so perfectly caught in Lautrec's images of him, refused to appear in the

76,77

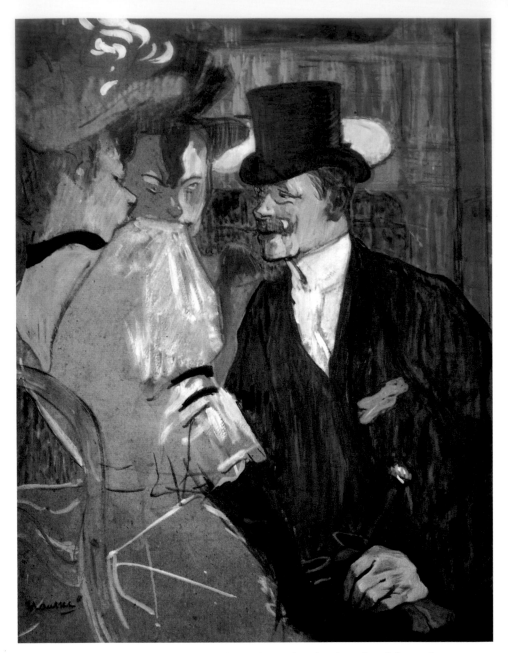

79, 80 *L'Anglais au Moulin Rouge*, in oil and gouache, and (right) the colour lithograph, 1892

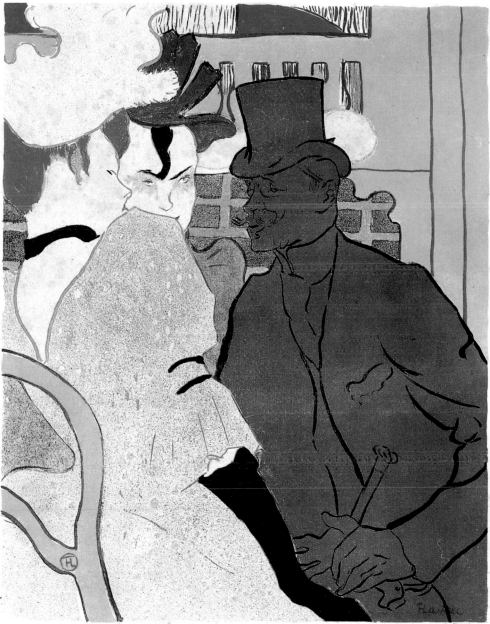

Imp. Edw. Ancourt à Paris.

Ambassadeurs unless the poster was accepted. It then was, and made almost as much impact as the Moulin Rouge poster. Thadée Natanson was a rich patron of the arts, a close friend of Lautrec, and the owner of the influential *La Revue Blanche*, which played so significant a part in the history of Symbolism and the movements connected with it. In a review of Lautrec's first one-man exhibition which Joyant had arranged at the Galerie Boussod, Manzi et Joyant, published in the February 1893 issue, Natanson enthused:

The posters that have burst forth on the walls of Paris, or are still adorning them, have surprised, disturbed and delighted us. The black crowd teeming round the dancer with her skirts tucked up, and her astonishing partner in the foreground, and the masterful portrait of Aristide Bruant, are equally unforgettable. One's eyes, delightfully moved, stop at the shop-window like display, in the joyous carefree colouring of a Chéret, they naturally seek to rediscover in their troubling memories the exquisite emotion of art that the disquieting intentions of M. Toulouse-Lautrec have made almost painful.

The version of the Bruant poster that Lautrec prepared was virtually a simple reversal of the earlier one. He had some problems with it but this time not of a technical nature, as he explained in a letter to Bruant: 'Bruant my good friend. Enclosed the states as requested. As far as the poster *ex edition* is concerned, there are no good impressions left. The Eldorado management was very mean, haggling over the price and giving me less than the printing costs at Caix. So I have worked at cost price. I am sorry they misused our good relations to exploit me. It remains to be hoped we shall be more careful next time.' In 1893 Lautrec produced another poster of Bruant in profile, which went on getting reprinted in different versions until 1912. Another, smaller version of it was also produced, signed and numbered, copies of which Bruant sold at the bar in the Mirliton. In addition, it featured on the cover of *Le Mirliton* for 9 June 1893 in a drawing by Steinlen, which showed a dandy in a top hat looking at the poster on the wall, with a group of dogs ostentatiously urinating in the background.

81 The final version appeared at the end of the year, and was quite different from the earlier images. Printed in olive green and black – some states have red on the collar and sleeve – it is a back view of the *chansonnier*, jaunty, with his hands in his jacket pockets, the general effect being more that of a book illustration than a poster. There is indeed justification for this. Like so many of Lautrec's works it had

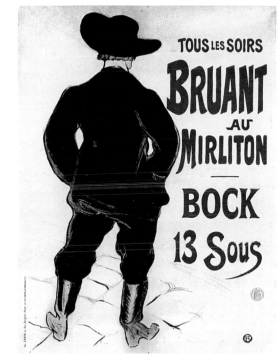

81 *Aristide Bruant*, the final version of Lautrec's poster for his appearance at the Mirliton, 1893

more than one role to play. As well as a poster for the Mirliton, and for the later Théâtre Bruant, it was also used as the advertisement and cover for a book of songs by Bruant edited by Oscar Méténier, with illustrations by Steinlen; presumably this is what Lautrec had had in mind all the time.

The technical simplicity of this Bruant poster was unusual. In 1892 for instance, he had produced a lithograph in an edition of one hundred numbered and signed copies, published by Boussod Valadon through Joyant, entitled *L'Anglais au Moulin Rouge*, showing an artist 79,80 from Lincoln, William Tom Warrener (1861–1934), who had been a pupil at the Académie Julian, dressed in the height of fashion, talking to two girls. In it Lautrec uses six colours; his favourite olive green, blue, red, yellow, purple and black, with Warrener's figure in a dominating purple, in contrast with the brightness of the girls – the same kind of dramatic juxtaposition as the figures of le Désossé and La Goulue in the Moulin Rouge poster. This purple is premixed ink, not 72 produced by an overlapping of the red and blue stones.

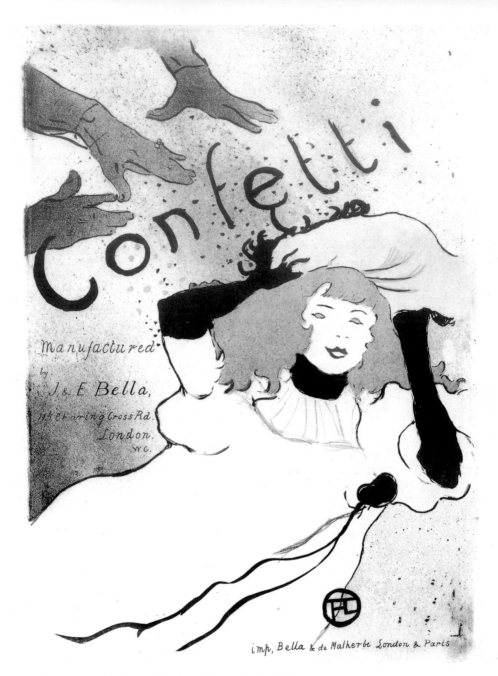

82 *Confetti*, poster for the English firm Bella & de Malherbe, 1894

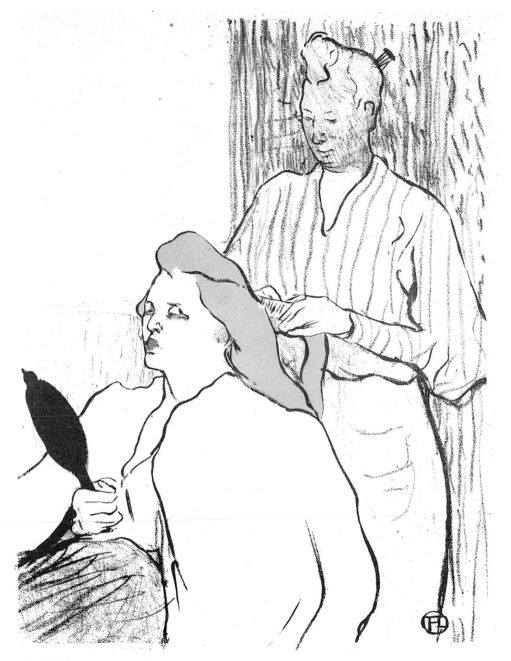

83 *La Coiffure*, programme for *Une Faillite* at the Théâtre Libre, 1893

84 *May Milton* (sketch for Ill. 86), 1895 85 *May Belfort* (sketch for Ill. 87), 1895

Lautrec could not have started his graphic work at a more propitious time. A taste for art was beginning to permeate social classes which had hitherto seen it as an inaccessible luxury, and there was a positive passion for prints of all kinds, with publishers bringing out special portfolios and at least four galleries dealing in them almost exclusively. Sagot, the pioneer in this field, had in his sale catalogue of 1892 two of Lautrec's posters, selling at 3 and 4 francs each. In the text they were praised as being 'of exceptional originality in terms of both drawing and colour. This is the only artist besides Chéret who is truly personal.' Sagot advertised for his graphic works, and included everything Lautrec did in this medium as soon as it appeared. Edouard Kleinmann commissioned thirty black-and-white lithographs of performers such as May Belfort, May Milton, Jane Avril and Marcelle Lender as well as producing limited and signed editions of black-and-white lithographs, including the cover for a book of songs by Désiré Dihau published by Gustave Ondet coloured by hand (not Lautrec's) with the aid of stencils. Ondet and other music publishers such as Paul

84,85,86,
87

114

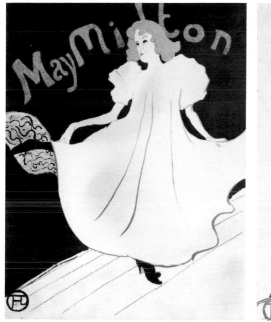

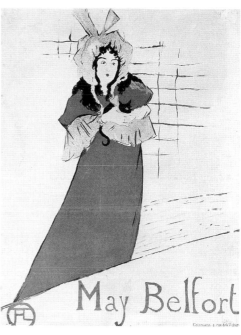

86 *May Milton,* 1895 87 *May Belfort,* 1895

Dupont and Bosc became a fruitful source of employment. Between 1893 and 1901 Lautrec illustrated covers for fifteen collections of sheet music by Dihau alone. The theatre too was a useful outlet. The actor André Antoine, who in 1893 had opened the Théâtre Libre in the Place Pigalle, in the foyer of which he hung paintings by Seurat, Signac and Van Gogh, commissioned programme covers from Lautrec and others. The first one Lautrec did, for *Une Faillite* by Björnstjerne Björnson, showing a woman having her hair done by a maid, was based on one of his Rue des Moulins drawings, and Kleinmann published an edition of it without the lettering in one hundred numbered impressions on imitation Japanese paper, signed (sometimes very falteringly) by the artist. In addition to these galleries which specialized in prints, others such as Boussod Valadon, now under the helpful direction of the invaluable Maurice Joyant, not only kept prints of various kinds as part of their stock in trade, but also commissioned works (such as *L'Anglais au Moulin Rouge*).

 The finances of such productions were complex, and Lautrec kept a

83

79,80

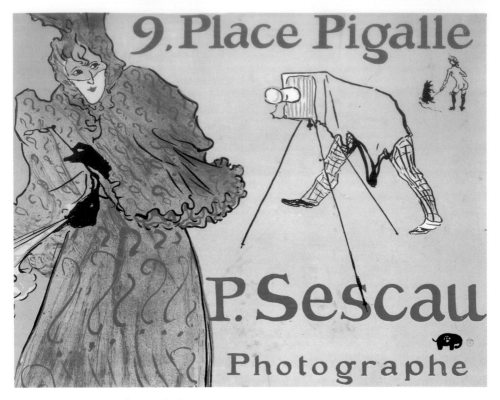

88 *Le Photographe Sescau*, 1894

very shrewd and watchful eye on them. The selling price of his posters, which of course was in addition to the original fee, was between 2 and 12 francs according to their condition, and his colour lithographs in small editions sold for around 20 francs. What Lautrec was actually paid varied a good deal. In 1897 Gustave Pellet published one of his most important works, the colour lithograph *La Grande Loge*, a superb example of the interplay of form and colour. The delicately sprayed tonal gradations enabled only a limited edition of twelve to be printed, and so the relatively high price of 50 to 60 francs was asked for each. In November 1898 Lautrec wrote to Pellet: 'On July 8th 1897, you took 25 impressions in black of *Intérieur de brasserie* at a net price of ten francs and 12 impressions of *Femmes dans la loge* [actually entitled *La Grande Loge*] at twenty francs net. You have sold two impressions of *Brasserie* making twenty francs and one impression of *La Loge* at twenty francs. Making a total of 40 francs. You advanced

89

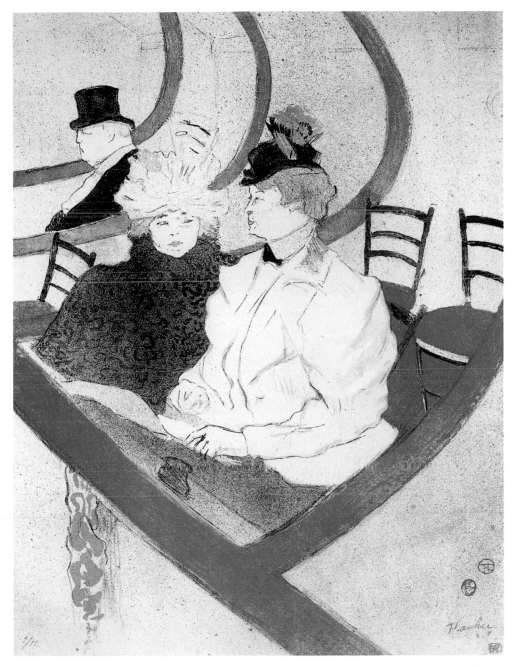

89 *La Grande Loge*, 1896–97

me 200 francs on the lot, 150 now outstanding. Therefore I am leaving you 8 impressions of *La Loge* on deposit and taking back the rest!' This seems to indicate that the general level of payment that Lautrec received for his work sold through print dealers was, on an average, fifty per cent of the selling price.

A more detailed analysis of the financial structure of print production can be derived from the correspondence between Lautrec and the English publisher W.H.B. Sands. Operating from Paris and London, Sands published *The Paris Magazine* and had his finger in all kinds of Anglo-French pies. On 28 February 1898 he wrote to Lautrec: 'Could you give me six drawings of Yvette G. [Guilbert] immediately – that is in two or three weeks. I think that these drawings will be in great demand at the beginning of May when she is here. This would be something for both of us, and also a little publicity, all the better for you because fashionable society will see them.' Lautrec agreed, but it was not until April that he sent Sands the eight lithographic stones for the drawings. Lautrec's printer, Henry Sterns, sent Sands the bill: the cost of the stones was 2 francs 40 centimes each; the preparation of the stones and the pulling of proofs came to 40 francs, and two packing cases 5 francs 50 centimes. Lautrec himself received 800 francs for the eight drawings. At about this period he received the highest price he had so far achieved for one of his direct paintings when Comte Moïse de Camondo, whose famous collection of Impressionist paintings in the Rue Gluck he used to visit with Joyant, paid 500 francs for a sketch of the clowness Cha–U–Kao, the original of which had been bought by the deposed King of Serbia.

It is obvious that throughout his career he made far more money out of his graphic work than out of his paintings. Nor was the medium considered an inferior art form, either by himself or by others. He sent posters and lithographs to almost all of the exhibitions in which he participated: with Les XX in Brussels; at the exhibition that he shared with Anquetin, Bernard and others in the gallery of the dealer Le Barc de Boutteville in the Rue le Peletier in 1891; at the three group exhibitions at the Cercle Artistique et Littéraire in the Rue Volney, and in his exhibition at the Galerie Boussod in 1893, which included thirty paintings and lithographs.

Opinion generally, on the occasions when it was favourable, tended to prefer Lautrec's graphic work to his paintings, an opinion which has been largely shared by posterity. The prints are innovative, adventurous and seem to look forward to future developments in European art in a way in which the paintings do not. In a book

published in 1898, *La Lithographie originale en couleurs*, the critic André Mellerio commented: 'Toulouse-Lautrec demands to be considered first. He has made a powerful and important contribution to the creation of original colour lithography both from the point of view of conception and technique. His personal inclinations and taste have inspired him to create a very large number of works. There can be no doubt that he is extremely gifted for his prints – and in our opinion, mainly for his prints. Indeed we prefer them to his painting, in which he doesn't seem completely at ease, in a medium which is more complicated, less direct. His remarkable inspiration and the elaborate techniques which he has evolved, his knowledge of the medium which has been reached through a training devised entirely by himself have rightly given him a leading role in original colour lithography.'

90 *La Loïe Fuller aux Folies Bergère*, 1892–93

Cabarets and brothels

Lautrec was to produce 368 lithographs and posters, all of them based on an immense infrastructure of paintings and drawings, which varied in the latter category from countless sketches of single anatomical elements, such as the legs of a dancer or the arms of a singer, to figure studies, often in chalk or watercolour, and compositional sketches for the work in hand. On many occasions, however, graphic works were seen predominantly as a means of reproducing already existing oil paintings. There was one exceptional translation into another medium. In November 1892 a spectacular pseudo-Japanese ballet *Papa Chrysanthème* was staged at the Nouveau Cirque, with dancers in the style of Loïe Fuller cavorting round a small lake covered with water lilies. Lautrec made two oil sketches of this on cardboard and in 1895 designed a stained-glass window based on them for Tiffany of New York.

90

It is especially easy to appreciate how he adapted media to the varying needs of the image he wished to produce because of the way in which he tended to get obsessed with particular individuals. Perhaps the most prominent of these was Jane Avril (1868–1933), to whom he was bound by ties of real affection and shared interests, whose image he returned to time and time again, and whose sympathy and support were to be with him during the dark, concluding months of his life. The illegitimate offspring of La Belle Elise, one of the *grandes horizontales* of the Second Empire, Jane Avril combined in a most engaging way wit, intelligence, an interest in literature and the arts and a certain demureness of behaviour with a choreographic wildness of frenzied dancing, closer to that of *Prince Igor* than La Goulue, which was to make her one of the star attractions of Paris. Pale-faced, with turquoise-blue eyes, she gave the impression of possessing, in the words of Arthur Symons, that wide-eyed commentator on *fin-de-siècle* Paris, 'an air of depraved virginity'. Sophisticated in her choice of costume, she preferred black, green, lilac and blue to the more gaudy colours affected by her colleagues at the Moulin Rouge and elsewhere, who called her 'Jane la Folle' – she

91 *Jane Avril*, 1893

92 *Jane Avril, La Mélinite*, 1892

did in fact spend spells in mental institutions. Her favourite reading was said to be Pascal's *Pensées*. In 1896 she appeared as Anitra in Lugné-Poë's famous production of *Peer Gynt*. In 1900 she toured the French provinces, and in 1901 went to New York; by 1905 her stage career was over, however, and she married Maurice Biais, a draughtsman; at the end of her life she was destitute and died in a home for the aged. Lautrec saw her as part of his personal and social life, meeting her not only at the Mirliton and the Moulin Rouge, but taking her to meals at the prestigious restaurant of Père Lathuille, and

88 introducing her to people such as Charles Conder, Paul Sescau the successful photographer, Edouard Dujardin the Symbolist poet, and Macarona, the internationally famous flamenco dancer. All these, with the exception of Conder, figure in Lautrec's painting of 1892, *Au*

145 *Moulin Rouge*, which in itself is a remarkable exercise in the creation of space by the use of converging diagonals – a technique that had been so highly developed by Caillebotte.

122

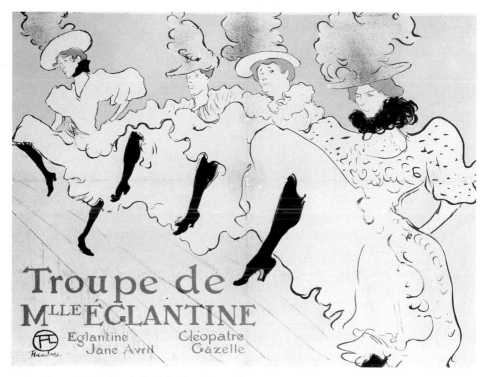

93 *La Troupe de Mademoiselle Eglantine,* 1895-96

In 1897 Jane went to London to feature in the troupe of 93
Mademoiselle Eglantine at the Palace Theatre and on 15 January
wrote to Lautrec from the Hôtel des Etrangers asking him to produce
a poster for her, giving the names of the other dancers and the
sequence in which they appeared, but leaving everything to his own
'good taste', and ending with a request for speed, adding, in English,
'please'. He sent her a sketch with the suggested colours marked in
handwriting – egg-yoke yellow, blue and red. Her clothes, her
gestures, and the characteristic hats, gloves and hair styles she affected
afforded him endless opportunities for compositional inventiveness.
In an oil sketch on cardboard in the Museum at Albi there is a picture 91
of her seen from behind (an approach much favoured by Lautrec) in
which the upper part of her body is a mere outline, whilst the hat
identifies her perfectly. Another sketch in the same medium omits the 92
details of the face completely but gives a remarkably vivid impression
of her stance when on the stage, the tilt of the shoulders, the position

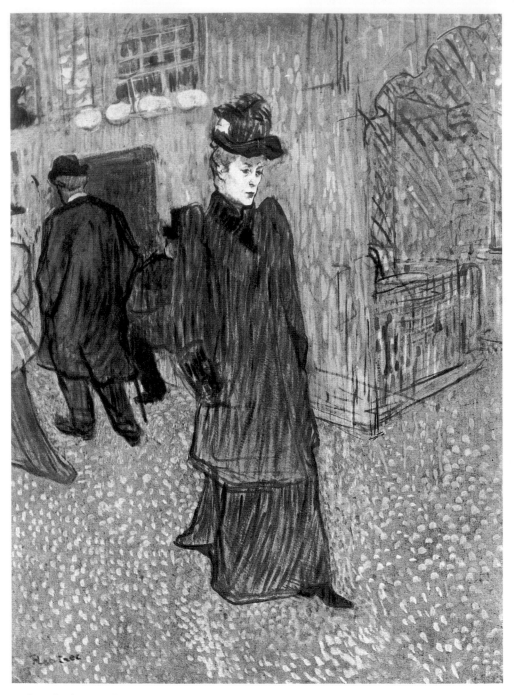

94 *Jane Avril sortant du Moulin Rouge*, 1892

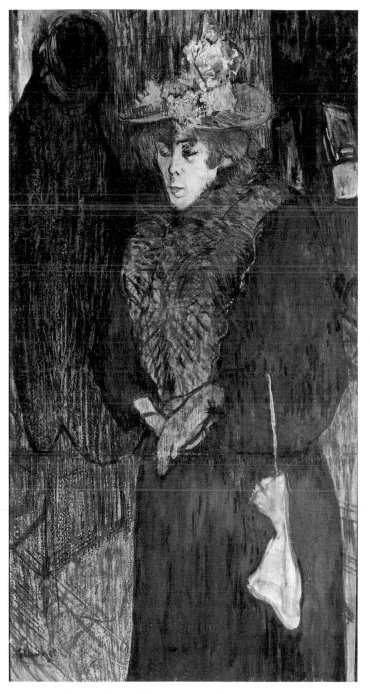

95 *Jane Avril entrant dans le Moulin Rouge*, 1892

of the arms, the movement of the legs and feet encased in shoes with bows, the whole composition in blue apart from a splash of yellow where her skirt meets her knees.

94,95 The extent to which Lautrec saw her as a person rather than as a stage-figure is suggested by two of his portraits of her. Both show her walking in her outdoor clothes, introspective, withdrawn, her eyes cast down. Both show her in the proximity of the Moulin Rouge, the one entering, the other leaving. In the first she is wearing a boa round her neck, her hands are clasped and a parasol hangs listlessly over her arm; in the other she is wearing a severe high-shouldered blue coat and a hat of matching colour, her arms are rigid by her side, the hands plunged into the low pockets of the coat; passers-by are going in the opposite direction as though abandoning her, and the look on her face is both melancholic and reflective, as if she were wondering how, only a short time before, she was displaying on the stage all that exuberance which earned for her the nickname of 'La Mélinite' (a form of dynamite).

The images of her that achieved the greatest renown, and that explain why an article in *L'Art Français* in July 1895 was headed 'Lautrec peintre de Jane Avril', were the posters he produced of her between 1892 and 1893. The first of these appeared on the hoardings on 20 January 1893, to advertise a small *café-concert* in the Rue des
96 Martyres called the Divan Japonais. Suitably embellished in mock bamboo with Japanese lanterns, it had been started by the poet Jehan Sarrazinand and attracted a literary clientèle, partly because of its décor, its waitresses dressed in kimonos and its blue and red billiard tables. Its star was Yvette Guilbert, the tall, thin, flat-chested singer with a harsh voice whose acidulous songs attracted a devoted following. She, too, was to play a significant part in Lautrec's iconography. Curiously enough, she could hardly be seen in this poster – for which he did several preliminary sketches. All that is visible of her is from the neck downwards, as she stands on the stage, her long arms, clad in her characteristic black gloves, crossed in front of her. The dominating image is that of Jane Avril, dressed in black, whilst behind her Edouard Dujardin reflectively taps his lips with his cane. The orchestra cuts across the image in a great yellowish-grey swathe, the necks of the instruments echoing, in some strange way, the minatory shape of le Désossé in the Moulin Rouge poster.

The same motif reappears in the poster Lautrec produced for Jane's
97 appearance at the Jardin de Paris later in the year. This time a single instrument, the cello, dominates, held by a hand, the hairs on the

126

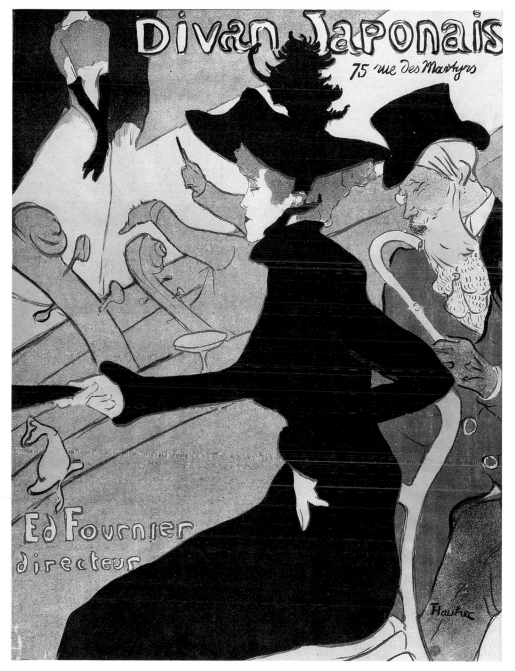

96 Poster for the Divan Japonais, 1892

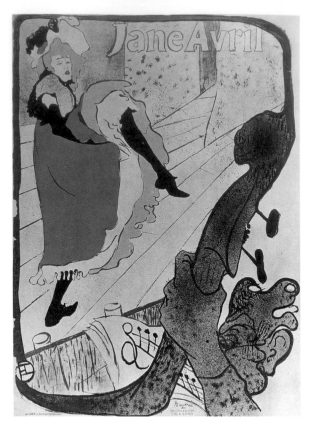

97 *Jane Avril au Jardin de Paris,*
1893

fingers clearly delineated; a fragment of a score can be seen, the clef
assuming a typically Lautrecian form. From the shoulder and the top
of the cello emerges a black line which circumscribes the dancing
figure of Jane Avril in a startling combination of yellow, orange, red
and black, applied with brush and spraying technique. The poster was
directly commissioned by Jane herself, with the approval of the
management; and in addition to the commercial edition, twenty
numbered impressions were printed on thick vellum paper and sold
by Kleinmann at 10 francs each. It became an established practice to
produce a limited signed edition of the lithographs and some of the
posters that he produced, upon vellum, Japanese or handmade paper,
usually in runs of fifty, though later there were some of as many as
98 three hundred and fifty. The cover of the Yvette Guilbert album of
1898 is one example, printed on handmade paper with satin clasps and
selling at 25 francs. (Some idea of the comparative value of money can

98 Cover for the 'Yvette Guilbert' album, 1898

be deduced from the fact that when Lautrec was living in the Rue Caulaincourt he paid 800 francs a month rent, and employed a live-in maid for 40 francs a month. Meal prices at the Chat Noir were 2 francs 50 centimes for lunch and 3 francs for dinner. The entrance fees to the Moulin Rouge, the Cirque Fernando and the Folies Bergère were 3 francs 50, and artists' models were paid 30 francs a week.)

Another image of Jane, distinct from her theatrical context, appeared on the cover of *L'Estampe Original* on 30 March 1893. This project was the brainchild of André Marty, art dealer and publisher, whose idea was to publish ten original graphics by 'the élite of today's young artists'. There were four issues a year, in an edition of one hundred, at an annual subscription of 150 francs, and amongst the artists included were Bonnard, Roussel and Maurice Denis. Lautrec's illustration for the first issue covered the front and back, and showed Jane Avril in a caped coat with a flamboyant black hat. She is looking

36

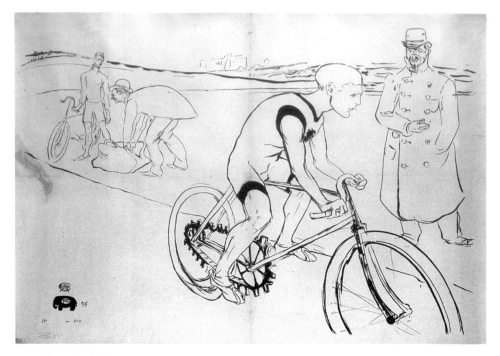

99 *Cycle Michael*, the poster Lautrec produced for the English bicycle firm Simpsons, 1896

at a proof which has just been pulled by Père Cotelle, the head printer of the firm of Edward Ancourt in the Faubourg Saint-Denis. He himself was famous, not only for the filthy smoking cap which he always wore, but also for his intimate knowledge of all the tricks of his trade, many of which he shared with Lautrec.

Closely linked with his personal interests was a poster he produced for an English firm. Ironically, for a period Lautrec became vitally interested in a sport for which, almost above all others, he was especially unsuited – cycling. Dunlop's invention of the rubber tyre had revolutionized the bicycle, which in Paris rapidly became both popular and chic. There were almost as many in the fashionable parades of the Bois de Boulogne as there were carriages, and characters such as the Prince de Sagan accompanied by Général de Gallifet, the Minister of War, in full dress uniform were regularly to be seen pedalling round the streets of the city. The various racing events, held in the several vélodromes that sprang up in the suburbs, were social events on the scale of Longchamps, and Lautrec became a frequent visitor. He had been initiated into the cult of the bicycle by

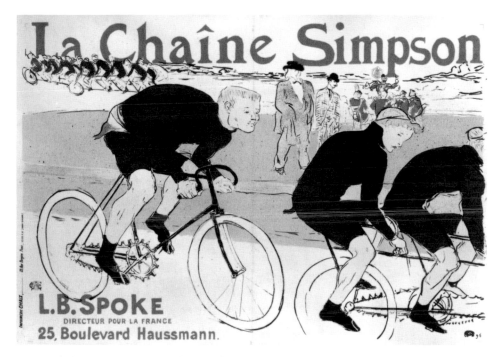

100 *La Chaîne Simpson*, the second poster for Simpsons, 1896

one of his most fascinating friends. Tristan Bernard (1866–1947) trained as a lawyer, became a businessman, then a journalist, poet, playwright and sporting impressario. A regular contributor to *La Revue Blanche* – for which his first article was entitled 'Du Symbole dans la Chanson du Café Concert' – he was also editor of *Le Journal des Vélocipédistes* and sporting-director of the two most famous racing tracks in Paris, the Vélodrome Buffalo and the Vélodrome de la Seine. In 1895 Lautrec painted a portrait of him standing in the Vélodrome Buffalo, solitary save for two cyclists tearing round in the distance, a plump, aggressive-looking little man, a bowler-hat perched on his head, clad in plus fours, his bushy beard at a rakish angle.

101

Another of his friends in this world was Louis Bouglé, the French representative of the English cycle firm Simpsons, who himself was interested in art. He succeeded in getting the firm to commission a poster from Lautrec and arranged for a trip to London. On his return, Lautrec wrote to his mother: 'I stayed there from Thursday till Monday. I was with a team of cyclists who've gone to the other side of the Channel. I spent three days out of doors and have come back

here to make a poster advertising "Simpson's Lever Chain", which may be destined to be a sensational success.' It wasn't, though he published it in an edition of two hundred. As a work of art it was fine, showing the Welsh rider Jimmy Michael, who always sucked a toothpick when in the saddle, cycling towards the right-hand side of the picture; he is watched by his trainer 'Choppy' Warburton, a particular crony of Lautrec's, and Frantz Riechel, a sports journalist. The technical details of the bicycle, however, were all wrong. Lautrec very rapidly produced another using the French cyclist Constant Huret, whilst in the background stand Louis Bouglé (who, as the poster indicates, used what he fondly thought of as the English name 'Spoke' in his business life) and the proud W.S. Simpson.

By now Lautrec had abandoned Montmartre for the more complex delights of central Paris, although he still lived at 24 Rue Caulaincourt, in one or other of the houses in which he was to maintain a studio until 1897. His places of entertainment were now in the Champs Elysées and in addition to the meretricious delights of the

101 *Tristan Bernard au Vélodrome Buffalo*, 1895

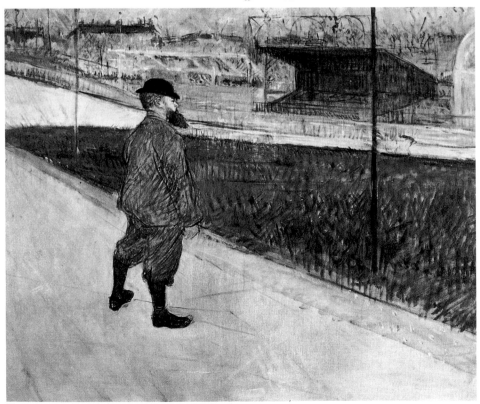

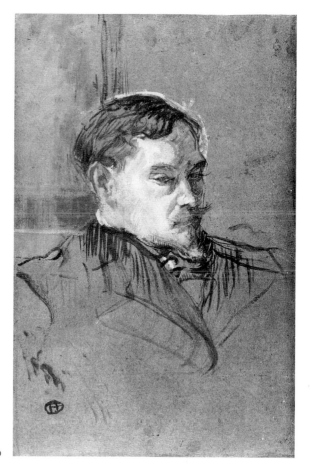

102 *Romain Coolus,* 1899

more famous *cafés-concerts* he became, under the guidance of a new
friend Romain Coolus (1868–1952), a member of the staff of *La Revue* 102
Blanche and an enthusiastic devotee of the theatre, a frequent visitor to
the Opéra, the Comédie Française, and the more adventurous Théâtre
Libre. He immediately started making lithographs of various scenes
and their players: Sarah Bernhardt in *Phèdre*, Madame Caron in *Faust* 103,104
at the Opéra, Leloir in *Les Femmes Savantes*, Bartet and Mounet-Sully
in *Antigone* at the Comédie.

The walls of friendship with which he surrounded himself were
constantly becoming more redoubtable, and one of their bastions was
all the more effective in that he was 'family'. This was Gabriel Tapié
de Céleyran, Lautrec's first cousin, who was even more intricately

133

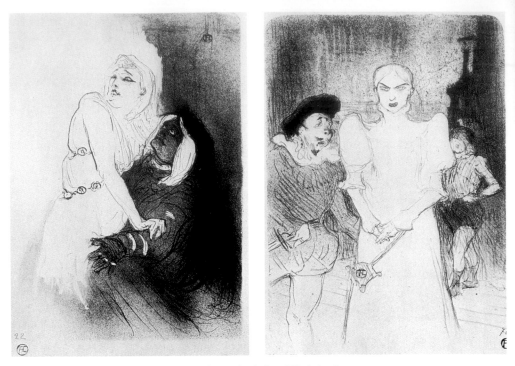

103 *A la Renaissance, Sarah Bernhardt dans 'Phedre',* 1893

104 *A l'Opéra, Madame Caron dans 'Faust',* 1893

linked into the family than the nominal relationship would seem to imply, since his mother was a sister of the artist's father, and his father a brother of the artist's mother. They had virtually grown up together, and the intimacy which was established then persisted throughout Lautrec's life. But it took on a new dimension in 1891 when Gabriel came to Paris and became an interne at the Hôpital Saint-Louis, under the celebrated surgeon Jules-Emile Péan (1830–1898). The cousins became almost inseparable companions in the nightly pilgrimage of pleasure, making what must have been a strange contrast: de Céleyran, some five years younger and more than a head taller, an ungainly figure with splay feet, an awkward gait and a small head, provided not only support and friendship, but a complaisant object for Lautrec's occasional outbreaks of bile. Paul Leclercq, the poet and a contributor to *La Revue Blanche*, in his book *Autour de Toulouse-Lautrec* (1954) about his friendship with the artist, recounted: 'Gabriel is his cousin's scapegoat. Lautrec is, in fact, deeply

109

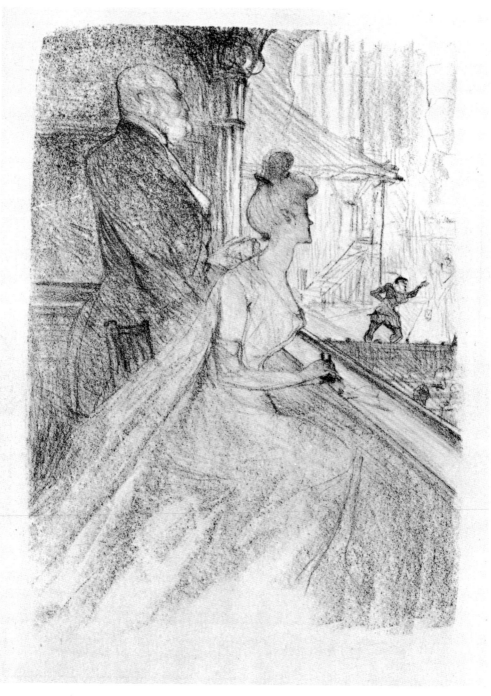

105 *La Loge, Thadée et Misia*, 1896

devoted to him, and wouldn't be without his company for anything, but frequently when the doctor dared to express an opinion displeasing to Lautrec, he would burst out into a sudden rage. On one occasion he snorted, "Well to begin with you've never noticed anything in your life, until it's been dragged to your attention." But the most deadly adjective he used to hurl at him was "incompetent", with a heavy accent on each syllable.'

De Céleyran appears constantly in Lautrec's work. He is the standing figure towering over the painter in the background of *Au Moulin Rouge*, in the rear of the poster for Ault and Wiborg (the American ink manufacturers), and in a large number of drawings now kept in the Museum at Albi. The most important of these works is the oil painting of 1894. Elegantly dressed, one hand in his pocket, his head reflectively bent, de Céleyran is shown in a corridor of the Comédie Française, his air that of a man looking for change. As with so many of Lautrec's paintings, the background is ill-defined, suggesting rather than describing the hurly-burly of theatre-goers during an interval. The elongated canvas tailored to match the emphatic, almost exaggerated length of the main figure, is suggestive of a portrait by El Greco.

Lautrec had already been in contact with the medical profession through Henri Bourges, with whom he had shared a flat in the Rue Fontaine shortly after he left the Greniers, and of whom he painted a portrait in his own studio (a background that he also used for portraits of Paul Sescau and another of his cousins, Louis Pascal) which is now in the Museum of Art of the Carnegie Institute. But his more intimate contact with de Céleyran promoted acquaintanceships of a more continuous and artistically rewarding type. These centred round de Céleyran's teacher Jules Péan, a surgeon described by Léon Daudet, another of his students, as 'a virtuoso of the knife, who amputates three legs and two arms in quick succession, dismantles a couple of shoulders, trepans five crania, takes out half a dozen wombs and cuts off a few testicles. He works like this for about two hours. He is dripping with blood and sweat. His feet stand in pools of blood.' Péan's fame was assured in a wider world when Henri Gervex, a leading Salon expert on the nude, produced the picture of the year in 1887 with his *Dr Péan à l'Hôpital Saint-Louis*, showing him lecturing a group of students over the naked body of a nubile patient. The combination of this event and de Céleyran's access to the great man prompted a flurry of interest from Lautrec, who attended several of his operations, sketchbook in hand, producing some forty-five

145

106

107

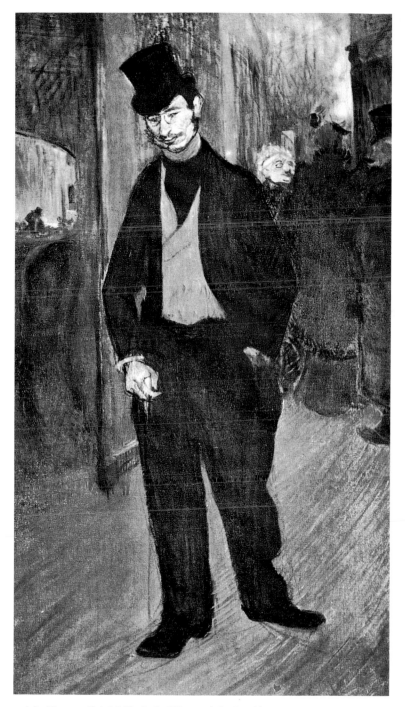

106 *Le Docteur Gabriel Tapie de Céleyran à la Comédie Française*, 1894

sketches in ink and pencil from which he distilled two paintings of Péan at work. The most dramatic and revealing of these has something of the fierce, agonized intensity of a Francis Bacon. Péan, with a napkin tied round his neck, leans intently over the patient, whose mouth seems to indicate a scream of agony, but whose face is otherwise obscured by an ether inhaler held by an assistant. The other painting gives an overall view of the operation taking place, with some dozen figures arranged around the operating table. Péan is seen from behind, recognizable not only by his shape, but also by his concession to antisepsis – the napkin tied around his neck. The sense of drama inherent in the other work is missing.

De Céleyran was assiduous in looking after Lautrec, even during his later periods of dementia, when he told his servant to refuse de Céleyran access because he was a 'spy'. Once he had qualified, de Céleyran lost interest in medicine as such and retired to his country estates, where he carried on research into the *phylloxera* disease that

107 *Monsieur le Docteur Bourges*, 1891

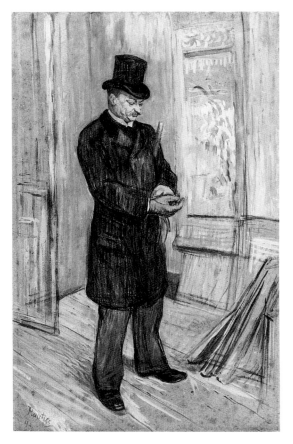

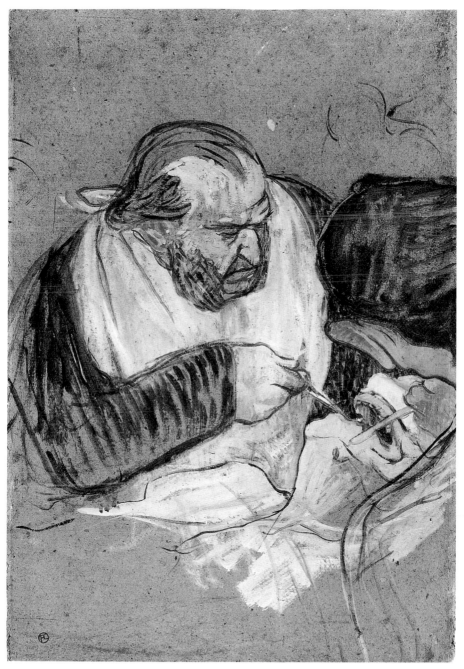

108 *Une Opération aux amygdales*, 1891

was ravaging the vines of France at that time. He remained loyally devoted to his cousin for the rest of his life, being responsible with Maurice Joyant for the foundation of the Toulouse-Lautrec Museum in the Palais de la Berbie – the Archbishop's Palace at Albi – to which he contributed his own important collection of the artist's works.

The range of Lautrec's friendships had always been fairly large, but by the early 1890s it had started to become even more extensive, and one of its main foci was *La Revue Blanche*. This had been founded in 1889 by Paul Leclercq, whose portrait Lautrec painted in 1897 in a composition which, though typical of his current style in its background, presents the sitter in a manner which very clearly indicates the debt he owed to Whistler by its use of black and the formalized posture of the figure. Leclercq described what it was like sitting for him:

109

> For a month or so I went regularly three or four times a week to the Avenue Frochot, though I also remember that I did not sit for more than three or four hours in all. As soon as I arrived he would ask me to sit in a large wicker arm chair while he, wearing the little black felt hat which he always kept on in the studio, would plant himself in front of the easel. Then he would stare intently at me through his spectacles, screw up his eyes, reach for a paintbrush and, after studying carefully what he had been looking at, place a few strokes of rather liquid paint on his canvas. While he was painting he remained silent, and, licking his lips, seemed as though he was relishing something with a particularly exquisite taste. Then he would start singing a bawdy song, the *Chanson de Forgeron*, put down his brush, and announce peremptorily, 'Enough work. The weather is too good', and off we would go for a walk around the *quartier*.

In 1891 the *Revue* was taken over by Thadée Natanson, whose home became for Lautrec very much what the Greniers' had been. The Natansons were of Polish origin, and very rich. Thadée, a large man in every way, known because of his splendid munificence as 'The Magnificent', together with his brothers Alexandre and Alfred, were not only lavish in their life-style but also perspicacious in their tastes. They helped and supported Mallarmé, Ibsen, Bonnard, Vuillard and Roussel; and amongst those to be found at their home in the Rue Saint-Florentin, or the office of the magazine in the Rue des Martyrs, were Signac, Renoir, Verlaine, Van Dongen, Sérusier and Proust, whose first published article appeared in its pages. The brothers were at the very heart of *fin-de-siècle* culture in Paris, and were always especially laudatory of Lautrec's work. Then there was Misia, whom

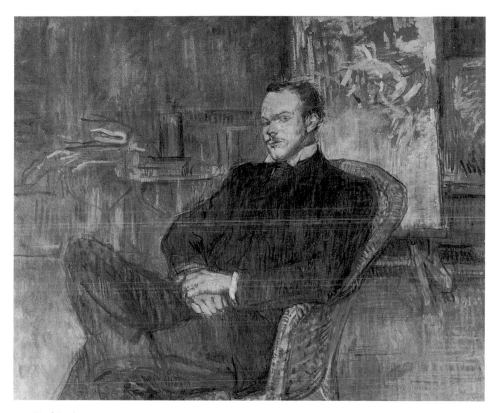

109 *Paul Leclercq*, 1897

Thadée had married when she was fifteen-and-a-half, and by whose beauty Lautrec was enthralled, recorded on a poster for the *Revue* in 1895. She soon afterwards abandoned Thadée for Alfred Edwards, the editor of *Le Matin*, who was also a close friend of Lautrec. Him she left for the Spanish painter Sert, and spent the rest of her life in luxurious obscurity. 75

The Natansons gave Lautrec much more than professional support and urban hospitality. They frequently invited him to their country home, first at Valvins and then at Villeneuve-sur-Yonne. Picnics, swimming excursions, long evenings listening to Misia playing the piano, country walks: these were idyllic intervals in his life. Perhaps one of the most memorable occasions was in 1897, after the funeral of Mallarmé (for whom the Natansons had bought a cottage at Valvins, and who was buried in the churchyard there), when amongst those

present in their house for the wake were Renoir, Vollard, the critic Octave Mirbeau, Maeterlinck, Vuillard, Bonnard, Roussel and Romain Coolus. Coolus was to be Lautrec's companion in his increasingly intense explorations of a world which he was to make especially his own, and which he was to record with a veracity and a skill unequalled by anyone else, even Degas: that of prostitution.

The position of the prostitute in nineteenth-century France was almost unique in that it attracted little of the odium that it incurred in most other European countries. A boy's first visit to a brothel was almost as momentous and significant as his first communion. During the school holidays brothels were so packed with adolescents that regular customers – perhaps clients would be a more discreet word – had to have their appointments cancelled. In the latter half of the nineteenth century it was estimated that, whereas London had some 24,000 prostitutes, Paris, with a population half its size, had 34,000; and these were just the professionals, to whose total must be added a small army of amateurs, estimated to number some 7,000 drawn from the ranks of waitresses, shop girls and laundresses (cf. p. 66). There was an annual directory of prostitutes, the *Guide Rose*, and some brothels were palatial establishments, catering for all tastes and all classes – rather like erotic department stores, with fixed prices. Maupassant describes one – in this case in a provincial town – where businessmen and other respectable types met to transact their affairs as in a café. The expansion of the prostitution industry in Paris, which made the name of the city a virtual synonym for sexual escapades, was clearly encouraged by its growing popularity as 'the capital of Europe', thanks in part at least to the number of international exhibitions that took place there in the second half of the century.

There was also, however, something peculiar to the ethos of the age which motivated the concern with prostitution so typical of the time. The idealization of woman as a thing of purity, even of inaccessibility, and the notion of romantic love which had been engendered by the poets, writers and moralists of the first half of the century, impelled men to use their wives for childbearing and domestic duties, other women for pleasure. Conversely this led to an enhancement of the prostitute's status. On a popular level this was expressed in the fame and popularity that attached to the *grandes horizontales*, who catered for the passions of the rich and powerful: women such as Cléo de Mèrode, Cora Pearl and Léonide Leblanc. On what might be called a higher level, the prostitute – whether gold-hearted or not – had become a heroine of French culture, celebrated in the works of Dumas

110 Caricature of Lautrec and Lily Grenier, 1888

Fils, Prosper Merimée, the Goncourts, Maupassant and Zola. One of Flaubert's heroes describes a brothel as 'the only place where I have been really happy'; and Pierre Loüys' *Aphrodite* was looked upon, in the words of Theodore Zeldin, as 'a breviary of prostitution'. (Published in 1896, it had sold 125,000 copies by 1904.)

Lautrec lived therefore in a milieu especially interested in prostitution, though this is not to say that his own motivations were of a purely theoretical kind. The myth of Vulcan, the crippled blacksmith famous for his erotic prowess, encapsulates the belief that people with a physical handicap often try to compensate for it with extensive sexual activity of a kind which Lautrec claimed for himself. Amongst his extant erotic drawings (many were presumably destroyed by his mother after his death) there is one surviving from his stay with the Greniers, showing Lily performing *fellatio* on him 110 whilst a delighted smile plays over his bespectacled face. This may well have been fantasy. He was frequently in the company of beautiful women such as Lily Grenier or Misia Natanson, whose imagined inaccessibility must have been especially distressing – he was sensitive to his ugliness, and aware of his apparent undesirability. Writing to his mother in January 1885, he advised her to 'wipe away a kiss as dirty as mine is', and later referred to himself as 'this horrible, abject creature'.

With prostitutes, there were no problems – no guilt, no sense of inadequacy. He was enraptured by their personalities, delighted by their bodies moving around naked, or nearly so, with a spontaneity unknown to professional models. So absorbed was he in this hidden life that to him, brothels became retreats, as monasteries to a monk. When he took Guibert to Bordeaux they stayed at a brothel, and in another, in the Rue d'Ambroise in Paris, he spent weeks at a time.

In 1894 this brothel was supplanted in Lautrec's affections by a more sumptuous establishment which had opened at 24 Rue des Moulins near the Bibliothèque Nationale. Magnificently furnished with antiques and bibelots, carved candlesticks, tapestries and mirrors, it had rooms to suit every taste, aesthetic or otherwise: a Chinese room, a great domed Moorish hall, a Gothic chamber, tastefully arranged with bundles of whips and other impedimenta for masochists. In this establishment, run by Madame Baron and her daughter Paulette (whom she passed off as her sister), Lautrec became

111

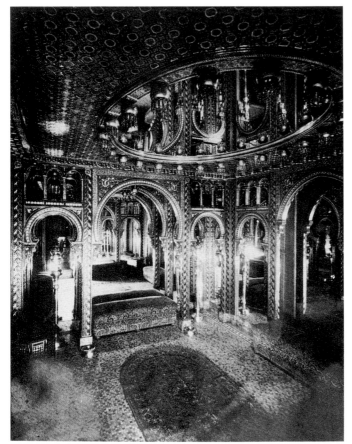

111 The Moorish hall in the brothel at 24 Rue des Moulins, 1890s

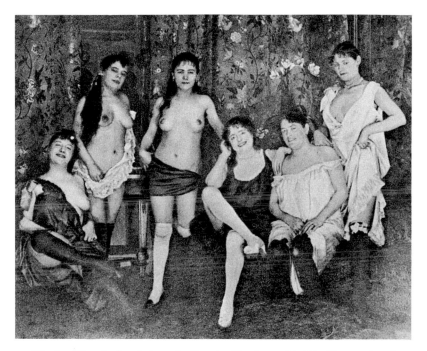

112 The 'staff' at the brothel on the Rue des Moulins, with Mireille seated at the far left. Photograph by François Gauzi.

a favoured lodger, known to its inmates as M. Henri, or sometimes – in tribute to his sexual prowess – as 'The Coffee Pot'. He brought them flowers and sweets, he played dice with them, he presided at table for their communal meals when all the customers were gone, and he worked the mechanical piano while they danced.

It was this brothel and its inhabitants which inspired a sequence of works that constitutes the height of Lautrec's creative achievement and presents an aspect of life in a way in which no other artist has ever surpassed. He produced more than forty paintings and drawings about its inhabitants. Not all of them are extant or traceable because of their overtly erotic nature, but those that are reveal, amongst other things, that basic anarchism which refused to subscribe to the accepted conventional view of prostitutes as an alienated segment of society. He painted and drew them as human beings, with no irony, no contempt, and at the same time with none of the sentimentality that

113 *Marcelle*, 1894

114 Edgar Degas, *Trois Prostituées au bordel, c.* 1879

115, 116 Emile Bernard, two plates from the album *Au Bordel*, 1888

117 Vittore Carpaccio,
Two Courtesans, c. 1495

other artists had used to ingratiate them in the eyes of the Salon-going
116 public. One of his own favourite pictures – he had a reproduction of it
117 pinned up in his studio – was Carpaccio's painting of two courtesans
(*c.* 1495), which shows two women sitting pensively on a balcony,
one playing with her dog, the other staring into space. This air of
quietude, of boredom almost, permeates many of his Rue des
Moulins works. Even in the most 'realistic', *La Rue des Moulins* of
1894, in which two not very young nor very attractive women stand
waiting for the legally obligatory medical examination of their
pudenda, holding their chemises up for easy access, there is no hint of
shame or embarrassment; they might well be queuing at the cash till
of a supermarket, caught up in the tedium of daily life with all its
boring routine.

120 The same year, Lautrec painted the famous *Au Salon de la rue des
Moulins*. This shows six girls, one of whom is seen from the back, and

148

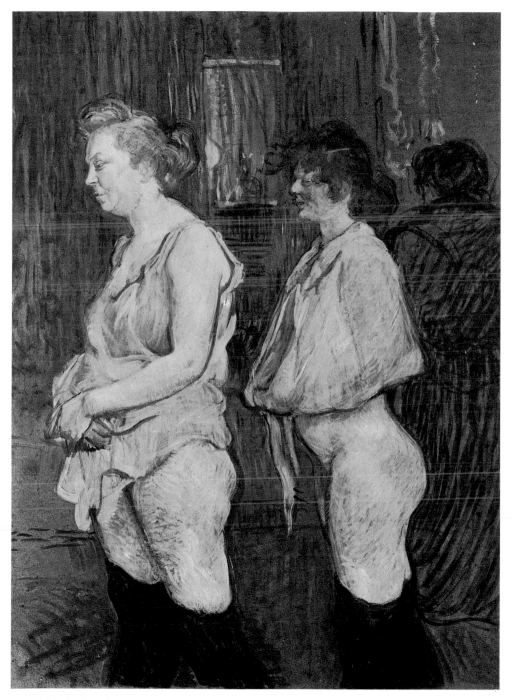

118 *La Rue des Moulins,* 1894

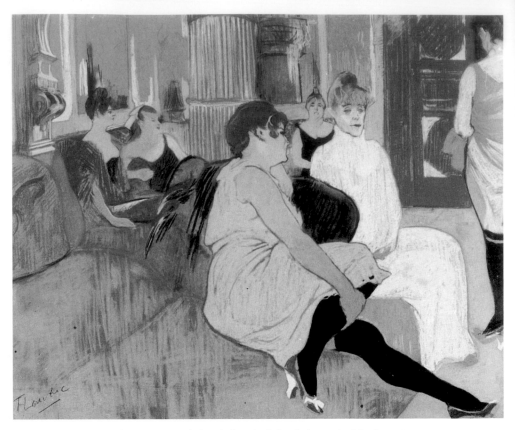

119 Preliminary pastel sketch for *Au Salon de la rue des Moulins*, 1894

cut off by the edge of the canvas in the manner that the Impressionists had learnt from the snap-shot and from Japanese prints. Madame Baron – looking remarkably like Jane Avril – sits primly, dressed in a frock of exceptional severity which comes virtually up to her chin.

112 Beside her on the settee sits Mireille, who had developed a special affection for Lautrec, her leg bent under her clasped by her left hand. The other three sit about in attitudes of bored expectancy in what is in reality a magnificent slave market, its great columns and Moorish arches shown in detail on the left but only roughly painted in on the

119 right. In a surviving preliminary pastel sketch for the painting, the whole of the background is painted in a very perfunctory manner, but the poses and counterpoint of the contrasting profiles, in a style

150

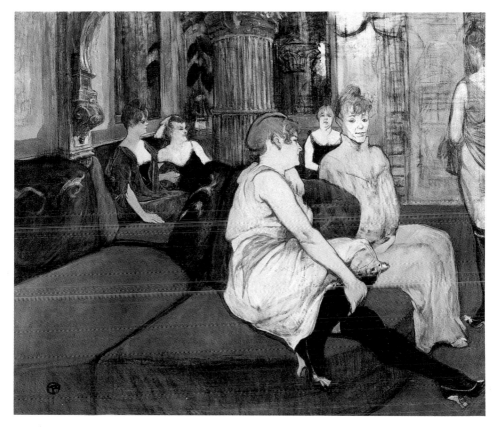

120 *Au Salon de la rue des Moulins*, 1894–95

reminiscent of Gauguin's treatment of the human face, are the same as
in the finished work. It was clearly painted in his studio, and various
elements derive from *Le Divan* of 1893, a study of the two women in
the left background and of the cut-off figure of the girl on the extreme
right.

From life in the brothel of the Rue des Moulins he built up a
repertory of imagery based on its day-to-day activities, of which he
was to make constant use: the laundryman with a grotesque mask-like 121
face delivering the laundry (it has been suggested, not implausibly,
that this represents the acting out of a sexual fantasy of the kind which,
according to Lautrec himself, many clients demanded); a girl pulling
up her stockings; two prostitutes with heavily made-up faces and

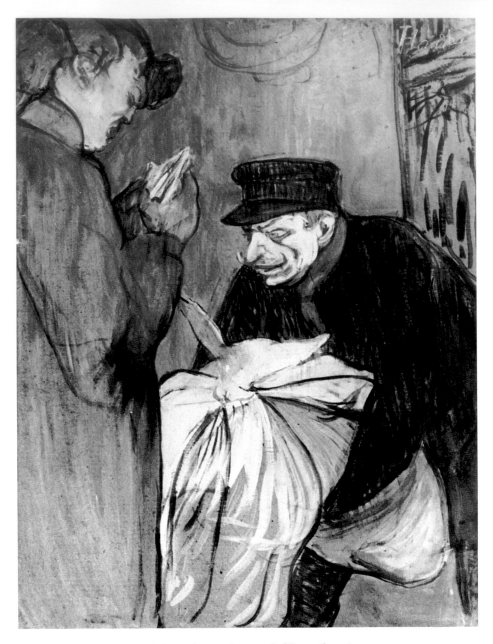

121 *Le Blanchisseur de la rue des Moulins avec la fille tourière*, 1894

122 *Ces Dames au réfectoire*, 1893

123 *Monsieur, madame et le chien*, 1893

124 Gustave Courbet, *Le Sommeil*, 1886

dressed in light-coloured gowns, playing cards in a desultory sort of
128 way on a brightly coloured red sofa; Rolande, known as 'Le Petit
Mac', with her recognizable turned-up nose, absent-mindedly
running her fingers through the hair of one of her colleagues on the
127 edge of a bed; and again, in bed, with one of her clients, her flared
nostrils seen from below in a characteristic Lautrecian pose.
Occasionally he would do straightforward portraits of the girls, such
113 as the tender profile of Marcelle with its technical virtuosity: the
carefully modelled, finely painted texture of the face, the freer, more
Degas-like handling of the hair, the open-necked dress, and the couch,
all set against the brown of the cardboard on which it is painted.

The theme of lesbianism, common enough in brothels, interested
him deeply. He once showed his friend, the etcher Charles Maurin, a
photograph of two women clinging together with the comment,
'This is better than anything else. Here is the very epitome of sensual
delight.' It was the subject of one of Lautrec's most moving works, *Les*

125 *Les Amies*, 1895

Amies, which shows two women recumbent on a divan, staring 125
tenderly into each other's eyes, in a composition with echoes of
Courbet's *Le Sommeil* (1886) and Velázquez' *Rokeby Venus* (1650) 124
which Lautrec must have seen in the National Gallery on one of his
many visits to London. There are two versions of another variation on 126
the same theme, one in the Tate Gallery, London, the other in the Albi
Museum, almost identically showing two women seated on a couch –
one huddled and semi-comatose, looking in fact as though she were
either ill or had just had an unpleasant experience, whilst the other
with her arm around her (very ineptly painted in the Albi version)
consoles her – in one version dominatingly, in the other tenderly.

The repertory of images that he acquired at 24 Rue des Moulins
was the basis for what has been described by Götz Adriani as 'one of
the highpoints of nineteenth-century art', a series of ten coloured
lithographs with a cover and frontispiece, titled *Elles*, produced in an 131
edition of one hundred numbered and signed impressions on

126 *Les Deux Amies*, 1894

127 *Au Lit*, 1894

128 *Le Divan, Rolande*, 1894

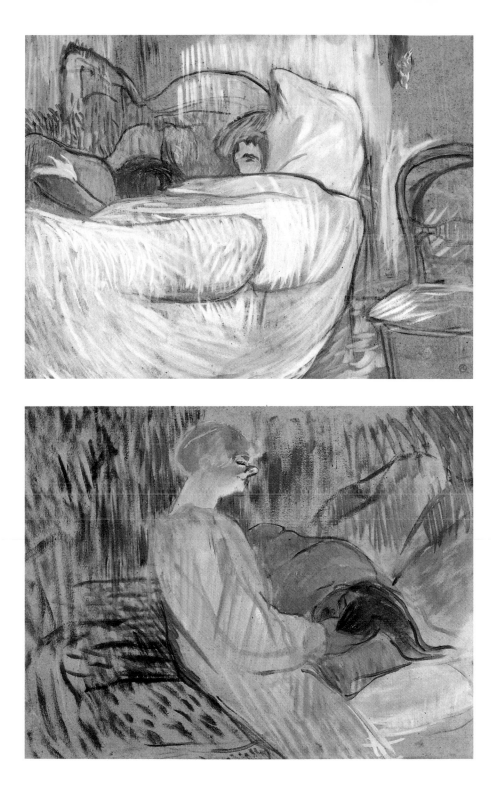

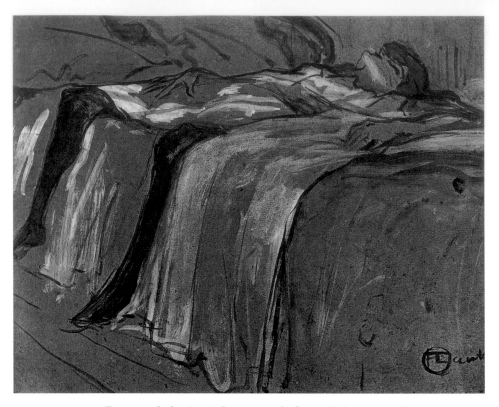

129 *Femme sur le dos, Lassitude*, 1896, study for tenth sheet in the *Elles* series

handmade Japanese paper, which sold – not at all successfully – at the very reasonable price of 300 francs for the whole portfolio. They were published by Gustave Pellet, whose mother had invented the elastic corset, and who had set himself up first as a bookseller, and then as a publisher in an old stable on the Quai Voltaire. Eventually the lack of success of the album – despite the efforts of Ambroise Vollard, who later took them over – led to the sheets being sold individually.

130 *Elles* was a remarkable record of the intimacies and daily life of women – filling baths, peering disconsolately into hand mirrors, doing up their hair in a room where the male presence is indicated by a top hat, tying their corsets under the satisfied gaze of a dandified client, or being served breakfast in bed by an indulgent Madame. Then there are occasional images of pure sensuality, such as that of a
129 naked girl lying stretched out lazily on a bed. The most popular of all,

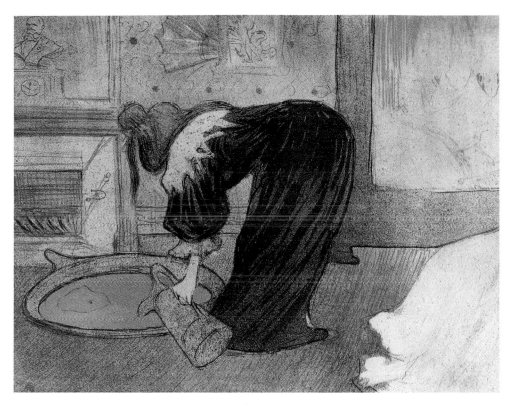

130 *Femme au tub*, 1896, fourth sheet in the *Elles* series

however, and the one which sold most copies when the portfolio was
broken up, was *La Clownesse Assise*, showing the *soi-disante* Cha-U-
Kao, one of the stars of the Nouveau Cirque, sitting with her legs
wide apart, staring into space. He had already painted other portraits
of her, the most famous being bought (at a higher price than had ever
been given for one of his paintings) by King Milan of Serbia, before
finding its way into the collection of Oscar Reinhart at Winterthur.

132

OVERLEAF

131 Frontispiece for *Elles*, 1896

132 *La Clownesse Assise, Mademoiselle
Cha-U-Kao*, 1896

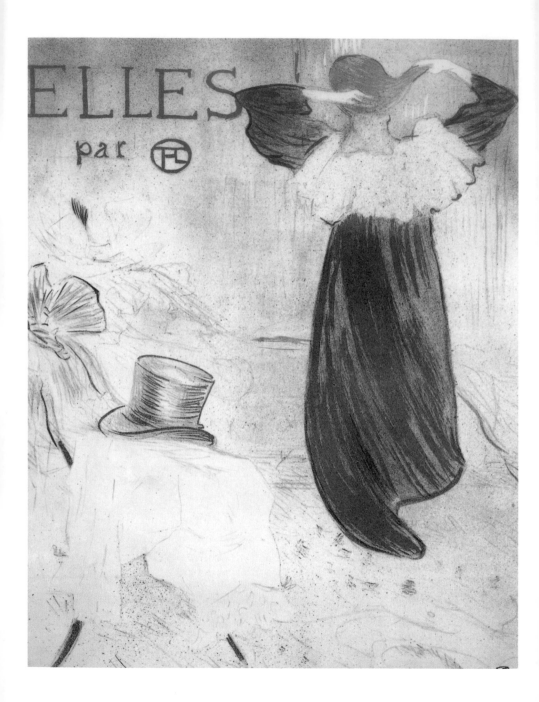

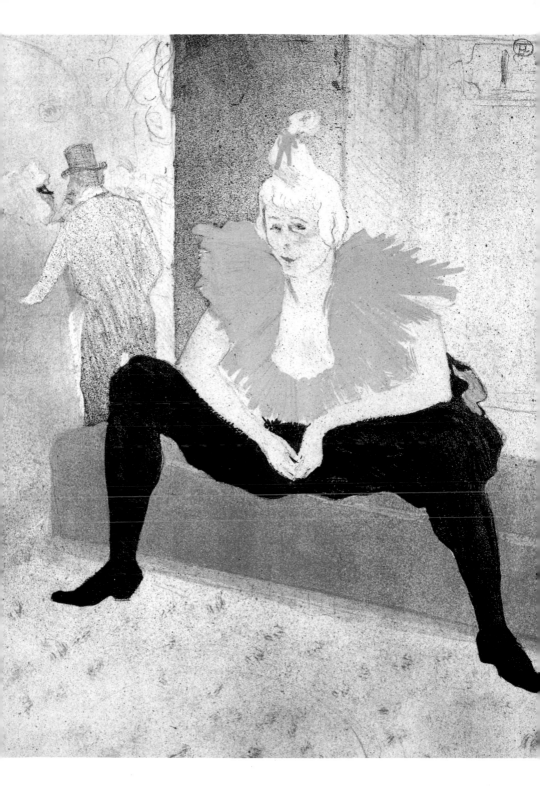

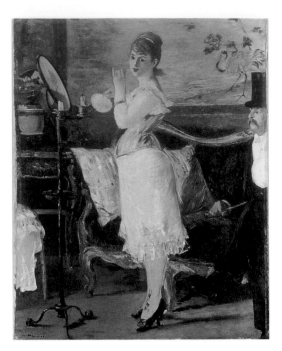

133 Edouard Manet, *Nana*, 1876–77

134 *Nu devant une glace*, 1897

135 *La Conquête de passage*, 1896

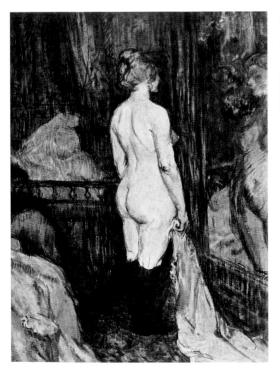

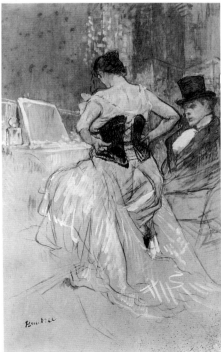

Shadows of Impressionism

The world of contemporary life that Lautrec almost exclusively inhabited – of bars, cafés and theatres, dancers, prostitutes and shop-girls – had once been the province of the Impressionists, who were the first to exploit the city's seamier side as suitable subject-matter for the attention of the artist. His relationship with the Impressionists had always been a rather complex one, at its simplest in the 1880s when he was directly influenced by Manet, by Pissarro and, of course, by Degas, who was to be a constant source of technical and iconographic inspiration to him.

His respect for Manet was continuous, and is most poignantly recorded in the fact that in the 1890s he paid regular visits, laden with gifts, to an ageing street performer living in the Rue de Douai, whom he described as being 'more famous than the President of the Republic'. She was Victorine Meurent who, some forty years before, had posed for Manet's *Olympia* which, together with the *Déjeuner sur l'herbe*, was one of his early ventures into that world of contemporary life. Lautrec and Manet shared an interest in the theatre and in the racecourse; they painted portraits in which a genre element indicated the personality and character, as can be seen in Manet's *Zola* (1857) and *Portrait de Theodore Duret* (1868), for instance, and in Lautrec's *Maxime Dethomas au bal de l'Opéra* (1896) and *Maurice Joyant* (1900). 166 Both artists held in common a preoccupation with the world of women, which is reflected, for example, in the way in which Manet's *Nana* of 1887 is echoed in Lautrec's *Nu devant une glace* and *La Conquête* 133,134 *de passage*. Manet tended on the whole to be flattering, Lautrec 135 dispassionate, and only occasionally cruel.

The closest affinities between the two are evident in the pastels which Manet produced towards the end of his life, when the encroachment of his fatal illness precluded him from the physical labour of painting in oils. The portraits of Irma Brunner of 1880 and of Méry Laurent, entitled *L'Automne*, along with a pastel version now in a private collection in Paris, clearly had a marked influence on Lautrec (who must have seen them at the Manet retrospective

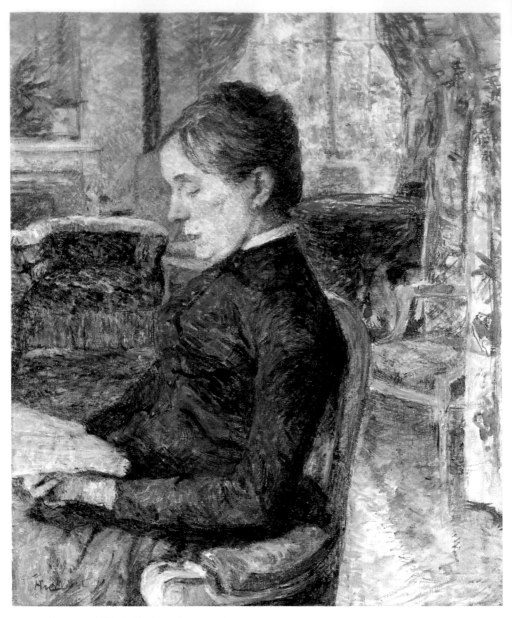

136 *La Comtesse Adèle de Toulouse-Lautrec*, 1887

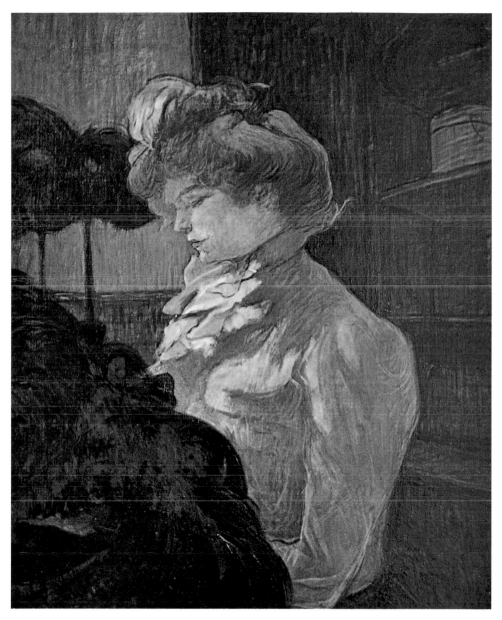

137 *La Modiste,* 1900

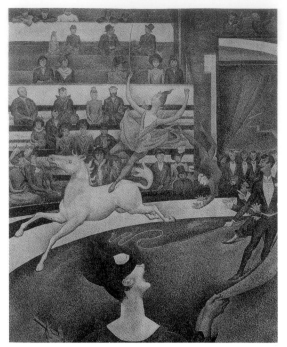

138 Georges Seurat, *Le Cirque*, 1890–91

139 *Au Cirque Fernando: L'Equestrienne*, 1888

exhibition in the Ecole des Beaux-Arts held in 1884), especially in their simplified colour areas and their dramatic use of profile.

25 Manet's technical influence is seen at its sharpest in some of the early portraits, such as that of the young Routy painted in 1882 with its light, sketchy brushwork, expressive blacks and its strong reminiscence of the facture of Frans Hals. Both painters had a first-hand experience of Hals' work, based in Manet's case on several visits made to his wife's native country, in Lautrec's on an excursion to Haarlem made with his friend Maxime Dethomas, a stage designer, in 1897. Even when he had largely abandoned the influence of Manet in his figure paintings, this brushwork persisted in the backgrounds of

137 works such as the *M. Boileau au café* (1893) and *La Modiste* (1900).

 In very much the same way the influence of Pissarro, who had evolved an easily understandable syntax of Impressionist techniques and doctrines, and even that of Monet, which is seen at its most

136 emphatic in Lautrec's portrait of his mother painted in 1887, persisted in a diluted form throughout most of his subsequent work, struggling against the wider formal simplifications and more emphatic use of colour that had filtered through from his graphic work into his

166

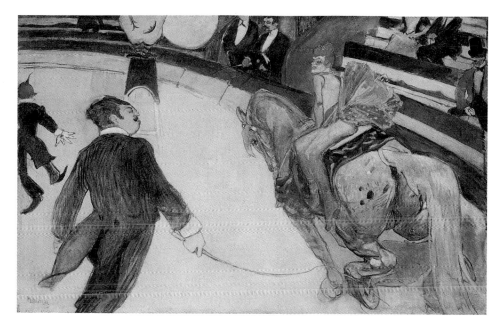

painting. But it was precisely in the year in which he painted this that
he made his most decisive break with the general Impressionist idiom,
a break which was signalized by *Au Cirque Fernando: L'Equestrienne*, 139
painted the following year (the first of several works he was to devote
to the circus, a subject which had fascinated him since early visits with
his father). To catch such a scene as this, and to express its sense of
movement, a technique less meticulous than that of Impressionism
was necessary and a new pictorial grammar had to be evolved. Some
of his contemporaries, Seurat for instance, whose *Le Cirque* (1890) 138
makes an instructive comparison with his own, were preoccupied
with precisely the same problem, and in the *Cirque Fernando* Lautrec
grappled seriously for the first time with resolving the incompatabi-
lity between his newly found desire to create a flat design of the type
that the Japanese had perfected, and the necessity to achieve at least a
nominal sense of visual reality. Douglas Cooper commented
perceptively on this picture:

The pictorial space is limited by the curving balustrade of the ring, which
divides the picture roughly in half, and the effect of depth is further reduced
by looking down on the ring, the plane of which thus rises up to the surface of
the canvas. The whole action therefore appears flattened, and this effect is
heightened by the fact that the distance separating the ring master from the

140 *Monsieur Désiré Dihau, Basson de l'Opéra*, 1890

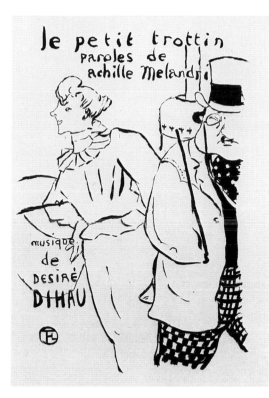

141 *'Le Petit Trottin'*, title page for a
score by Dihau, 1893

two performing clowns is not precisely indicated, and by the exaggerated
foreshortening in the drawing of the cantering horse. As a result all the
performers appear to be roughly on the same plane.

If Lautrec owed some of this compositional know-how to the
Japanese, the extent to which he was indebted to Degas for this and
much more was considerable. Degas was the one living artist for
whom he had the greatest regard and the greatest affection – neither of
which, it might be said, was reciprocated. They first met in the house
of the musician Désiré Dihau (1835–1909), who was a bassoonist at the
Opéra, composed music for the Chat Noir (Lautrec made litho-
graphic title pages for his scores) and was a distant cousin of the
painter. Dihau was the central figure in Degas' *L'Orchestre de l'Opéra*
(1868–69), and Lautrec painted a portrait of him twenty years later
seated, reading a paper, seen in three-quarter profile, in the garden of
the house of Père Forest, where he often painted. This painting was
exhibited in 1890 at an exhibition in the Cercle Artistique et Littéraire,

141

142 Edgar Degas, *Mademoiselle Dihau au piano*, 1869–72

143 Vincent van Gogh, *Marguerite Gachet au piano*, 1890

and later that year at the fifth Salon des Indépendants. The Dihaus had a number of paintings by Degas including one of their daughter Marie playing the piano (1869–72); in 1890 Lautrec decided to paint a riposte to this, showing her in profile, but with the Degas portrait clearly visible in the background. The painting was exhibited at the sixth exhibition of the Salon des Indépendants, and Théo van Gogh, in a letter to his brother which commented on the exhibition, noted: 'From Lautrec there is a very good portrait of a woman playing a piano.' Vincent, when he saw the painting, wrote back to Théo saying, 'Lautrec's picture, the portrait of a musician, is amazing. I was very moved by it.' How moved can be seen from Van Gogh's own portrait of Marguerite Gachet playing the piano, painted in the same year, in which the analogies with Lautrec's work are obvious.

The meeting between Degas and Lautrec led to no further intimacy; the older man could be notoriously antisocial when so

144 *Mademoiselle Dihau au piano*, 1890

inclined, and he clearly felt little or no affinity with Lautrec, whom he might even have seen as an inept disciple – there can be no doubt that Lautrec wanted to be treated as a follower. In September 1891 he wrote to his mother, 'Degas has encouraged me by saying my work this summer wasn't at all bad' – a remark embedded in information that his studio had been swept and cleaned, and that thanks to the application of 'populeum ointment' his piles were much better. Degas visited the exhibition that Lautrec shared with Charles Maurin at the Goupil Gallery in 1893, and later told a friend, 'Buy Maurin. Lautrec is certainly talented, but he is too closely linked to his own time; he will become the Gavarni of our age. For me there are only two painters, Ingres and Maurin.' More viciously, he is reported to have said to Suzanne Valadon, 'He wears my clothes, but they are cut down to his size'; and fifteen years after Lautrec's death, Degas said of the Rue des Moulins paintings, 'They stink of syphilis.'

The 'clothes' which Lautrec borrowed from Degas are obvious enough: his subject-matter – women at work and play portrayed in their intimate activities, the theatre, dancing, audiences at spectacles, and café and street life – and his style. Technically Lautrec owed much to Degas. Some of the more obvious debts are the cropping of images and their interaction with the edge of the canvas, board or paper, the snapshot-like presentation of subjects, the use of lighting from below to emphasize the compositional significance of a figure or object – the mask-like face of a girl to the lower right of the picture in *Au* 145 *Moulin Rouge* of 1892, for instance – and the manipulation of abruptly receding diagonal lines to give an illusion of depth.

But having recognized these and other similarities, the differences remain and are revealingly significant. Lautrec preferred the Moulin Rouge to the Opéra, the cabaret to the theatre; he put a heavy emphasis on the importance of individual 'stars', such as La Goulue, Jane Avril and Yvette Guilbert, and their personalities, whereas the very titles of his paintings confer on Degas' characters a degree of anonymity, even when they are his friends. What is virtually a portrait of Dihau becomes *L'Orchestre de l'Opéra*; Ludovic Halévy and Albert Cave pictured talking to each other in 1879 is described as *Les Amis du théâtre*. When he portrays one of the most popular *chansonnières* of her time, Thérésa, in 1876, the painting is entitled *La Chanson du chien*. Lautrec's whole artistic output on the other hand is studded with the names of the people who figure in his works. Degas used human beings as elements in the presentation of a purely pictorial image from which all allusions to individuality and personal identity

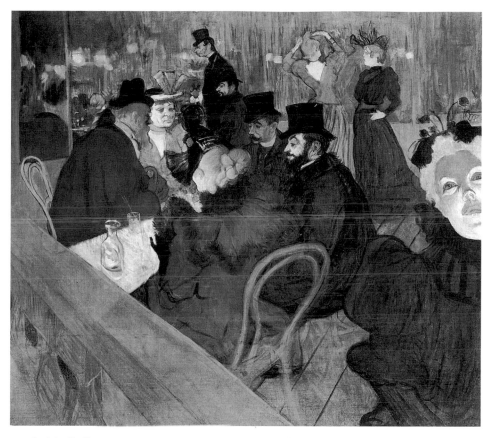

145 *Au Moulin Rouge*, 1892

have been expunged. This is quite different from Lautrec's approach, which not only emphasizes the 'feeling' of the person he portrays, but does so pictorially even to the point of caricature. This had been apparent from his earliest days at Cormon's. Describing his work there, François Gauzi wrote:

At Cormon's studio he wrestled with the problem of making an accurate drawing from a model; but in spite of himself he would exaggerate certain typical details, or even the general character of the figure, so that he was apt to distort without even trying or wanting to. I have known him deliberately 'try to make something pretty', even a portrait for which he was being paid, without ever being able, in my opinion, to bring it off. The first drawings and painting he did after leaving Cormon's were always from nature.

173

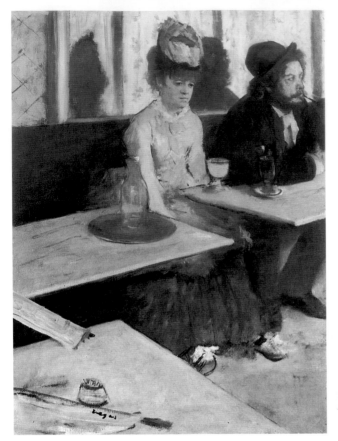

146 Edgar Degas,
L'Absinthe, 1876

147 *A la mie*, 1891

A comparison of two almost identical subjects painted by Degas and Lautrec strikingly reveal the differences between them. In
146 *L'Absinthe*, which Degas painted in 1876, the actress Ellen Andrée and Degas' great friend Marcellin Desboutin are shown seated at a table in the Nouvelle Athènes with drinks in front of them, crowded into the right-hand side of the picture. They are ruminant, impassive, virtually unaware of each other; indeed forty-five years after its execution Ellen Andrée, remembering the event, noted: 'we sat there looking like stuffed sausages'. When in 1891 Lautrec chose to depict a scene that, apart from some minor accessories, was almost ident-
147 ical, the result was totally different. *A la mie* shows Lautrec's friend Maurice Guibert (of whom he had made some twenty drawings and caricatures), seated at a table with an unknown and not very attractive

174

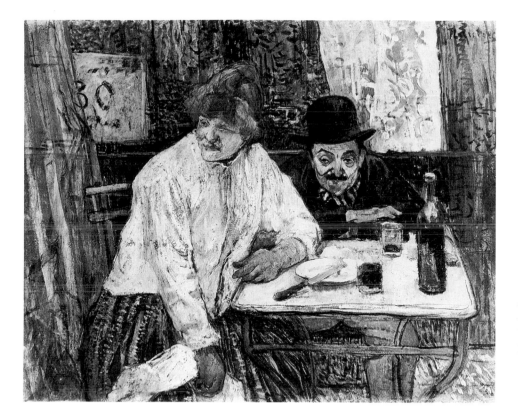

female model. Wearing a hat similar to that worn by Desboutin in the
Degas painting, he looks at once both cynical and sinister. Leaning
heavily on the table, his jowls unshaven, his eyes bitterly critical, he is
watching the same scene or incident that has attracted the attention of
his companion who, clutching a used napkin, allows a look of partly
amused contempt to play over her features. Lautrec was always
concerned, as Degas was not, with feeling and the observation of
character, to achieve which he exaggerated forms, using colour more
to express than to define. In this he came close, though in different
ways, to both Van Gogh and Gauguin, who were together at the
forefront of the reactions against the strictly perceptual preoccu-
pations of the Impressionists.

It was perhaps understandable, in view of his own leanings, that
Cézanne, when asked his opinion about Degas, should have replied, 'I
prefer Lautrec.' On the other hand, Lautrec never abandoned that
concern with Realism which had been an important strand in the

Impressionist approach; unlike, say, Bonnard or Vuillard he never used colour for purely decorative effects alone, even in the backgrounds, where his affinities to the Nabis are most apparent. In *A la toilette* of 1898, for instance, the mosaicized background is beautifully attuned to the auburn hair of the sitter, whilst the accessories, the jar and mirror on the dressing table, the carafes on the shelf behind, echo the pale blues of her dress. The overall effect, however, is one of melancholy accentuated by the heavy downward brush strokes, the almost completely hidden face. The title of the work, despite the beauty of the colour, could well be '*Vanitas vanitatum et omnia sunt vanitas*'.

Appreciation of his paintings increased as the century drew to its close. Joyant acted as an enthusiastic and skilled agent. In 1892 he sold *La Goulue entrant dans le Moulin Rouge* to Charles Zidler, one of the owners of that establishment, for 400 francs, and *Au Moulin Rouge* to a collector named Dupuis, who had been one of the firm's most enlightened customers, but who committed suicide shortly afterwards. The brilliant Camondo (cf. p. 118), who left his collection to the Louvre when he died in 1908, had been one of the earliest to buy Lautrec's paintings, as was Renoir's patron Paul Gallimard, whose son Paul founded the famous publishing firm. An increasing number of dealers started to become interested too. Durand-Ruel included his works in his stock and was to organize the first retrospective exhibition in 1902. Eugène Blot, who started as a collector and later became a dealer, bought some of his paintings and promoted them in his gallery. Bernheim Jeune took some works on sale or return, but did not promote them until after the artist's death.

His frequent appearances at the exhibitions of Les XX and its successor, the Libre Esthétique at Brussels, did much to enhance his reputation, for they were recognized as including all that was most vital in contemporary painting. They did not, however, bring him direct sales; the only one recorded is of a portrait – possibly of Dihau – in 1892. The sole exhibition of his paintings and prints held in London was at Goupil's in Regent Street in 1898. It had been the assiduous Joyant who had arranged the exhibition, which consisted of seventy-eight works. Goupils was a branch of Boussod Valadon, where Van Gogh had once worked, and it usually specialized in safer works by artists such as Corot, Millet and the Dutchmen Mauve and the brothers Maris. The English critics were mixed in their reactions. Major publications such as *The Times* and the *Daily Telegraph* preserved a deathly silence; others tended to deplore the viciousness,

vulgarity and the lack of 'moral beauty' displayed in his work. On the other hand nearly all praised his technique. *The Morning Leader* observed, 'Everything that the modern society portraitist insists upon with such affection Lautrec avoids. He presents to us facts which are unattractive; compositions which are sometimes excessively singular, but nothing which lacks character', and added somewhat coyly: 'Whatever the profession of his models may have been, M. Lautrec seems to have studied it at very close quarters.' *The Standard* was the most enthusiastic and the most percipient. It pointed out that 'M. Lautrec is preeminently a modern artist, who is both bold and extremely skilful. He is known chiefly as a master of poster-art, but his straightforward work deserves to be better known. He is a sharp and pitiless observer of life, who rarely finds beauty in the human form he depicts, but does so much more frequently in the colour harmonies which he observes or invents.' On 13 May *The British Architect* commented, 'The exhibition of portraits and other works by M. Henri de Toulouse-Lautrec at the Goupil Gallery in Regent Street must surely be a little exasperating for an English critic. It displays at the same time such refinement and such vulgarity, marvellously exquisite colours and such vulgar faces, absolutely marvellous draughtsmanship and such grotesque poses. Without doubt, if this exhibition does nothing else it shows at once the best and the worst of French painting methods.' On 24 May *The Echo* concluded a rather similar criticism with a few comments on his penchant for Montmartre, followed by the final, damning indictment: 'In stature he is very small and he affects a Bohemian sort of dress so pronounced that it verges on sheer untidiness.' *The Lady's Pictorial* waited until 11 June before making its comment, 'The Lautrec exhibition is over. What a relief!'

Lautrec was not represented at the famous Post-Impressionist exhibition organized by Clive Bell and Roger Fry in 1910, and it was not until the 1920s that English collectors such as Samuel Courtauld became seriously interested in his works, though by then they were fetching sums in the region of £8,000.

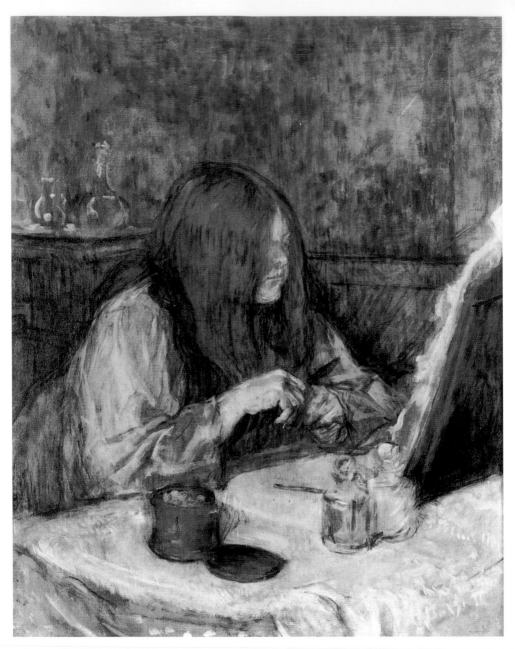

148 *A la toilette, Madame Poupoule*, 1898

The end of suffering

A fairly peripatetic pattern had asserted itself in Lautrec's life by the 1890s. There were annual trips to Brussels, which sometimes took in Holland, from where in 1894 he wrote to his mother,

For three days we've been in the midst of Dutchmen who hardly understand a word you say. Fortunately the little English I know and pantomime gets us along. We're in Amsterdam, which is an extraordinary city, the Venice of the North, because it's built on piles. We're travelling Baedeker in hand among the wonders of the Dutch masters, which are a mere nothing compared with nature, which is unbelievable. The amount of beer we're drinking is incalculable, and no less incalculable is the kindness of Anquetin . . . It's useless to list for you the beautiful things I've seen, with an experience of art acquired little by little, which means that I have had a fine eight day lesson with Professors Rembrandt, Hals etc.

In 1895 he set off on a boat cruise from Le Havre with Maurice Guibert, in the course of which he became passionately interested in the wife of a colonial officer on his way to Senegal travelling in cabin 54. He took a photograph of her sitting in a deckchair, made sketches of her (one is in the Museum at Albi) and an overall study, which was the basis of a lithograph used as an advertisement in the avant-garde magazine *La Plume* for one of the exhibitions it sponsored on the premises of the Salon des Cents, at 31 Rue Bonaparte. When the boat reached Bordeaux, their original destination, Lautrec insisted on their accompanying the couple to Dakar, but was eventually persuaded to disembark at Lisbon. From there they went to Madrid which, despite the attractions of the Prado, he didn't very much like. Toledo he found preferable, largely because of the El Grecos. He returned again to Spain the following year, despite his initial reactions, this time with his friend Louis Fabre, who owned the Villa Bagatelle at Taussat, where Lautrec liked to stay on one or other of his intermittent escapes from the ardours of Parisian life. At San Sebastian they saw a bullfight, visited Burgos to see the cathedral and two monasteries,

149
150

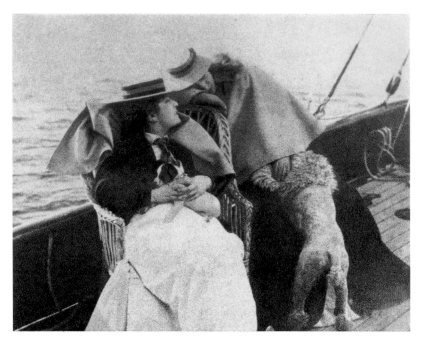

149 The wife of a colonial officer, travelling on a cruise with Lautrec in 1895

stayed at the Grand Hôtel de la Paix in Madrid, again visited Toledo, and returned to Paris by sleeper.

His life in Paris was broken by excursions not only to Taussat but also to the Natansons', to Rouen, Le Havre, Arcachon (where he sometimes rented a villa with Guibert), and of course to Albi. He always aroused a certain amount of interest amongst his fellow travellers because of his stature, in addition to which there was his sausage-shaped case of considerable length but very reduced height, which he had made because he could not carry a normal-sized portmanteau.

In 1892 he had spent ten days in London, and made further visits of about a week each in 1894, 1895 and 1898. Apart from friends such as Conder, one of his English contacts was Lionel Sackville-West, second Baron Sackville, who had been British Ambassador in Paris from 1872 until 1878, where he had been friendly with Comte Alphonse; but who, having made a grievous diplomatic blunder when he was Ambassador in Washington, was now living in

150 *La Passagère du 54, Promenade en yacht*, 1895

crotchety retirement, dividing his time between Knole and his London clubs. Then there was Whistler, whose work Lautrec greatly admired, and whose influence can be seen in several of his portraits, notably that of the poet Georges-Henri Manuel (1898), and with whom he had visited Brussels for the XX exhibition in 1888. During Lautrec's visit to London in 1895, Whistler took him to a gastronomically unsuccessful dinner at the Café Royal, along with Joyant, and Lautrec riposted with a gourmet-type English meal at the Criterion Restaurant.

Lautrec usually stayed in the Charing Cross Hotel, from where he had once written to his mother in 1892: 'I'm already in the grip of the spell arising from the London hustle and bustle. Everybody wrapped up in his business and nobody – either man or beast – letting out a useless cry or word. The hansom cabs here have an air that would put many carriages to shame.' His manner of brisk normality – so often assumed in letters to his mother, whom he was always anxious to impress with his good behaviour – was especially interesting in this context because his friends, *mirabile dictu*, used to persuade him to go to London in the hope of weakening his growing dependence on alcohol. This was based on an assumption verbalized by Joyant: 'In this country, where drunkenness is a sad ritual, which has to be achieved with a certain ritualistic propriety, Lautrec, paradoxically enough, used to stop drinking.' This seems to have been an overoptimistic observation. At the private view of his exhibition at Goupil's in 1898, Lautrec sat asleep in a chair throughout the whole proceedings. This despite the fact that it was an impressive social occasion, graced by the presence of the Prince of Wales, whose attendance was prompted no doubt by the fact that the exhibition contained portraits of Jane Avril and others of his Parisian friends.

Towards the end of the 1890s, many of his trips and excursions abroad were suggested by his friends in foolhardy attempts to reduce his consumption of alcohol, the effects of which were beginning to be all too apparent. The Natansons removed hard spirits from their country house, for instance, when he came to stay with them, and Joyant was especially active in devising all kinds of possible remedies. One of these was the suggestion that Lautrec should illustrate Edmond de Goncourt's novel *La Fille Eliza* (1877), but all that emerged from this exercise was some sixteen chalk and watercolour drawings in Joyant's copy of the book and a copy of Utamaro's *Pillow Book* which he acquired from Edmond de Goncourt, and which had an undeniable influence on *Elles* (cf. p. 155).

151 Horseguard, drawn by Lautrec during one of his last
visits to London with Joyant, in 1898

He had acquired drinking habits from his early days at Cormon's
where, as at most art establishments in Paris at this time, it was an
essential part of student life. It is in fact difficult to understand
Lautrec's alcoholism without realizing something of the social
background to a disease that had only been classified as such, by the
Swedish physician Magnus Huss, as late as 1852 and had only reached
the domain of public discussion with the enormous success of Zola's
L'Assommoir in 1877. France was a wine-producing country, and the
majority of Frenchmen saw drinking as a patriotic exercise; the effects
of different kinds of alcohol were tried on the army, and there
emerged a remarkable and highly praised condition known as
'l'ivresse gauloise'. But the most spectacular phenomenon in French
drinking habits during the last two decades of the nineteenth century
was the increase in the amount of spirits consumed. This rose from
two litres annually per head of the population to four-and-a-half by
1890 – the highest rate of distilled alcohol drunk in French history,
meaning that the consumption of all kinds of alcohol, including beer
and wine, had risen to seventeen litres of pure alcohol.
 The main culprit was absinthe – along with cognac Lautrec's
favourite drink and the very symbol of *fin-de-siècle* culture. Its name,

significantly derived from the Greek 'apsinthion', meaning 'undrink-able', started to appear in French art and literature in the 1870s, reaching the apex of its meteoric rise to popularity in 1900, when some 238,467 hectolitres were being drunk. Made in part from the distillation of wormwood, high in alcoholic content, it had a bitter taste and an attractive green colour. It was almost certainly at least slightly poisonous, though it had originally been developed in Switzerland for medicinal purposes. (Its production and sale were to be forbidden by law in 1915.) It was cheap, less than half the price of a bottle of beer, had the social advantage as a so-called 'aperitif' that it could be drunk at any time of the night or day, and it was ideally suited for consumption in places such as the Moulin Rouge – especially for spectators such as Lautrec, who could hardly be expected to sit sipping soda-water. Its effects were various, but always formidable. It led Paul Verlaine to shoot his lover and, like so many forms of alcohol, it was mistakenly endowed with aphrodisiac qualities. Oscar Wilde gave the most revealing description of the reactions it provoked, which throws at least some light on the nature of Lautrec's art: 'After the first glass you see things as you wish they were; after the second you see things as they are not; finally you see things as they really are, and that is the most horrible thing in the world.'

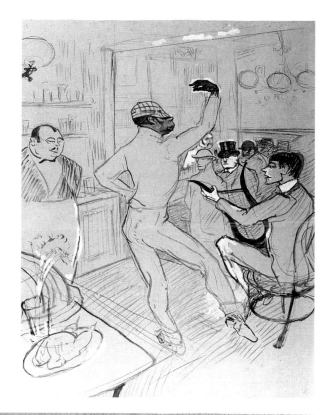

152 *Oscar Wilde et Romain Coolus*, 1896

153 *Chocolat dansant*, 1896

154 *Irish and American Bar, Rue Royale*, 1895. *The Chap Book* was an American magazine.

IMPRIMERIE CHAIX (Ateliers Chéret), 20, rue Bergère, PARIS.— (Encres Lorilleux)

Lautrec, however, was not content with mere absinthe. One particular combination of absinthe and cognac, which he called 'un tremblement de terre' (earthquake), consisted of equal parts of absinthe and brandy. By the 1890s he was coming to frequent places such as the Café Weber and the Irish and American Bar, both in the Rue Royale, more assiduously, and the Picton Bar near the Opéra, all of them the haunts of sportsmen, jockeys, journalists and other professional drinkers, whose appearance and activities he recorded in 153 sketches such as *Chocolat dansant* (1896). At establishments of this kind only the abstemious drank whisky or ordinary spirits; most preferred those elaborate concoctions (later to be domesticated as cocktails) in which spirits and liqueurs were mixed together to compose 'Rainbow Cups' as exotic in appearance as they were lethal in effect.

By spring 1897 he was living in what seemed an ideal apartment, however, with a studio attached. He wrote enthusiastically to his mother, 'I have finally found for 1,600 francs at 15 Avenue Frochot an extraordinary apartment, where I hope to end my days in peace. There's a country-sized kitchen, trees and nine windows giving out onto the garden.' The prognostication was to prove in part more accurate than even he could have suspected. Shortly after moving in he had a fall in a drunken stupor and broke his collarbone. Often he was brought home by the police, and his social behaviour was becoming more unpredictable. One night at the Natansons' he started assaulting the maid; on other social occasions he, by nature the gentlest of men, would violently insult people, or imagine that other guests were criticizing him. He took his stick to bed with him so that he could defend himself against possible attacks, and was so convinced that his studio was alive with microbes that he kept having the floor sprayed with paraffin. He started producing strange hallucinatory lithographs and drawings – one, for instance, of a dog wearing spectacles and spurs with a pipe under its tail. Even his straightforward work began to take on a bizarre quality, seen at its most obvious in the 155 poster commissioned by Jane Avril in 1899 but never used. She is shown in a strangely distorted pose, with a cobra writhing around her. The hat or headdress she is wearing has taken on a gargoyle-like shape and cascades out of the top left-hand corner of the picture. Lautrec began to have hallucinations himself. He imagined that he was being attacked by a cardboard elephant, by a monstrous headless animal, or by a pack of terriers.

A crisis came early in 1899 and was probably precipitated by the departure of his mother from Paris to live more or less permanently in

155 *Jane Avril*, 1899. The poster had been commissioned by Jane Avril but was never released.

the country, leaving him with what seems like a bribe of 1,000 francs and a guardian angel in the shape of Berthe Sarrazin, her devoted housekeeper. Berthe's letters, either to the Countess or to Adeline Cormont (another servant at Albi who had been close to Lautrec when he was a child), are a remarkable record of Lautrec's condition during the first four months of 1899, and of her own devotion and loyalty. She wrote to Adeline (adding 'don't tell Madame') that on one night out he had spent 1,000 francs. He kept buying antiques and knick-knacks, especially dolls, lighting newspapers in the lavatory pan and rubbing glycerine on his pictures with an old sock. He would complain that his mother and family had abandoned him, and had an errand boy from a local shop come round at nights to make sure that nobody was hiding in his studio. He tried to lock up Tapié de Céleyran in the broom cupboard. At times he would threaten Berthe with prison and then, when she cried, say it was really his family he wanted to prosecute and that it wasn't her fault. Once, unable to pay 4 francs for a room he had hired to take a prostitute to, he was nearly imprisoned – despite his assertions that he was the Comte de Toulouse – and had to borrow the money from a local bartender. Sometimes he made sexual advances to Berthe or, as she put it, 'M. Henri wasn't decent to me.' To Berthe, the villains of the piece were Edmond Calmèse, a coachman who kept a livery stable nearby, himself an alcoholic, and Big Gabrielle, a prostitute who, usually with one of her colleagues, often shared the painter's bed. Together they got everything they could out of Lautrec. The three spent whole days drinking at the nearby wine bar of Père François, to which establishment Lautrec had cases of wine sent up from the vineyards of Albi and Céleyran. But Berthe also blamed the Countess, as far as she was capable of assuming such an attitute to her employer, whose reactions were at least initially escapist; for she, like other members of the family, saw in Henri's condition a slur on the family name. She did, however, contact her son's two faithful medical friends, Henri Bourges and Gabriel Tapié de Céleyran, but they were able to do little or nothing as Lautrec evolved various devices for avoiding contact with them. Attempts were made to provide him with a 'keeper', but the details of this exercise are vague. One of them turned out to be a drunkard himself, and Lautrec became very skilful at evading the other who took his place.

In February the Countess returned to the Cité du Rétiro, and after Lautrec had been again examined started to think of having him confined in a nursing home. On 27 February her brother Amédée

wrote to her, advising her of the gravity of such a decision: 'Think it over well before making this confinement decision because it is terribly serious.' The Count's reactions were not unexpected. He stated that he would not oppose such a decision but added splenetically, with what sounds like a glancing blow at the temperance movement in England, that he considered it 'revolting that there should be this assault on the right to drink by both the French people and those of neighbouring countries.' Both Joyant and Bourges, however, agreed that such a move was essential, and sometime towards the end of February a doctor and two male nurses took Lautrec away to Dr Semelaigne's palatial establishment at Neuilly for what was virtually a period of compulsory detoxification. The splendidly titled Château Saint-James – whether it derived its name from a Stuart connection or from a commercially motivated desire to attract English clients it is difficult to discover – was situated in fifteen acres of park and garden in the Avenue de Madrid. Founded half a century before, by the nephew of the famous alienist Dr Pinel, who had been the first to introduce into France the concept of kindly and considerate treatment of the mentally disturbed, it provided luxurious accommodation for fifty patients who paid some 2,000 francs a month.

Joyant communicated the information to the press early in March. The reactions from some quarters were unbelievably vicious and vividly reflect the hatred which non-traditional art inspired. Alexandre Hepp, in *Le Journal* of 26 March, wrote: 'Lautrec has been taken to an asylum. Now that he has been put away, it will be officially recognized that his paintings and posters are the work of a madman.' In *L'Echo de Paris* two days later le Pelletier wrote:

The sordid debauchery and commercial traveller's *affaires* in which Toulouse-Lautrec loved to indulge, and in which he involved his friends, together with the irritation aroused by the awareness of his physical deformity and moral decadence, certainly helped to lead him to the madhouse. And now in that strange paradise of human degeneracy, in the curious Valhalla which is a place of terror only to those mortals still burdened with sanity, he is as happy as is possible to be. He rejoices unfettered in what he believes to be his strength, his good looks and talent. He can paint endless frescoes and unlimited canvases with a bewildering mastery, and at the same time he can embrace beautiful bodies, for he is surrounded by comely and shapely figures, and an endless flow of sensual pleasures fill his being with a continuous enjoyment of new sensations. Thanks to his happy lunacy he sails

156 *Mon Gardien*, 1899

towards the enchanted isles where he is king, far from the ugliness and sadness of his own world. He no longer sells art, he no longer buys love; he is in bliss.

On the other hand Jules Clarétie, a successful Parisian columnist, displayed that strain of obsequious snobbery which indubitably tinctured some reactions to Lautrec:

An artist who bears one of the great names, and who himself is highly talented has been taken for a short time to a nursing home. 'The end of a dynasty' wrote one paper the other day. The descendant of Odet de Foix, lord of Lautrec and of Gaston de Foix, killed at the battle of Ravenna is shut up . . . in a lunatic asylum.

The shock to Lautrec was obviously traumatic, but also salutary, and he was to stay there only until 17 May. By the middle of the previous March he had asked Joyant to send him 'lithographic stones,

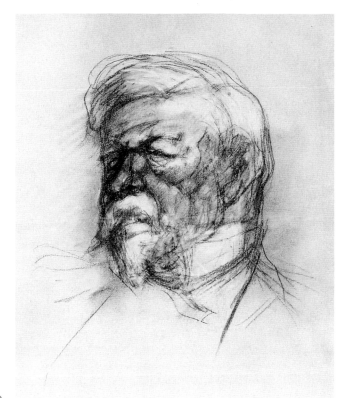

157 *Tête de vieil homme*, 1899

a box of watercolours with sepia, paint brushes, litho crayons, good quality Indian ink, and paper.' And on 20 March Arsène Alexandre had published an encouraging article in *Le Figaro*: 'I saw a lunatic full of wisdom, an alcoholic who no longer drinks, a stricken man who never looked healthier. There is so much vitality in this supposedly dying man, such an innate strength in this supposedly sick creature that those who watched him hurrying to disaster are astonished to see him so splendidly restored to health.'

There is a touch of hyperbole here, but no doubt Lautrec had indeed drawn on hidden resources to reassert himself over his weakness. He started by recording some of his surroundings, drawing a portrait of his nurse, and a remarkably sympathetic and revealing 156
likeness of an elderly fellow patient in coloured chalks on blue-grey 157
paper. He made daily visits to the Jardin d'Acclimitisation to study the animals and complete the series of twenty-two lithographs – meticulously accurate in conception and execution – which he had

158 *Au Cirque, Clown dresseur*, 1899

been doing for the *Histoire Naturelle* of Jules Renard, a friend of the
Natansons and on which he had been working intermittently since
1894. He also produced an extraordinary series of pictures of the circus
– all obviously based on memory –, some in chalks on paper, some in
158 the form of monotypes. One of them, *Au Cirque, Clown dresseur*
(1899), bears the inscription 'Madrid, Paques 1899; A Arsène
Alexandre, souvenir de ma captivité, T-Lautrec'. He also became
interested again in racehorses and the ambience of the paddock and
the course. At the suggestion of the publisher Pierrefort, who visited
him at Neuilly with Henri Stern, his printer, he commenced a series to
be entitled *Les Courses*. In the event Pierrefort only published one, *Le*
159 *Jockey*, in an edition of two states, monochrome and coloured. The
other three Lautrec had done passed into the general stock-in-trade of
his dealers, usually in these two alternative forms, but sometimes
showing considerable variations in the drawing and composition as
160 Lautrec made changes. This is especially so of *Le Jockey se rendant au*
poteau, of which there are five states known.

 The belief that he expressed to Joyant, 'I have bought my freedom
with my drawings', was fully justified. The verdict of the doctors at
Neuilly convened by the Countess to report on her son concluded
that, though there was a slight trembling and uncertainty of memory,

192

he could be discharged, but added with chilling realism, 'Owing to the amnesia, the instability of his character and lack of will-power, it is essential that M. Henri de Toulouse-Lautrec should be subject in his life outside these premises to material and continued supervision, so that he may not have the opportunity of returning to his former alcoholic habits, which would cause a relapse of a more serious nature than his previous breakdown.' His mother and his friends had just the right solution.

He was to have another keeper, but this time they had exactly the right person in mind. Paul Viaud was a remote cousin who had fallen on bad times as a result of injudicious speculation on the stock exchange. Tall (Lautrec always seemed to have tall intimates), distinguished in appearance (the contrast was complete), he had one invaluable attribute – owing to some obscure stomach complaint, he was incapable of drinking alcohol in any form whatsoever. Although Lautrec sometimes introduced him as 'a broken man of means', or 'my elephant keeper', a remarkable mutual affection grew up between the two, which persisted to the very end. More mundane restrictions were imposed by the family. He was given access to two

159 *Le Jockey* 1899

160 *Le Jockey se rendant au poteau,* 1899

161 *Soldat Anglais fumant sa pipe*, 1898, study for the poster advertising 'Job' cigarette papers, but never used.

accounts administered by a lawyer. Into the first the family estates' manager would pay a fixed monthly amount. The other would consist of all monies received by Joyant as his agent from the sale of works of art, and the amounts paid in were not to be divulged to the family. It was a shrewd arrangement. On the one hand he would be secure, but unable to dissipate the family fortune on drink and loose women. On the other, he would have an incentive to work because that would be the only way in which he could secure money to pay for any untoward form of self-indulgence.

His first visit on release from Dr Semelaigne's care was to Albi. Then it was decided that a month at the seaside would be good for him, so he and Viaud went first to Le Crotoy and then to Le Havre. There he first drew in red chalk, and then painted in oil on a limewood 162,164 panel, the portrait of 'Miss Dolly' of the Star, *L'Anglaise du Star du Havre* (1899), a remarkably joyful and fresh vision with a strange

194

162 *L'Anglaise du Star du Havre*,
(chalk study for Ill. 164), 1899

Cubist-style background. 'I hope my guardian will be pleased with
it', he wrote to Joyant when he sent him the picture, and evident in his
attitude at this time is a clear intention to show that he could still 'do
it'. As ever he seemed to revel in being by the seaside, although friends
such as Lucien Guitry the actor and Marie Brandès of the Comédie-
Française detected a sense of flatness in him, as if he were merely
pretending to be his former self.

In July 1899 he and Viaud went to Bordeaux, and then to Taussat
where they stayed for some weeks with Fabre at the Villa Bagatelle.
There they obtained the use of an old whale-boat in which they made
constant swimming and fishing excursions in the company of a
boatman called Zakarie, to whom Lautrec became very attached. By
September he was staying with Viaud at Malromé and a month or so
later was back in Paris. He had a little less than two years to live. Very
soon he was drinking again, visiting especially places such as La

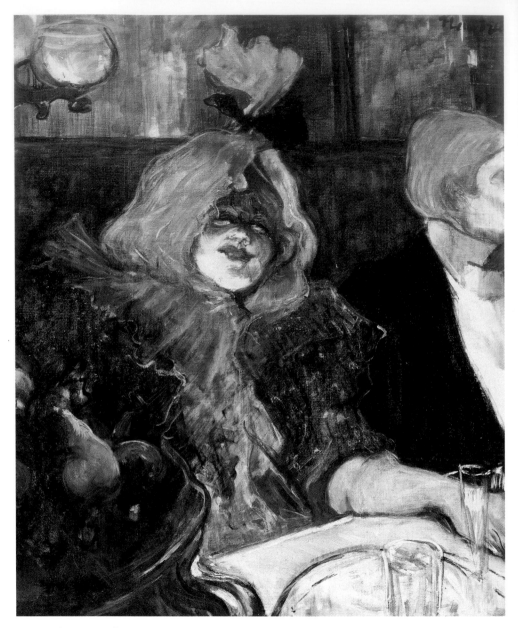

163 *En cabinet particulier au Rat Mort*, 1899

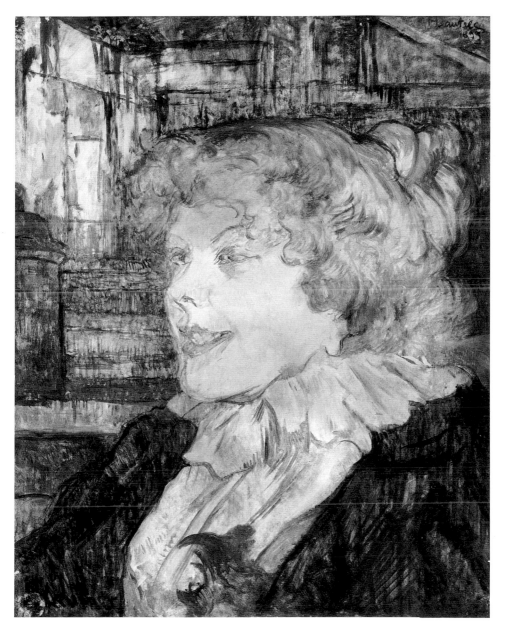

164 *L'Anglaise du Star du Havre*, 1899

Souris, known for its lesbian connections, and painted one of its
habitués Lucy Jourdain in the restaurant of the Rat Mort.

It is clear from this painting that a change had taken place in
Lautrec's art. It had become more painterly, more concerned with
tonal values; a subtler brush stroke and a greater sensitivity of
observation are to be seen in the transparent quality of the gauze
headcover, the almost Cézanne-like fruit, and the modelling of the
face. Similar qualities can be found in *La Modiste*, where the lighting
and the tender treatment of the face give the work a certain resonance
which has undercurrents of both Daumier and Manet. The subject of
this painting was a young *modiste*, Louise Blouet, for a while Joyant's
mistress, who worked in the shop of Renée Vert, the mistress of
Adolphe Albert. She was eighteen at the time, and there are a number
of photographs of her, mostly taken by Joyant, one showing her
actually posing for this portrait. In his *Autour de Toulouse-Lautrec*, Paul
Leclercq described Lautrec's relationship with the girl:

Lautrec adored the company of women, and the more illogical, scatter-
brained, impulsive or foolish they were the more he delighted in it, provided
always that they were completely unaffected . . . One of his friend's
temporary girl-friends became at this time one of his most cherished
companions. She was a young milliner with abundant golden hair and the
delicate face of an alert squirrel. He called her Crocesi-Margouin, or just
Margouin [the slang word for a mannequin]. Their relationship resembled
that of two children who enjoy complete mutual understanding. His feeling
towards the women he admired was a strange mixture of jovial camaraderie
and suppressed desire. Since he was convinced of his own inferiority, and
since paltry jealousy was as alien to him as it was to Cyrano, when he
cherished a woman to whom he was reluctant to declare his love, he derived
enormous pleasure from her belonging to one of his friends.

Alfred Natanson invited him to design a poster for a play by Jean
Richepin (1849–1926), *La Gitane*, in which his wife, the actress
Marthe Mello, played the leading role. The play opened on 22
January 1900 at the Théâtre Antoine. Simpler than most of his other
work, but very dramatic, with a striking white figure dominating and
taking up most of the picture space, it was never printed in an edition
and Lautrec, who attended the first night, spent the whole time
drinking in the theatre bar. His moods became uncertain and
belligerent, and they were not alleviated by the fact that, because of
floods in the area of the Tarn and subsequent damage to vines and

165 *La Gitane*, 1899–1900

166 *Maurice Joyant*, 1900

crops generally, his allowance was cut. In May he went again to Le Crotoy and seemed to recover somewhat, painting a portrait of Joyant in oilskins standing in a boat and holding a rifle. Then he visited Le Havre but, finding the Star and other bars under the surveillance of the *police des moeurs*, left for Taussat. 166

A visit to Malromé, undertaken no doubt partly from affection and nostalgia, partly from a desire to reassure his mother, passed off uneventfully. His only gesture towards his art was to commence a portrait of Viaud in the dress of an eighteenth-century admiral staring balefully at another man-of-war from the poop of his own ship, a picture which was intended to decorate the dining room at Malromé (it measures 39 by 51 inches) but has subsequently found its way into the Museum of Sao Paolo, Brazil.

Instead of returning to Paris – perhaps he was more than half-conscious of the dangers it posed – he went from Malromé to Bordeaux, renting a studio in the Rue de Dijeaux owned by the art dealer Imberti, who had been an early supporter of the Impressionists and who exhibited some of Lautrec's works in his gallery. Lautrec was quite active during his stay there, and spent a good deal of time in the theatre. On 6 December he wrote to Joyant, 'I am hard at work. You will shortly receive some of the results . . . Here we are all delighted with *La Belle Hélène* [Jacques Offenbach's operetta]; it is excellently produced; I have caught the spirit of it. Hélène is played by a fat trollop called Cocyte.' He did indeed paint a remarkable watercolour portrait of her, glittering with self-approval, her immense bulk crowned with vivid red hair, brightly lit by the footlights which glisten in her eyes. The next production which caught his fancy was an opera, *Messalina* by Isidore de Lara, in which he particularly admired Mlle Ganne, who played the leading role. He produced six paintings inspired by this rather mediocre work, the most spectacular of which shows the Empress splendid in a brilliant red robe sweeping down a staircase, whilst in the corner loom the forbidding figures of heavily armed and helmeted soldiers. The painterly qualities which marked his work at this time are evident in the handling of the soldiers' armour, the lighting on their faces and the interplay of tonal values. The figures of Messalina and of the chorus standing on the stairs, however, are visually unconvincing, their expressiveness purely gestural – almost cardboard figures. Less dramatic but more visually rewarding is another, darker, image of Messalina, standing beneath a partly visible statue of a naked figure, the whole impression strongly reminiscent of some of Degas' pastels. 167

His letters to Albi and Malromé reveal a certain rather shrill self-confidence. At the end of December he wrote a New Year's Day letter to his grandmother: 'I'm at Bordeaux and wish you a happy New Year. I share your opinion about the fogs of the Gironde, but I'm so busy I hardly have any time to think about it. I'm working all day long. I'm showing four pictures at the Bordeaux Exhibition and am having success. I hope that will please you a little. I wish you a prosperous New Year – and from a ghost like me that counts double – for what my wishes are worth. I kiss you.' The pathetic last sentence is more convincing than the statement about the constant work; a great deal of his time was spent in the bars and brothels of Bordeaux. He must have been conscious of his declining physical and creative powers for he confessed to Joyant that he had been sculpting a little and writing poetry, clearly trying to find in other media a stimulation that he found lacking in his own.

In April 1901 he returned to Paris. 'It was with heavy hearts that we saw him after nine months' absence', wrote Joyant, 'thin, weak, with poor appetite, but as lucid as ever, and occasionally full of his old high spirits.' One consolation was that some of his paintings which had come up for sale at the Hôtel Drouot fetched satisfyingly good prices – *A la toilette* going for 4,000 francs. Perhaps it was this, or perhaps a prescience of death that impelled him during these weeks to organize the paintings in his studio, signing those that needed it, arranging his works in groups. On 15 July he left his studio for the last time, to visit Taussat, but his stay there was short. In the middle of August he collapsed with an attack of paralysis. Viaud sent a telegram to the Countess who came at once and took him back to Malromé. His situation was appalling: he could not walk; he had become almost completely deaf; and he had attacks of delirium. His father arrived from Paris and Lautrec greeted him with the words 'I knew you'd be in at the death.' In the early morning of the following day, 9 September, the Count was trying to keep the flies away from his son's face with his elastic boot strap when Henri looked up at him, murmured 'You silly old bugger', and died. The following day his father wrote to Lautrec's first real teacher, Princeteau:

Your former protégé, to whom you were such an example, Henri, my son, 'the little one' as you called him, died at 2.15 a.m. I had arrived four or five hours earlier and shall never forget the terrible sight of the kindest soul you could ever have met . . . He was always kind and friendly, and never reproached anyone, although he suffered much from his appearance, which

167 *Messaline descend l'escalier borde de figurantes*, 1900–01

made people turn round and stare, though usually more in pity than in mockery. For him death meant the end of suffering, and we hope for another life where we shall meet again in eternal affection, where there will be no law to separate a father and son, and the attraction of two who really love each other will not be forbidden and punished in the fruit of the same blood which should never have been allowed to marry.

It was a letter which revealed the true nature of this fractious man, his love for his son and his awareness of the hereditary disease which had made Henri what he was. It was this disease which no doubt was one of the causes of Henri's early death, but it was aggravated both by his alcoholism and by syphilis, which he had apparently contracted in his early twenties. He was buried in the cemetery of Saint-André-du-Bois near Malromé, but fearing that it was going to be abandoned and deconsecrated, the Countess later had his remains transferred to nearby Verdelais.

The immediate verdicts varied. Le Pelletier (cf. p. 47) in the *Echo de Paris* expressed a widely held view: 'Among the painters of our age Lautrec will certainly leave the trace of his curious and immoral talent, which was that of a deformed man who saw ugliness in everything around him and exaggerated that ugliness while recording all the blemishes, perversities and realities of life.' Jules Roques in *Le Courrier Français* was of the same opinion: 'Lautrec's talent, for it would be absurd to deny him one, was an immoral talent of pernicious and unfortunate influences.' His father seems even to have had doubts about his talent, for when in 1909 there was talk of erecting a statue to Lautrec in Toulouse, he wrote to the committee that 'My son had no talent, and I shall oppose the proposal to the utmost of my power.' Quite apart of course from the fact that Lautrec was hardly an appropriate subject for a statue, the Count may not have wished his own feeling of guilt so to be perpetuated.

There was one remarkable exception to these pieces, however. On 10 September the *Journal de Paris* published a notably perceptive obituary, in the course of which it stated:

His wealthy background gave him freedom from all the hardships of life, and he devoted himself to the observation of the world. What he saw is not very flattering to the end of the last century, of which he was the true painter. He sought the reality, disdaining fictions or chimeras which falsify ideas by unbalancing minds. Some will say that he was a snooper, a dilettante of rather melancholic originality, to which disposition, natural for one who suffers, he felt himself drawn. But this was a mistake and all his work shows it. He did

168 *Un Examen à la Faculté de Médecine de Paris,* 1901

not overturn reality to discover truth, nor strive to depict something that was not there. He contented himself with looking. He did not see, as many do, what we seem to be, but what we are.

Almost exactly seventy years later the Italian film director Federico Fellini paid another tribute to Toulouse-Lautrec: 'I have always had the feeling that Lautrec was my brother and my friend. Perhaps this is because before the Lumière brothers he forecast the visual techniques of the cinema, perhaps because he was always drawn to the disinherited and the despised, for those whom society calls vicious. One thing I know: that never have I been able to look with indifference on a painting, a poster or a lithograph by Lautrec. His memory has never left me.'

★ ★ ★

It would be a grave misunderstanding of Lautrec's achievement to see it – as many do – in terms of a successful personality cult. His influence on the future patterns of Western art was cumulatively even more important than the merits of his individual works. Perhaps the most significant contribution he made lies in a field wider than the purely aesthetic, in that no-man's-land between the artist and the general public which might roughly be described as 'taste'. The massive revolution in art that had been initiated by Impressionism had, by the end of the nineteenth century, only percolated through to a small section of that comparatively limited section of the general public known as 'art lovers'. By the popular success of his prints and posters Lautrec created a far greater awareness of the revolutions that had been taking place in the free use of colour, in the emancipation of line and form from a dependence on assumed visual 'reality', in the demonstration that a concern for decorative qualities could override a preoccupation with description, and that a work of art could create its own frame of reference. He ignored traditional perspective systems, juxtaposed flat colours, the choice of which was often determined on purely arbitrary grounds, and created anatomical distortions of a kind that would have been ridiculed two or three decades earlier. Yet his creations adorned the streets of Paris, and were seen on theatre programmes, on advertisements and in numerous prints and publications without arousing any of the kind of hostile criticism that was directed against the works of Cézanne or Van Gogh.

He had in fact brought modern art into that realm of mechanical reproduction which had not been widely explored by the great innovators of the immediate past, who even when they did venture into the field of graphics did so without that intense application to the technical aspects of the process which Lautrec cultivated. Even his more 'serious' contemporaries such as Vuillard were tentative and unsure when they made excursions into colour lithography. His achievements here too gave an enormous impetus to the whole art of illustration, strengthening its links with painting, and endowing it with a sense of creative self-confidence. A century after his death the influence of Lautrec can be seen still in advertising, in the strip cartoon (notably coloured ones such as *Asterix*) and in the illustrations of science fiction.

The most notable and significant aspect of Lautrec's graphics – still the most popular and widely known of his works – is that they were based on a formidable infrastructure of painting and drawing. It was in his sketchbooks and on his canvases that he defined and re-defined

images, from which he pared away visual superfluities to catch the essence of a look, the significance of a stance, and that he experimented with colours, and liberated them, in a way in which the Impressionists had never attempted to do, from any dependence on perceived reality. He was a significant figure in that evolution of Western painting rather roughly described as Post-Impressionism, which in many ways forecast most of the developments in art of the whole of the twentieth century. This is most readily apparent from the work of those artists who were immediately influenced by Lautrec, including even the fiercely independent Van Gogh, who in paintings such as *La Salle de danse à Arles* of 1888 reflected what he called 'the Parisian style', of which he saw Lautrec as the supreme examplar. The work of Bonnard and of Vuillard, even though it placed a greater emphasis on decorative qualities than on analysis and structure of form, was largely derived from Lautrec during the 1890s, and so too was that of Edvard Munch (1863–1944) who was living and working in Paris, and who came into close contact with the Natansons, who reproduced one of his most celebrated works *The Scream* in the pages of *La Revue Blanche*, and commissioned Strindberg to write an article about him. Munch himself did theatre programmes in black-and-white lithography, which utilized several of Lautrec's compositional devices, including the accentual use of diagonals, seen at its most obvious in the horizontally shaped programme he did for a performance of Ibsen's *Jean Gabriel Borkman* at the Theatre de l'Oeuvre in 1898.

The erotic elements that often underlay much of Lautrec's work, even when they were not explicit, affected the way other artists approached the same theme. Rodin's watercolours, the contorted nudes of Egon Schiele (1890–1918), the early works of Matisse, the paintings of the Blaue Reiter and indeed a whole dimension of Expressionism were related to the innovations of Lautrec. It was, however, his influence on probably the most explorative artist of the twentieth century, Pablo Picasso, which was most striking. Strangely enough there were parallels in their careers. In February 1899 Picasso went back to Barcelona from Horta de Ebro, and became an habitué of 'Els 4 Gats', a *cabaret-artistique* with rooms for exhibitions, recitals and a marionette theatre in direct imitation of Bruant's Mirliton, which had been opened two years previously by Pere Romeu. It was the centre of the Spanish avant-garde, and in close contact with its equivalent in Montmartre, displaying Lautrec's posters and cultivating the kind of aesthetic radicalism which he so strikingly demonstrated. It was the background to the genesis of Picasso's 'blue period'

with its marked dependence on Lautrec's use of form and colour, evident not only in works such as *The Frugal Meal* of 1904, *The Green Stockings* of 1902, and the portrait of Joaquin Mir of 1901, but in the countless sketches and drawings of brothel scenes, women of the world (some of them looking like Jane Avril) and the passing life of the streets which flowed from him in such profusion between 1899 and 1907. When in 1900 he made his first short visit to Paris he recollected later that it was then that 'I discovered what a great painter Lautrec really was'. It is a judgement with which it is impossible to disagree.

169 Lautrec with his mother at Malromé, *c.* 1899–1900

Chronology

1864 24 November. Born at the Hôtel du Bosc, 14 Rue de l'Ecole Mage, Albi. His parents were Alphonse-Charles Toulouse-Lautrec-Monfa (1838–1912) and his wife Adèle-Zoë, née Tapié de Céleyran (1841–1930). He was baptized Henri Marie-Raymond, the last name being frequently used by the Comtes de Toulouse.

1872 The Countess with Henri moves to the Hôtel Pérey at 5 Cité du Retiro, Rue Boissy d'Anglas, Paris, and at the beginning of term Henri starts attending the Lycée Fontanes (later Condorcet).

1874 Wins various prizes and commendations at school in January, and in the summer visits Nice.

1876 June. First communion

1877 1 March. Tells grandparents that he is 'limping with my left foot'.

1878 At Albi in the spring fractures left leg.

1881 Fails first attempt at *baccalauréat*, but passes at Toulouse in November. Abandons formal education.

1882 Starts to study with René Princeteau at 233 Faubourg Saint-Honoré, but then moves to work at Bonnat's studio, which Bonnat then gives up in September. Henri accepts an easel in the studio of Fernand Cormon at 10 Rue Constance. There he meets Emile Bernard, François Gauzi, René Grenier, Adolphe Albert, Louis Anquetin, and later Vincent van Gogh.

1883 His mother buys the Château de Malromé, where he is to spend a good deal of time.

1884 Shares a flat with René and Lily Grenier in the Rue Fontaine.

1885 Starts frequenting the Mirliton; visits Monet; paints murals in the inn of Père Ancelin at Villiers sur Morin, where the Greniers have a cottage.

1886 The Mirliton starts exhibiting his works on a permanent basis. He takes a studio of his own on the fourth floor of 27 Rue Caulaincourt, on the corner of 7 Rue Tourlaque, which he keeps till 1897. In December he exhibits at the Salon des Arts Incohérents.

1887 Takes a flat with Henri Bourges in the same house as the Greniers, and meets Van Rysselberghe.

1888 Exhibits at fifth exhibition of Les XX at Brussels. Exhibits at Cercle Volney, and shows *Moulin de la Galette* at the fifth Salon des Indépendants.

1889 Exhibits at Cercle Volney.

1890 Visits Brussels to attend exhibition of Les XX, and defends Van Gogh against a fellow-exhibitor Henri de Groux. Exhibits *Mlle Dihau au piano* at the sixth Salon des Indépendants, and also shows work at Cercle Volney. Visits Biarritz, and on his return moves with Bourges to 21 Rue Fontaine.

1891 On the advice and with the help of Bonnard and the printer Edward Ancourt, he starts working in lithography, and produces *Le Moulin Rouge, La Goulue* commissioned by Charles Zidler. Exhibits at the seventh Salon des Indépendants, Le Barc de Boutteville (with Anquetin and Bonnard).

1892 Exhibits with Les XX in Brussels, at the eighth Salon des Indépendants, the Cercle Volney and Le Barc de Boutteville. In May visits London, staying at the Charing Cross Hotel.

1893 Exhibits with Les XX at Brussels (showing posters at nearby Ixelles); at Boussod Valadon, with Charles Maurin; at the ninth Salon des Indépendants; at the fifth exhibition of the Peintres-Graveurs. Stays with Aristide Bruant at Saint-Jean-les-Deux-Jumeaux, and visits Anquetin in Normandy. Bourges marries and Lautrec moves into the ground floor flat next to his studio. Does work for *Figaro Illustré*.

1894 Visits Belgium, Holland, Rouen and London. Exhibits at Durand-Ruel's and the Royal Aquarium, London (posters).

1895 Visits Brussels, where he exhibits five prints at the Libre Esthétique, and London, where he meets Oscar Wilde, who refuses to sit for him, paints Whistler in Chelsea, and once again exhibits posters at the Royal Aquarium. In Paris he exhibits at the eleventh Salon des Indépendants, the Salon de la Société Nationale de Beaux-Arts, the Centenaire de la Lithographie, the fourteenth Salon des Cent and the Manzi-Joyant Gallery, 9 Rue Forest, which includes two rooms of works not for public viewing. Visits Normandy, sails from Le Havre to Arcachon; goes to Lisbon and returns via Madrid with Maurice Guibert.

1896 Exhibits at the third Salon de la Libre Esthétique in Brussels, at Manzi-Joyant and the Salon des Cent. Visits Le Havre, Bordeaux, Arcachon, Walcheren (by boat), San Sebastian, Burgos, Madrid and Toledo. Makes drawings at trial of Anarchists.

1897 Exhibits at the Libre Esthétique in Brussels, the thirteenth Salon des Indépendants. Visits London, where he is in contact with William Rothenstein, and moves to new studio at 15 Avenue Frochot.

1898 Exhibits at the studio in the Cité Frochot, and shows 78 works in London at Goupil's Gallery in Regent Street; is painted by Vuillard whilst staying with the Natansons at Villeneuve-sur-Yonne.

1899 Early in February his mother hires two male nurses to look after him, and between 27 February and 17 May he is confined to a hospital for alcoholics run by Dr Sémelaigne at 16 Avenue de Madrid, Neuilly, where he receives regular visits from Berthe Sarrazin, a family servant. After his release goes to Albi, cruises from Le Havre to Bordeaux, and then stays with his mother in Malromé. Member of jury for the lithographic section of the 1900 World's Fair.

1900 Has exhibition at 14 Avenue Frochot next to his studio. Visits Le Havre, Malromé and Bordeaux, where he rents an apartment.

1901 Opens year at Bordeaux and Malromé; returns to Paris for a short time and then goes to Malromé on 20 August. Dies there on 9 September. Is buried first at Saint-André-du-Bois and later his body is transferred to Verdelais, nearby.

Bibliography

Adhémar, Jean, *Toulouse-Lautrec, Elles*, Monte Carlo 1952

Adriani, Götz, *Lautrec und das Paris um 1900*, Cologne 1978

Adriani, Götz, *Toulouse-Lautrec*, London 1987

Adriani, Götz (ed.), *Toulouse-Lautrec: The Complete Graphic Works*, exh. cat., Royal Academy of Arts, London 1988

Blanche, Jacques-Emile, *Propos de peintre*, Paris 1921

Bouret, J., *Toulouse-Lautrec*, London 1964

Castleman, Riva and Wolfgang Wittrock, *Henri de Toulouse-Lautrec: Images of the 1890s*, exh. cat., Museum of Modern Arts, New York 1985

Catalogue Musée Toulouse-Lautrec, Albi 1985

Cooper, D., *Henri de Toulouse-Lautrec*, London 1955

Devoisins, Jean, *L'Univers de Toulouse-Lautrec*, Paris 1980

Dortu, M. G., *Toulouse-Lautrec et son oeuvre*, 6 vols, New York 1971

Fellini, Federico, 'Pourquoi j'aime Toulouse-Lautrec', *Gazette des beaux-arts*, February 1976

Florisoone, Michel and Julien, Edouard, *Exposition Toulouse-Lautrec à l'Orangerie des Tuileries*, Paris 1952

Foucart, Bruno, *La Poste-modernité de Toulouse-Lautrec. Tout l'oeuvre peint de Toulouse-Lautrec*, Paris 1986

Gassiot-Talabo, Gérard, *Toulouse-Lautrec au Musée d'Albi*, Paris 1966

Gauzi, F., *My Friend Toulouse-Lautrec*, London 1957

Goldschmidt, L. and H. Schimmel, *Unpublished Correspondence of Toulouse-Lautrec*, London 1969

Guilbert, Yvette, *Chansons de ma vie*, Paris 1927

Hanson, L. and H., *The Tragic Life of Toulouse-Lautrec*, London 1956

Hartrick, A. S., *A Painter's Pilgrimage through Fifty Years*, Cambridge 1939

Huisman, P. and M. G. Dortu, *Lautrec by Lautrec*, London and New York 1964

Joyant, Maurice, *Henri de Toulouse-Lautrec, I. Peintures, II. Dessins, estampes, affiches*, Paris 1926–27

Julien, Edouard, *Toulouse-Lautrec au Musée d'Albi*, Albi 1952

Julien, Edouard, *Toulouse-Lautrec au cirque*, Paris 1956

Julien, Edouard, *Toulouse-Lautrec, Moulin Rouge et cabarets*, Paris 1958

Lassaigne, J., *Toulouse-Lautrec and the Paris of Cabarets*, New York 1970

Longstreet, S., *The Drawings of Toulouse-Lautrec*, Alhambra 1966

Mack, Gerstler, *Toulouse-Lautrec*, New York 1938

Natanson, Thadée, *Un Henri de Toulouse-Lautrec*, Geneva 1951

Perruchot, H., *Toulouse-Lautrec*, London 1960

Post-Impressionism, exh. cat., Royal Academy of Arts, London 1979

Rewald, J., *Post-Impressionism from Van Gogh to Gauguin*, London and New York 1978

Rothenstein, William, *Men and Memories*, London 1931

Schaub-Koch, Emile, *Psychoanalyse d'un peintre moderne, Henri de Toulouse-Lautrec*, Paris 1935

Symons, Arthur, *Parisian Nights*, London 1926

Tapié de Céleyran, Mary, *Notre oncle Lautrec*, Geneva 1956

Van Schmidt, *Toulouse-Lautrec Case Report and Diagnostic*, Copenhagen 1966

Wittrock, W., *Toulouse-Lautrec. The Complete Prints*, London 1985

Sources of Quotations

Sources of quotations not given in the text are listed here by chapter and page number. Books included in the bibliography are indicated by author's name only.

CHAPTER ONE
11 Gauzi, p. 91; Natanson and Guilbert quoted in Perruchot, pp. 190–91
12 Huisman and Dortu, pp. 22–23
13 Goldschmidt and Schimmel, p. 19; Gauzi, p. 27
17 Information from Mary Tapié de Céleyran, in Perruchot, p. 23
18 Perruchot, p. 42
19 Perruchot, p. 267; Huisman and Dortu, p. 194

CHAPTER TWO
21 Goldschmidt and Schimmel, p. 3
27 Huisman and Dortu, p. 20
26 Perruchot, p. 199; Joyant quoted in Gauzi, p. 79
30–32 Joyant, p. 192
39 Adriani, 1987, p. 13
41 Goldschmidt and Schimmel, pp. 64–65
42 Huisman and Dortu, p. 36
43 Joyant, pp. 139–41; Goldschmidt and Schimmel, p. 67

CHAPTER THREE
45–46 Goldschmidt and Schimmel, pp. 69, 83, 84, 85
46 Perruchot, p. 71
48 Huisman and Dortu p. 44
50 Signac's diary, 24 May 1897, reproduced in *Gazette de Beaux Arts*, April 1952
53 Pierre Mornand, *Emile Bernard et ses amies*, Geneva 1957, p. 57
54 Huisman and Dortu, p. 44
59 Charles Baudelaire, 'Le Peintre de la vie moderne' in *Ecrits sur l'art*, vol. 2, Paris 1971, p. 145

CHAPTER FOUR
63 John Milne, *The Studios of Paris*, New Haven 1988, p. 129; Goldschmidt and Schimmel, p. 85; Perruchot, pp. 85–88
73 Emile Zola, *L'Assommoir*, Paris 1969 edition, p. 261
74 Perruchot, p. 99
82 Adriani, pp. 63–64; Robert L. Herbert, *Impressionism: Art, Leisure and Parisian Society*, New Haven 1988, p. 87
85 John Rewald (ed.), *Camille Pissarro: Letters to his son Lucien*, New York 1943 (letter of 13 April 1891)

CHAPTER FIVE
90 Gauzi, p. 82
94 *The Complete Letters of Vincent van Gogh*, London 1958 (letter 476)
96 Maurice Joyant in *L'Art et les artistes*, 25 February 1927, quoted in Perruchot, p. 94
99 Aristide Bruant, *Dans la rue*, Paris 1924
102–03 Joan U. Halperin (ed.), *Félix Fénéon, Oeuvres plus que complètes*, Geneva 1970, pp. 229–30
106 Huisman and Dortu, p. 90
110 Adriani, 1988, p. 23
116 Goldschmidt and Schimmel, p. 198
118 Herbert D. Schimmel and Philip Denis Cate, *The Henri de Toulouse-Lautrec and W.H.B. Sands Correspondence*, New York 1983

CHAPTER SEVEN
167–69 Cooper, p. 74

CHAPTER EIGHT
179 Goldschmidt and Schimmel, p. 169
208 Juan-Eduardo Cirlot, *Picasso: Birth of a Genius*, London 1972, p. 106

List of Illustrations

Measurements are in inches and centimetres, height before width.

54 *La Baraque de la Goulue*, 1895. Chinese ink, 9 × 14¼ (22.8 × 36.2). Musée Toulouse-Lautrec, Albi.

55 The Moulin Rouge, in the Boulevard de Clichy. Photo H. Roger Viollet.

56 *Foire du Trône* (panel for La Goulue's booth), 1895. Oil on canvas, 112¼ × 121 (285 × 307.5). Musée d'Orsay, Paris. Photo Réunion des Musées Nationaux.

57 *Au Moulin Rouge*, 1890. Oil on canvas, 45 × 59 (114.3 × 149.8). Museum of Art, Philadelphia, The Henry P. McIlhenny Collection, in memory of Frances P. McIlhenny.

58 *Le Quadrille de la chaise Louis-XIII*, 1886. Chinese ink and charcoal, 19⅝ × 12⅝ (50 × 32). Musée Toulouse-Lautrec, Albi.

59 The Chat Noir, at 84 Boulevard Rochechouart. Photograph.

60 *Le Gin Cocktail*, 1886. Charcoal and chalk on blue-grey paper, 18¾ × 24⅜ (47.5 × 62). Musée Toulouse-Lautrec, Albi.

61 *Un Jour de première communion*, 1888. Charcoal and oil on cardboard 25½ × 14½ (64.7 × 36.8). Musée des Augustins, Toulouse.

62 Édouard Manet, *Le Prune*, c. 1877. Oil on canvas, 29 × 19¾ (73.6 × 50.2). National Gallery of Art, Washington, D.C., Collection of Mr and Mrs Paul Mellon, 1971.

63 *La Gueule de bois*, 1889. Ink and blue pencil, 19⅜ × 24⅞ (49.3 × 63.2). Musée Toulouse-Lautrec, Albi.

64 Vincent van Gogh, *Au Tambourin*, 1887. Oil on canvas, 21¾ × 18¼ (55.4 × 46.5). Rijksmuseum Vincent van Gogh, Amsterdam.

65 *Suzanne Valadon*, 1886. Oil on canvas, 21¼ × 17¾ (54 × 45). The Ny Carlsberg Glyptotek, Copenhagen.

66 Study for *Boulevard Extérieur*, 1889. Chinese ink on paper, 25⅞ × 16¼ (65 × 41). Private collection.

67 *Jeanne Wenz*, 1886. Oil on canvas, 31⅞ × 23¼ (81 × 59). The Art Institute of Chicago, Mr and Mrs Lewis L. Coburn Memorial Collection.

68 *Poudre de riz*, 1887–88. Oil on cardboard, 22 × 18⅛ (56 × 46). Stedelijk Museum, Amsterdam.

69 Théophile-Alexandre Steinlen, cover for *Le Mirliton*, 15 January 1886.

70 *Le Dernier Salut*, cover for *Le Mirliton*, March 1887.

71 Cover for *Le Mirliton*, August 1887.

72 *La Goulue*, poster for the Moulin Rouge, 1891. Colour lithograph, 53 × 48 (84 × 122).

73 Pierre Bonnard, *France-Champagne*, 1889. Lithograph, poster, 30⅛ × 23 (76.5 × 58.4).

74 Jules Chéret, *Bal au Moulin Rouge*, 1889. Lithograph, poster 23⅜ × 16½ (59.7 × 41.9).

75 *La Revue Blanche* (second state), 1895. Colour lithograph, poster, 49⅜ × 35⅞ (125.5 × 91.2).

76 *Aristide Bruant dans son cabaret*, 1892. Colour lithograph, poster for the Eldorado, 53¹⁄₁₀ × 38 (137 × 96.5).

77 *Aristide Bruant dans son cabaret*, 1892. Colour lithograph, poster for the Ambassadeurs, 52⅞ × 36⅛ (133.8 × 91.7).

78 *Bruant à bicyclette*, 1892. Oil on cardboard, 29⅜ × 25⅝ (74.5 × 65). Musée Toulouse-Lautrec, Albi.

79 *L'Anglais au Moulin Rouge*, 1892. Oil and gouache on cardboard, 33¾ × 26 (85.7 × 66). The Metropolitan Museum of Art, New York. Bequest of Miss Adelaide Milton de Groot, 1967.

80 *L'Anglais au Moulin Rouge*, 1892. Colour lithograph, 18½ × 14⅝ (47 × 37.3).

81 *Aristide Bruant*, 1893. Colour lithograph, final version of Lautrec's poster for the Mirliton, 31⅞ × 39⅝ (81 × 55).

82 *Confetti*, 1894. Colour lithograph, poster for the English firm Bella & de Malherbe, 22½ × 15⅜ (57 × 39).

83 *La Coiffure*, 1893. Colour lithograph, programme for *Une Faillite* at the Théâtre Libre (second state), 13 × 10 (33 × 25.5).

84 *May Milton*, 1895. Blue and black chalk on paper, 29⅛ × 23⅛ (74 × 58.9). Yale University Art Gallery, New Haven. Gift of Walter Bareiss, 1940.

85 *May Belfort*, 1895. Gouache on paper, 32⅝ × 24¾ (83 × 62). Private collection.

86 *May Milton*, 1895. Colour lithograph, poster (second state), 31¼ × 24 (79.5 × 61).

87 *May Belfort*, 1895. Colour lithograph, poster (fourth state), 31¼ × 24 (79.5 × 61).

88 *Le Photographe Sescau*, 1894. Colour lithograph, poster (third state), 23⅞ × 31¼ (60.7 × 79.5).

89 *La Grande Loge*, 1896–97. Colour lithograph (second state), 20¼ × 15¾ (51.3 × 40).

90 *La Loïe Fuller aux Folies Bergère*, 1892–93. Black chalk and oil on cardboard, 24⅞ × 17⅞ (63.2 × 45.3). Musée Toulouse-Lautrec, Albi.

91 *Jane Avril*, 1893. Oil on cardboard, 26¼ × 20⅝ (66.8 × 52.2). Musée Toulouse-Lautrec, Albi.

92 *Jane Avril, La Mélinite*, 1892. Oil on cardboard, 34 × 25⅝ (86.5 × 65). Musée Toulouse-Lautrec, Albi.

93 *La Troupe de Mademoiselle Eglantine*, 1895–96. Colour lithograph, poster (third state), 24⅛ × 31⅛ (61.7 × 80.4).

94 *Jane Avril sortant du Moulin Rouge*, 1892. Gouache on cardboard, 33⅛ × 25 (84.4 × 63.5). Wadsworth Atheneum, Hartford, Connecticut.

95 *Jane Avril entrant dans le Moulin Rouge*, 1892. Oil and pastel on cardboard, 40⅛ × 21⅝ (102 × 55). Courtauld Institute Galleries, London, Samuel Courtauld Collection.

96 *Le Divan Japonais*, 1892. Colour lithograph, poster, 31¾ × 23⅝ (80.8 × 60.8).

97 *Jane Avril au Jardin de Paris*, 1893. Colour lithograph, poster, 48⅞ × 36 (124 × 91.5).

98 Cover for the 'Yvette Guilbert' album, 1898. Lithograph (third state), 8⅞ × 6½ (22.7 × 16.5).

99 *Cycle Michael*, 1896. Lithograph, design for a poster, 32 × 4⅞ (81.5 × 121).

100 *La Châine Simpson*, 1896. Colour lithograph, poster, 32½ × 47¼ (82.8 × 120).

101 *Tristan Bernard au Vélodrome Buffalo*, 1895. Oil on canvas, 25⅝ × 31⅞ (65 × 80.9). Private collection.

102 *Romain Coolus*, 1899. Oil on cardboard, 22⅛ × 14½ (56.2 × 36.8). Musée Toulouse-Lautrec, Albi.

103 *A la Renaissance, Sarah Bernhardt dans 'Phèdre'*, 1893. Lithograph, 13½ × 9⅛ (34.2 × 23.5).

104 *A l'Opéra, Madame Caron dans 'Faust'*, 1893. Lithograph, 14½ × 10⅜ (36.2 × 26.5).

105 *La Loge, Thadée et Misia*, 1896. Lithograph, 14⅝ × 10½ (37.2 × 26.8).

106 *Le Docteur Gabriel Tapié de Céleyran à la Comédie Française*, 1894. Oil on canvas, 43¼ × 22 (110 × 56). Musée Toulouse-Lautrec, Albi.

107 *Monsieur le Docteur Bourges*, 1891. Oil on cardboard, 31⅛ × 19⅝ (79 × 50.5). Museum of Art, Carnegie Institute, Pittsburgh (acquired through the generosity of the Sarah Mellon Scaife family, 1966).

108 *Une Opération sur amygdales*, 1891. Oil on cardboard, 29 × 19⅝ (73.9 × 49.9). Sterling and Francine Clark Art Institute, Williamstown.

109 *Paul Leclercq*, 1897. Oil on cardboard, 21¼ × 25¼ (54 × 64). Musée d'Orsay, Paris. Photo Réunion des Musées Nationaux.

110 Caricature of Lautrec and Lily Grenier, 1888. Pen and ink on paper, 4⅜ × 7 (11.1 × 17.7). Private collection.

111 The Moorish hall in the brothel at 24 Rue des Moulins, 1890s. Photograph. Bibliothèque Nationale, Paris.

112 The 'staff' at the brothel on the Rue des Moulins. Photo F. Gauzi.

113 *Marcelle*, 1894. Oil on cardboard, 18¼ × 11⅝ (46.5 × 29.5). Musée Toulouse-Lautrec, Albi.

114 Edgar Degas, *Trois Prostituées au bordel*, c. 1879. Pastel over monotype in grey, 6¼ × 8½ (16 × 21.5). Rijksprentenkabinet, Rijksmuseum, Amsterdam.

115 Emile Bernard, plate from the album *Au Bordel*, 1888. Stedelijk Museum, Amsterdam.

116 Emile Bernard, plate from the album *Au Bordel*, 1888.

117 Vittore Carpaccio, *Two Courtesans*, c. 1495. Oil on panel 37 × 32⅛ (94 × 64). Museo Correr, Venice.

118 *La Rue des Moulins*, 1894. Oil on cardboard, mounted on wood, 32⅞ × 24⅛ (83.5 × 61.4). National Gallery of Art, Washington, D.C., Chester Dale Collection 1962.

119 *Au Salon de la rue des Moulins*, 1894. Pastel, 43¾ × 52 (111 × 132). Musée Toulouse-Lautrec, Albi.

120 *Au Salon de la rue des Moulins*, 1894–5. Black chalk and oil on canvas, 43⅞ × 52⅛ (111.5 × 132.5). Musée Toulouse-Lautrec, Albi.

121 *Le Blanchisseur de la rue des Moulins avec la fille tourière*, 1894. Oil on cardboard, 22¾ × 18⅛ (57.8 × 46.2). Musée Toulouse-Lautrec, Albi.

122 *Ces Dames au réfectoire*, 1893. Oil on cardboard, 23¾ × 31⅝ (60.3 × 80.3). Szépművészeti Museum, Budapest.

123 *Monsieur, madame et le chien*, 1893. Black chalk and oil on canvas, 18⅞ × 23⅝ (48 × 60). Musée Toulouse-Lautrec, Albi.

124 Gustave Courbet, *Le Sommeil*, 1886. Oil on canvas, 53⅛ × 78¾ (135 × 200). Musée Petit Palais, Paris.

125 *Les Amies*, 1895. Oil on cardboard, 17⅞ × 26½ (45.5 × 67.5). Private collection.

126 *Les Deux Amies*, 1894. Oil on cardboard, 18⅞ × 13¾ (48 × 34). Tate Gallery, London.

127 *Au Lit*, 1894. Oil on cardboard, 20½ × 26½ (52 × 67.3). Musée Toulouse-Lautrec, Albi.

128 *Le Divan, Rolande*, 1894. Oil on cardboard, 20⅜ × 26⅜ (51.7 × 66.9). Musée Toulouse-Lautrec, Albi.

129 *Femme sur le dos, Lassitude*, 1896. Oil on cardboard, study for the tenth sheet in the *Elles* series. 15¾ × 23⅝ (40 × 60). Private collection.

130 *Femme au tub*, 1896. Colour lithograph, fourth sheet in the *Elles* series. 15¾ × 20⅝ (49 × 52.5).

131 Frontispiece for *Elles*, 1896. Colour lithograph (second state), 20⅝ × 15⅞ (52.4 × 40.4).

132 *La Clownesse Assise, Mademoiselle Cha-U-Kao*, 1896. Colour lithograph, 20¾ × 16 (52.7 × 40.5).

133 Edouard Manet, *Nana*, 1876–77. Oil on canvas, 60¾ × 45⅛ (154 × 115). Kunsthalle, Hamburg.

134 *Nu devant une glace*, 1897. Oil on cardboard, 24¾ × 18⅞ (62.8 × 47.9). Private collection.

135 *La Conquête de passage*, 1896. Black chalk and oil on silk, 41 × 26 (104 × 66). Musée Toulouse-Lautrec, Albi.

136 *La Comtesse Adèle de Toulouse-Lautrec*, 1887. Oil on canvas, 21⅞ × 18⅛ (55 × 46). Musée Toulouse-Lautrec, Albi.

137 *La Modiste*, 1900. Oil on wood, 24 × 19⅜ (60.9 × 49.2). Musée Toulouse-Lautrec, Albi.

138 Georges Seurat, *Le Cirque*, 1890–91. Oil on canvas, 73 × 59⅛ (185.4 × 150.1). Musée d'Orsay, Paris. Photo Bulloz.

139 *Au Cirque Fernando: L'Equestrienne*, 1888. Oil on canvas, 38¾ × 63½ (98.4 × 161.3). Art Institute of Chicago, Joseph Winterbotham Collection.

140 *Monsieur Désiré Dihau, Basson de l'Opéra*, 1890. Oil on canvas, 22⅛ × 17¾ (56.2 × 45). Musée Toulouse-Lautrec, Albi.

141 *'Le Petit Trottin'*, 1893. Lithograph, 11 × 7½

(27.8 × 18.9).

142 Edgar Degas, *Mademoiselle Dihau au piano*, c. 1869–72. Oil on canvas, 15⅜ × 12⅝ (39 × 32). Musée d'Orsay, Paris. Photo Réunion des Musées Nationaux.

143 Vincent van Gogh, *Marguerite Gachet au piano*, 1890. Oil on canvas, 40⅛ × 19⅝ (102 × 50). Kunstmuseum, Basel.

144 *Mademoiselle Dihau au piano*, 1890. Oil on cardboard, 27¼ × 19¼ (69 × 49). Musée Toulouse-Lautrec, Albi.

145 *Au Moulin Rouge*, 1892. Oil on canvas, 48⅜ × 55¼ (122.8 × 140.3). Art Institute of Chicago, Helen Birch Bartlett Memorial Collection.

146 Edgar Degas, *L'Absinthe*, 1876. Oil on canvas, 36¼ × 26¾ (92 × 68). Musée d'Orsay, Paris.

147 *A la mie*, 1891. Oil on cardboard, 20⅞ × 26¾ (53 × 68). Museum of Fine Arts, Boston.

148 *A la toilette, Madame Poupoule*, 1898. Oil on wood, 24 × 19½ (60.8 × 49.6). Musée Toulouse-Lautrec, Albi.

149 The wife of a colonial officer, travelling on a cruise with Lautrec in 1895. Photograph.

150 *La Passagère du 54, Promenade en yacht*, 1895. Colour lithograph, poster, 24 × 17⅝ (61 × 44.7).

151 *Horseguard*, 1898. Pen on paper, 10¼ × 10⅝ (26 × 26.9). Musée Toulouse-Lautrec, Albi.

152 *Oscar Wilde et Romain Coolus*, 1896. Lithograph, 11⅞ × 19¼ (30.3 × 49).

153 *Chocolat dansant*, 1896. Paint and pencil, 25½ × 19⅝ (65 × 50). Musée Toulouse-Lautrec, Albi.

154 *Irish and American Bar, Rue Royale*, 1895. Lithograph, 11⅞ × 19¼ (30.3 × 49).

155 *Jane Avril*, 1899. Pencil on paper, 21⅞ × 14⅞ (55.8 × 37.6). Private collection.

156 *Mon Gardien*, 1899. Oil on wood, 16⅞ × 14⅛ (43 × 36). Musée Toulouse-Lautrec, Albi.

157 *Tête de vieil homme*, 1899. Coloured chalks on blue-grey paper, 13¾ × 11⅞ (35 × 30.4). Musée Toulouse-Lautrec, Albi.

158 *Au Cirque, Clown dresseur*, 1899. Coloured chalks on beige paper, 10⅝ × 17 (25.9 × 43.3). Statens Museum for Kunst, Copenhagen.

159 *Le Jockey*, 1899. Colour lithograph (second state), 20⅜ × 14¼ (51.8 × 36.2).

160 *Le Jockey se rendant au poteau*, 1899. Colour lithograph, 17½ × 11¼ (44.6 × 28.5).

161 *Soldat Anglais fumant sa pipe*, 1898. Charcoal on paper, 56⅝ × 43¼ (144 × 110). Musée Toulouse-Lautrec, Albi.

162 *L'Anglaise du Star du Havre*, 1899. Red and white chalk on blue-grey paper, 24⅜ × 18½ (62 × 47). Musée Toulouse-Lautrec, Albi.

163 *En cabinet particulier au Rat Mort*, 1899. Oil on canvas, 21½ × 17¾ (54.6 × 45). Courtauld Institute Galleries, Samuel Courtauld Collection.

164 *L'Anglaise du Star du Havre*, 1899. Oil on canvas, 16⅛ × 12⅝ (41 × 32). Musée Toulouse-Lautrec, Albi.

165 *La Gitane*, 1899–1900. Colour lithograph, poster, 35⅞ × 25 (91 × 63.5).

166 *Maurice Joyant*, 1900. Oil on wood, 45⅞ × 31⅞ (116.5 × 81). Musée Toulouse-Lautrec, Albi.

167 *Messaline descend l'escalier bordé de figurantes*, 1900–01. Oil on canvas, 39 × 28½ (99.1 × 72.4). Los Angeles County Museum of Art, Los Angeles, Mr and Mrs George Gard de Sylva Collection.

168 *Un Examen à la Faculté de Médecine de Paris*, 1901. Oil on canvas, 25⅝ × 31⅞ (65 × 81). Musée Toulouse-Lautrec, Albi.

169 Lautrec with his mother at Malromé, c. 1899–1900. Photograph. Bibliothèque Nationale, Paris.

Index

Numerals in **bold type** indicate illustration numbers